SOURCES AND DOCUMENTS IN THE
HISTORY OF ART SERIES

H. W. Janson, *Editor*

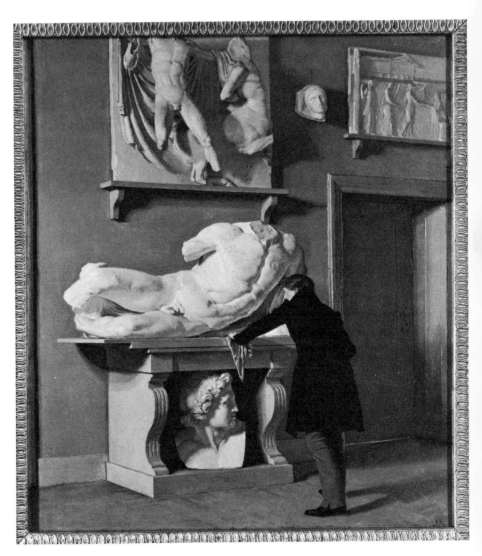

*C. Købke, Young Artist Studying Casts of the Elgin Marbles,
1830, Hirschsprungske Samling, Copenhagen*

Neoclassicism
and Romanticism

1750-1850

SOURCES and DOCUMENTS

Volume II
Restoration / Twilight of Humanism

Lorenz Eitner

Stanford University

PRENTICE-HALL, INC.
Englewood Cliffs, New Jersey

Library of Congress Catalog Card Number: 74-94425

Printed in the United States of America 13-610915-2

Current Printing (Last Digit)

10 9 8 7 6 5 4 3 2 1

PRENTICE-HALL INTERNATIONAL, INC., *London*
PRENTICE-HALL OF AUSTRALIA, PTY. LTD., *Sydney*
PRENTICE-HALL OF CANADA, LTD., *Toronto*
PRENTICE-HALL OF INDIA (PRIVATE) LTD., *New Delhi*
PRENTICE-HALL OF JAPAN, INC., *Tokyo*

In Memory of W. E.

Preface

The two volumes of *Neoclassicism and Romanticism* trace one continuous development, rather than describe two separate periods. The book was conceived as a unity, and its division into two volumes resulted from technical necessity. While this, the second volume, dwells mainly on the latter half (1800–1850) of the century which the entire book attempts to cover, nearly everything in it is so dependent on the events, the persons, and the ideas of the preceding generations (1750–1800), dealt with in the first volume, that it can hardly be considered an independent entity. In order to avoid repetitious explanatory comments, I have connected the two volumes by numerous cross references, for which I beg your indulgence. The one advantage of the book's division is, perhaps, that it underlines the peculiar relationship between the two halves of the hundred-year span under discussion, and thus helps us to see the earlier as a period of sharp action and innovation, and the later as one of response and reflection.

To all those who contributed help or encouragement, and most of all to my wife, I give my warmest thanks. I feel a particular debt to the Carnegie Corporation for a research grant which greatly eased and accelerated the work on this book.

<div align="right">Lorenz Eitner</div>

Contents

NEOCLASSICISM AND ROMANTICISM
1750–1850

3

Restoration

INTRODUCTION

The revolutionary enthusiasm of the last decades of the 18th century had pervaded every sphere of life, raised every hope, and released immense energies. Nearly all the artists of the time, whatever their nationality, class, or personal bent, were stimulated by it, Blake in Felpham no less than David in Paris, or Carstens in Rome. "A fresh morning gradually dawned for all these artists," Carus wrote in his life of Friedrich, "the volcanic tremors which transformed Europe after 1789 reverberated in peculiar ways in the arts as well as the sciences. . . ."[1]
But the earliest signs of fatigue and retreat already began to appear before 1800, and, by 1810, the movement of reaction had become general. Exhausted by revolutions and wars, tired of the quest for liberty, afraid of further experiment, men sought peace in a return to stable institutions and old beliefs. It was not only the historical circumstance of Napoleon's downfall, it was a general readiness and resignation which permitted the systematic reconstruction, after 1815, of church and monarchy, and of a great variety of authoritarian institutions besides, the discredited academies among them. But the movement of reaction did not only revive prerevolutionary ideas and institutions, it converted to its own ends many of the innovations of the revolutionary period. Thus the study of national origins and traditions, begun by the libertarians of Storm and Stress, was continued in the interest of state and monarchy by conservative nationalists; the Museum, a creation of the Enlightenment and the Revolution, became a mainstay for the promoters of retrospection and revival. In the arts, the time about 1815 marks a division between two eras. Although the main movements, classicism as well as romanticism, seemingly continued uninterrupted, and actually grew into their more popular and familiar forms only after that date, the vital and innovative phase of their development had in fact come to an end by 1815. What followed directly was an aftermath of limited and imitative art, given over to refinements of style and sentiment. The progressive work of Constable and Turner, Gericault and Delacroix derived from other sources and signalled a fresh start.

[1] C. G. Carus, "Friedrich der Landschaftsmaler," *Kunstblatt*, 1840, p. 357.

REVIVAL OF INSTITUTIONS

The period following the Revolution witnessed the rapid growth of state-sponsored institutions and the return of state patronage. This development was most spectacular in France, where the revolutionary government already had created the prototype of the modern national museum and had begun to centralize the administration of the arts. Napoleon availed himself of these beginnings, and was able to assemble within a very short time the greatest museum collection which had ever existed, while organizing simultaneously a system of state patronage of the arts which equalled the most ambitious enterprises of Renaissance popes and Baroque monarchs. The other European nations, particularly England (see page 82), Russia, Spain, Austria, Bavaria, and Prussia followed the French example, though more slowly and on a more modest scale.

The Central Museum

During the latter half of the 18th century, princely collections of art throughout Europe gradually acquired the character of public museums. In Paris, a portion of the royal collections was opened to the public at the Luxembourg as early as 1750. For several decades thereafter, ambitious projects were made for a more complete installation of the king's pictures in the long gallery of the Louvre. By 1781, the opening of the great museum seemed imminent. The English engraver, Valentine Green, reported: [2]

The Parisian Academy is now assembling the works of all their great masters; and by a thorough renovation of them, in whatsoever parts they may have been impaired by time, or accident, they will set them before an applauding people with all their original splendor. . . . To give honourable reception to those Pictures and Statues, the upper apartments of the New Louvre are under preparation; and through the whole extent of that magnificent palace, a length of upward of 1300 feet . . . new lights are introduced from its roof and sides, in addition to those it originally possessed . . . in order to produce a regular, impartial, and equal distribution of light. In addition to those works of the French School, will be collected, the numerous and valuable Pictures, which for want of room, are huddled together in the most unfavourable manner,

[2] Valentine Green, *A Review of the Polite Arts in France*, London, 1782, p. 25.

in and about the Palace of Versailles, to the amount of some thousands, by the best Italian, and other Masters, and of the first order. . . .

But the project of a central, national museum of the arts was not to be realized for yet another decade. The Revolution finally achieved, with dazzling speed and on the most impressive scale, what the monarchy had so sluggishly begun. The first revolutionary foundation was the Museum of French Monuments which was begun in 1790 for the purpose of gathering together the confiscated art properties of the church, and to preserve from further damage the fragments of vandalized ecclesiastical and royal monuments. The collection was in charge of the painter Alexandre Lenoir (1762–1839) who converted what might have been a simple depot into a well-organized, public museum of sculpture. In the preface of the museum's catalogue (1810), he described his intention: [3]

The destruction of monuments of art was an inevitable consequence of the political disorders. It is only too well known to what excesses a misguided multitude can be brought whose fury is all the more redoubtable for being inspired by the idea of wrongs to be avenged. In those stormy times, the officials of the government showed a great deal of zeal and prudence. They surrounded themselves with virtuous citizens who, to this day, merit the praise of the public, because of their intelligence and probity. . . . The National Assembly, having decreed the nationalization of the property of the clergy, charged its Committee for Confiscations with the conservation of works of art which fell under this heading. M. de Larochefoucauld, the president of the Committee, gathered together several scholars and artists to undertake the selection of those monuments and books which were to be preserved. The municipality of Paris, charged with the execution of the National Assembly's decree, on its part also appointed scholars and artists to assist the Committee for Confiscations. The scholars thus appointed formed a commission known as the *Commission des monuments*. Next, a convenient location had to be found for the storage of the treasures that were to be saved from destruction. The Committee for Confiscations chose the monastery of the Petits-Augustins to house the sculptures and paintings, and the monasteries of the Capucins, the Jesuits, and the Cordeliers for the books and manuscripts. The Commission published expert instructions concerning methods for the preservation of the precious objects which it intended to collect. I was attached to this commission at the time (October 12, 1790) and entrusted in particular with the collection, arrangement,

3 Alexandre Lenoir, *Museum of French Monuments* (J. Griffith, trans.), Paris, 1803, p. XVI. See also Cecil Gould, *Trophy of Conquest,* Faber and Faber, London, 1965, for an account of the development of French national museums in the period of the Revolution and the Empire.

and conservation of sculptural monuments. . . . Animated by a true love of art, I did more than that. I gathered together all the monuments which misguided fury had mutilated or destroyed. I shall pass over the difficulties, the annoyances, the obstacles, and even dangers which I had to overcome in order to assemble some five hundred monuments of the French monarchy, to put them in order, to restore, classify, describe, and reproduce them by means of engravings. . . .

The public display in Paris of hundreds of sculptures from the old churches and monasteries of France gave a powerful stimulus to the revival of interest in medieval and Christian art. Lenoir's careful historical arrangement of his collection increased its value for scholars, the romantic style of his display fascinated artists and the general public. An English traveller who visited the Museum in 1802 wrote of his impressions: [4]

This morning we spent three or four delightful hours in the *Musée National des Monuments Francais*—an institution which was projected and organized by Citizen Lenoir. To his industry and sagacity the Republic is indebted for the restoration of upwards of five hundred Gallic monuments, which he has arranged in the several apartments of the convent. By classing these specimens of art according to the ages in which they were respectively produced, he has contrived to give an excellent elucidation of the state of sculpture in France, at every period, from the decline of the Roman empire to the end of the reign of Louis XV. In the distribution of the several classes, Lenoir has evinced a considerable degree of judgment. The dim religious gloom of the apartments destined for the reception of the recumbent figures of the saints and warriors of the middle ages, lends the rude efforts of art an interest which they do not in themselves possess. The more exquisite productions of the time of Francis I and the well-wrought sculpture of the age of Louis XIV are disposed in the lightsome halls, where their beauties will be best discerned. In the garden of the convent, which is planted with acacias and willows, he has deposited several ancient tombstones. Here the English traveller will not fail to distinguish the simple monument of Abelard and Heloise. The windows and cloisters are ornamented with painted glass, transported from the glowing windows of a thousand churches, which the bigoted intolerance of modern philosophy had doomed to devastation and pillage.

Alexandre Lenoir clearly recognized the importance of the museum as a place of study for artists, and he accurately predicted that museums

[4] Rev. William Shepherd, *Paris in Eighteen Hundred and Two,* London, 1814, pp. 83 ff.

would some day rival, and perhaps replace, the Academy. The oppor-
tunity for independent study which the new museums offered was to have
a more radical and lasting effect on the future of artist-training than the
temporary suppression of the Academy during the Revolution. Lenoir
wrote in 1803: [5]

Versed from my infancy in the art of drawing, I became convinced
that collections were of more service to the progress of the arts than
schools, where the pupils never see any works of art. . . . A museum . . .
ought to have two objects in view, the one political, the other that of
public instruction. In a political point of view, it should be established
with sufficient splendor and magnificence to strike the eye and attract the
curious from every quarter of the globe, who would consider it as their
duty to be munificent amongst a people friendly to the arts; in point of
instruction, it ought to contain all that the arts and sciences combined can
produce toward the assistance of public teaching: such were the museums
of the ancients, whose memory we still respect.

If, for the success of the arts, it were ever necessary to do away with
the academies, formed on an imperfect basis, the progress of the arts
would demand that a clear and easy method of teaching be instituted to
enable students to consult the great masters with facility. Such means
of study naturally present themselves in a museum chronologically ar-
ranged, where youth will find, by the comparisons which they themselves
make, certain and proper models to direct their studies.

The Musée Napoleon

After the fall of the French monarchy in 1792, the revolutionary
government rapidly carried out the old project of transferring the royal
collections to the Louvre. While the sculptural monuments were being
assembled at the Petits-Augustins under Lenoir's care, some five hundred
paintings from the king's collection and from the secularized churches
were brought to the Louvre, which was formally opened to the public
on August 10, 1793. Shortly thereafter, the national museum received
a huge addition, in the form of the spoils of the Belgian campaign of
1794. It was during this campaign that the policy of systematic art loot
in the conquered territories was first instituted by the French government.
Commissioners, attached to the army command, carried out the selection
and removal of works of art from churches and princely collections for
the benefit of the museum. The system was continued on an even larger
scale during Napoleon's campaigns in Italy in 1795–1797. The finest

[5] Alexandre Lenoir, *Description historique et chronologique des monumens . . .*
réunis au Musée des Monumens Francais, Paris, 1803; see also L. Courajod, *Alexandre*
Lenoir, son journal et le Musée des Monuments Francais, Paris, 1878.

paintings and sculptures were taken from the churches and collections of Parma, Modena, Milan, Bologna, Verona, and Venice, from the Papal collections in the Vatican, and the royal collections in Turin. The shipments reached Paris during 1797 and 1798. Napoleon wished to mark the entry of these captive works of art into the Louvre, soon to be called Musée Napoleon, by a great procession, styled after the triumphs of Roman conquerors, but also reminiscent of the Republican festivals which David had organized for Robespierre (see Vol. I, p. 134). The following account was written by a pupil of David, the painter Etienne Delécluze (1781–1863): [6]

It was resolved to arrange a triumphal entry on that day (July 27, 1798, the anniversary of Robespierre's fall) for all the crates containing the manuscripts, books, statues, and paintings from the library and museum of the Vatican. For this purpose, the crates were placed on enormous carts, drawn by richly caparisoned horses, and to these treasures of art, treasures of another kind were added, to give the procession a character of encyclopedic completeness. . . . The whole long train was divided into four sections. At the head advanced the crates filled with manuscripts and books. Next came those which contained the most interesting mineral products of Italy, among them the Veronese fossils. To complete this museum of natural history on wheels, there were iron cages holding lions, tigers, and panthers, surmounted by huge palm branches, carobs, and other exotic plants brought to France by our naval officers.

These were followed by a long file of carts filled with crated paintings, inscribed with the titles of the most famous works, such as Raphael's *Transfiguration*, and Titian's *Christ*. . . . Finally, on specially constructed, heavy carts followed the sculptures and marble groups: the *Apollo of Belvedere*, the *Nine Muses*, the *Antinous*, three or four statues of *Bacchus*, the *Laocoon*, the *Gladiator*, and other specimens of the best antique sculpture. These carts and their precious cargoes bore numbers and were bedecked with laurel branches, bouquets and wreaths of flowers, and with flags taken from the enemy. Inscriptions in French, Latin, and Greek identified the divinities and other personages represented by the statues, or celebrated the glorious achievements of the Army and of its general to whom we owed these prodigious riches.

Each of the four sections was preceded by detachments of cavalry and infantry, with drummers and bands, and by the members of the Institute whose field of specialization corresponded to each of the four sections, accompanied by scholars and artists. Behind them marched actors, chanting hymns of joy. . . . This immense procession traversed

[6] E. Delécluze, *Louis David, son école et son temps*, Paris, 1855, pp. 206 ff.

all of Paris, to pass in review at the Champ de Mars, before the five members of the Directory who stood at the Altar of the Fatherland, surrounded by the ministers of state and high officials of the government, the generals of the garrison, and an immense crowd of spectators who had come to witness a public ceremony which aroused the liveliest and most sincere enthusiasm. As can be imagined, this enthusiasm was especially strong among the artists. . . .

One man only held a contrary opinion, and had the courage to express it—David. . . . Etienne [the author] resolved to question him about it. "Bear in mind, dear Etienne," said David, "that the arts are not naturally loved in France; the taste for them is artificial. You can be sure that, in spite of all the enthusiasm which we see these days, the masterworks from Italy will soon be regarded only as curiosities. The site of a work of art, the distance one must travel to see it contribute singularly to our notion of its worth. This is particularly true of the paintings which one hung in churches. They will lose much of their beauty and effect when they are no longer seen in the places for which they were made. The sight of these masterpieces will perhaps produce scholars, men like Winckelmann, but artists—no!"

After the Peace of Amiens, in 1802, which opened the French frontiers, many Englishmen and Germans took the road to Paris expressly to see the spoils of Flanders and Italy at the Louvre. Among the English artists who made the voyage were Turner, Flaxman, Opie, Farington, Hoppner, and Shee; the American Benjamin West and the Swiss Fuseli came from London, the architect Gilly and the brothers Schlegel from Germany. Some of the visitors found the sheer number and variety of the exhibited works confusing. The painter Martin Shee (1769–1850) wrote: [7]

The extraordinary assemblage of works of Art deposited in the Louvre at Paris appears in this respect on the first view quite embarrassing. All is confusion and astonishment, the eye is dazzled and bewildered, wandering from side to side, from picture to picture; like a glutton at a feast, anxious to devour everything, till the intellectual stomach, palled and oppressed by variety, loses the pleasure of taste, and the power of digestion.

The German publicist, J. F. Reichardt, expressed the more common sentiment of admiration: [8]

[7] Martin A. Shee, *The Elements of Art*, London, 1809, p. 174.
[8] J. F. Reichardt, *Vertraute Briefe aus Paris, geschrieben in den Jahren 1802 und 1803*, Hamburg, 1805 (second edition), I, 124 ff.

I have already spent several delightful mornings in the magnificent *Musée Central des Arts,* in incredibly rich galleries filled with ancient sculptures and with paintings of all the schools. It is a pity, however, that the light which enters the gallery from two sides makes it impossible to see the paintings properly. Large pictures in particular can almost never be encompassed in one glance. It is necessary to find the proper light for each of their various parts by moving from one to the other. . . . In the immense gallery which extends a great distance without interruption, we find, to begin with, the best painters of the French school. Here the works of Lebrun, Poussin, and Lesueur fascinate the lover of art above all. Vernet is represented by some of his most beautiful works, but I think that I have seen better pictures by Claude Lorrain elsewhere, though there is a *Sunset* here which must surely be among his most important works.

The collection of Netherlandish and German paintings which follows is especially rich in beautiful Van Dycks and Rembrandts, and in splendid masterworks by Rubens. Contemplating these last, I was initially put off at finding so many of them hung side by side. Lovers of art who are familiar with this master's work will understand the reason why. There are also numerous, excellent works by our worthy Dürer and by Holbein here, but these masters can be better studied in Basel, Nuremberg, Augsburg, and other German cities, just as Van der Werff is better represented in Düsseldorf.

It was only when entering the last section of the gallery, which houses the Italian school, that I felt I had reached my destination. What an abundance of the most beautiful, most magnificent works of art, and, in the majority of them, what elevation and beauty of artistic character! With what deep pleasure one finds here the works of Albano, the Carracci, of Correggio, Domenichino, and Guercino, more complete than anywhere else in the world. And yet, after enjoying these paintings for hours on end, one has still to see the work of the divine Raphael. This highest pleasure has intentionally been saved for the last. Marvellous works by this master are shown here, and several more, of even larger format, will soon be put on view. These are still in the hands of restorers, for, unfortunately, many of the works brought from Italy have suffered barbarous treatment, despite all the loudly-trumpeted claims of care and precaution.

. . . Today, I yielded to a temptation to sneak into the restorer's shop. The guardian of the key proved corruptible. Heavens! what delights, what inexpressible delights I experienced in looking at Raphael's inconceivably beautiful *Transfiguration.* This, the most exalted masterwork of art, the greatest which the excellent, divinely inspired Raphael executed with his own hand, and which, when it was still in Italy, could

be seen only in the miserable gloom of a church—I saw it here in the light of noon, the best possible illumination. And I was able to contemplate it alone, locked into its room for hours on end. I have not enjoyed a work of art so keenly since last I sat before the same master's magnificent *Madonna* in the Gallery of Dresden. . . .

Several hundred of the best Italian paintings still fill the racks of damaged pictures. Most of them are in sad condition. A *Holy Family* by Raphael is in such a ruinous state that it is difficult to believe it can ever be restored in such a way as to satisfy the eye of the connoisseur. . . .

The antique sculptures seem to have been more carefully handled during shipment. Some of the most important pieces, however, the *Laocoon,* for instance, have suffered damage which, though not serious, is quite noticeable. . . . Many of the sculptures, including the *Apollo of Belvedere,* are placed too high. His feet are roughly at the spectator's eye level, and his divine body can only be seen from below. In Italy, he also stood too high, but at least was better illuminated. Here he received light from a window at his side which descends to a point lower than his feet. To see the statue well in its true character, one must climb on a stool opposite. In Italy, the statue was seen to best advantage by torch light, a form of illumination which has not yet come into fashion in Paris.

The annoying Roman custom of covering the private parts of antique statues with metal fig-leaves, tinted green, has not been followed here, but the obtrusive Papal inscriptions have been imitated. The pedestal of the *Apollo of Belvedere,* for instance, carries a bronze plaque with a lengthy inscription which Bonaparte himself fastened to the statue when he first inspected it here:

> The Statue of Apollo which Rises upon this Pedestal
> Was Found at Antium at the End of the Fifteenth Century, and
> Placed in the Vatican by Julius II at the Beginning of the Sixteenth.
> Conquered in the Fifth Year of the Republic by the Armies of Italy
> Under the Orders of General Bonaparte,
> It was Placed here on the 10th of April, 1800,
> In the First Year of his Consulate.

Throughout the reign of Napoleon, the Museum continued to grow, enriched by the spoils of the successive campaigns in Germany and Spain, and by further acquisitions from Italy. After Napoleon's first abdication, in 1814, the question of restitution remained unresolved, but after his final defeat at Waterloo, in 1815, the Allies swiftly dismantled the Musée Napoleon, *despite the protests of the French government and the resistance of the Museum's energetic director, Vivant Denon. The re-*

moval of the works of art aroused a long and bitter quarrel over the morality and legality of this particular venture in museum building, and over the general issue of the museum's usefulness to students of art. The following account, written in 1814 by a British visitor to Paris, reflects these controversies: [9]

As I walked along the Gallery of Pictures, I looked out from the windows on the Place du Carousel. It was a court day at the Tuileries, and the Gardes du Corps of Louis were lounging over the balcony of the Palace, while crowds were assembled to see the ministers and nobility, who went to pay their respect to His Majesty. A few months before, and all this was happening in favor of Napoleon. . . . His N's and his monuments are everywhere about, but he himself is removed! And this temple of taste, and these palaces—many years have not elapsed since they were the scenes of savage ferocity and wanton carnage. Through this gallery a French King and his family flew, pursued by murderers, never more to return to a royal residence.—These multitudes, that are now pressing round pictures and chattering criticism on works of taste, were formerly equally occupied and amused with an exhibition of dancing dogs under the guillotine!

It is only such a people as this, that could have collected what is amassed together in Paris, and it is only such a people as this that could vaunt of such a collection, amassed under such peculiar circumstances, in the tone and language which they use. Others have gone to the seats of these sacred monuments to admire and venerate—but they went to pack and transport. Their armies advanced, burning houses and violating women; and in their rear came the members of the Institute to worship fine art and commit sacrilege in its temples. . . . A worse mistake cannot be committed than the supposition that facilities are chiefly useful to the cause of taste and science. . . . Let the student be exposed to hazards . . . let him incur difficulties; they will, if he be worthy of his pursuit, encrease his ardour. . . . Let the student be led in a painful pilgrimage to the honour of his divinity, from Paris to Germany, from Germany to Rome, from Rome to Florence. The sacred flame will be fanned by the motion, and his mind be informed and corrected by observation.

Magnificent galleries of foreign productions do little or no credit to the mind of a country, and perhaps it would not be too much to say that they are positively injurious to the mind. The Greeks had no galleries of Egyptian art;—if they had, we should not have received from their artists the precious bequests which have survived to this day. . . .

[9] John Scott, *A Visit to Paris in 1814*, London, 1816, pp. 246 ff.

The following account of the removal of the looted works of art from the Louvre was written by a British officer who witnessed the operation in 1815: [10]

At the first entrance of the armies in Paris, and very shortly after the contribution levied through the Prefect of the Seine, by Blucher, a requisition was made by the same vieille moustache, to have some pictures and a statue, that had been taken from Prussia, restored. Some of the pictures had ornamented the apartments of the Queen of Prussia, and were then in the Palace of St. Cloud; the bronze statue was in the gallery of the Museum. Denon, the director, demurred to this proposal; he was consequently arrested by some Prussian soldiers. . . . With such arguments there could be no debate. The pictures, among which were two of Correggio, and the statue, were packed up, as well as some others claimed by the King, as belonging to Aix la Chapelle and Cologne, and sent off. The French hoped that this was the last attack on their riches. It may be easily conceived their surprise and chagrin, when a fresh claim started up toward the latter end of August from the new King of the Belgians, for the pictures that were taken from the churches in that country, and this claim was supported by our minister in Paris. . . .

The ice, once broken, a general restitution seemed resolved on, and Canova, the celebrated sculptor, arriving from Rome, hastened the measure to a conclusion, as he claimed the protection of the British government. The attack now became general. The guardianship of the galleries was virtually taken from the French, and a guard of British troops stationed there, who prevented the French, with few exceptions, from entering—possibly in the fear that they might take their revenge by mutilating the pictures. These were easily removed and packed up, but it was a different affair with respect to the statues. It was said that the French did not require any orders from the Government to avoid giving assistance, as not one of them would lend a hand. I went frequently in during the process of packing, and saw several men there at work, who bore all the appearance of Parisian workmen, but the guardians of the Museum positively asserted that these were not Frenchmen, but foreigners settled in Paris. Being in coloured clothes, I insinuated myself among the groups of Frenchmen that occupied the space in front of the Louvre, and its approaches, and was much edified at the expressions of mingled rage, shame, and grief; if we had partitioned France among the allies, and made all the inhabitants tributary serfs, there could have been scarcely greater consternation. . . . Everyone has heard the story of the girl who fell in love with the Apollo; the grief and sorrow of both men and women for its departure were of the deepest character,

10 Anonymous, *Cogitations of a Vagabond,* London, 1838, pp. 175 ff.

and nearly equalled that of the passion of the young lady. Some of the artists who were allowed to be present when this inimitable statue was put into its case, shed tears, and kissed the hand of marble. All the feelings . . . reached their climax when the train of carriages with the packages moved off, under an escort of our 52nd light infantry. . . . The pictures, as I have said, were more manageable, and some of them were taken out of the frames and rolled up, but the celebrated one of the Transfiguration being painted on wood, could not be easily stowed away. The workmen, in lowering it down, let it slip out of their hands, and it fell on the floor. The fall caused the dust out of innumerable worm holes in the back of the picture to fly out, and for a moment to hide the picture itself. A cry of horror broke from the spectators, imagining that it was smashed to pieces; fortunately, they were deceived. . . .

The Reorganization of State Patronage under Napoleon

The scope and style of Napoleon's management of the arts are apparent in the detailed administrative memorandum which he sent, on August 6, 1805, to Pierre Daru, Intendant-General of the Imperial Household: [11]

It will be necessary to do something about the small park of Versailles . . . the grill must be repaired, guards and door keepers must be installed. Money has been set aside for the repair of the walls of the small park. Have the fountains and gardens of the Petit Trianon put in as good a shape as they have ever been in. . . .

As for the encouragement to be shown to the arts: the Imperial Library is under the authority of the Minister of the Interior, at whose disposal I have put 200,000 francs for the purpose this year; I do not know why the Minister of Finance has been unwilling to pay him this sum. A large part of the budget of the Imperial Household is spent on furnishings, paintings, the decoration of palaces, all of which amounts to an encouragement of the arts. With this in mind, the Intendant-General must exercise all his care and ingenuity to promote whatever might serve to stimulate industry, give encouragement to the arts, and excite the zeal of artists. David receives rather considerable sums for the arts. My librarian has made me subscribe to numerous engravings and books. I shall not refuse whatever you believe to be necessary for the encouragement of artists, but I do not want this to be considered as an obligation. The manufactories of Savonnerie, of the Gobelins, and of Sèvres must be made to function in such a way as not to burden the budget of the Imperial Household, in other words, their cost must be

[11] *Correspondance de Napoleon I^{er}*, Paris, 1862, XI (An XIII), 78, No. 9050.

repaid in the form of goods. Whenever embellishments are undertaken in one of the palaces, the interests of the arts and of industry must be considered, this is something which is still neglected at present. The Museum is operated at my expense, it costs a large sum of money; this, too, is an encouragement given to the arts. All these things are being done incoherently. It will be necessary to take hold of all these activities, to pay the various people involved personally, to look them over, and know their functions. I want you to know that I intend to direct the arts particularly toward those subjects which will help to perpetuate the memory of the events of the past fifteen years. It is amazing that I have not been able to persuade the Gobelin tapestry works to leave Holy Writ alone and to put their artists to work at last on the many deeds which have recently distinguished the army and the nation. When you have the time, please give me an itemization of the statues, engravings, paintings, etc., which I have ordered. I imagine that M. Ségur who has the money for the execution of the Coronation Book will have started this work by now. It is an important undertaking. The work of M. Denon who is touring the Italian battle fields to prepare topographical drawings and maps . . . will open still another opportunity for artistic enterprise. . . .

David in the Service of Napoleon

David achieved the transition from regicide to courtier with re-markable ease and speed. From 1797 onward, he enjoyed the protection of Bonaparte who had recognized, with a sharp eye for strategic ad-vantage, the important part which the arts could play in the seizure of power. By flattering David, then still in half-disgrace, he won for his cause the most influential artist of France and, at the same time, a prominent ex-Jacobin willing to be rehabilitated. It was Napoleon's plan to complete, on the grandest scale, the design for state sponsorship and control of the arts which the revolution had only sketched in out-line. He found in David a deeply experienced helper, chastened by recent misfortune, but still fiercely ambitious. Immediately after Na-poleon's accession to the imperial throne, in 1804, David was appointed to the position of premier peintre. *As such, he tried—with little success —to persuade Napoleon to invest him with the rights and privileges which Le Brun had enjoyed as court painter to Louis XIV. Only ten years had passed since the fall of Robespierre. David, once the friend of Marat, now took his stand at the foot of Napoleon's throne and dedicated his great talent to the restoration of monarchical traditions.*[12]

[12] J. L. Jules David, *Le peintre Louis David,* Paris, 1880, pp. 417 ff.

To M. de Fleurieu, Intendant-General to His Majesty, etc. [June 30, 1805]

Dear Sir,

As you read the enclosed proposal which I am asking you to submit to His Majesty, I flatter myself that you will not find my demands exaggerated; the functions which it defines are those which have always been attached to the position of *premier peintre*.

Since the time of Louis XIV, the Direction of Arts and Manufactures has always been in the charge of the Superintendant-General of Buildings. Colbert worked with the king, Le Brun worked with Colbert. With regards to the arts, I should be what Colbert was, if His Majesty deigns to accept my request. You would be the intermediary between the artists and the Throne, and I should be the artists' spokesman with you. This, Mr. Intendant-General, is the hierarchical order which was indicated to me and which I have scrupulously followed. . . .

[signed] David

To His Majesty, Emperor of the French and King of Italy.

Sire:

All the greatness which has shed its luster on your accession to the throne, all the astounding virtues which you unite within yourself and of which every single one would suffice to make a hero—all of these would be lost in the darkness of time, were it not for the arts, and the tribute of gratitude which they owe to you. You have bequeathed to them all your thoughts and all your actions; now history, poetry, painting, sculpture, and architecture have the mission to transmit them to posterity. . . .

Your First Painter, whom Your Majesty has honored with one of the most eminent positions in the arts, begs you to define the functions of his position, in order that he may gloriously complete, under your august protection, the salutary revolution which he has brought about in the arts.

Deeply confident of that kindness of which Your Majesty has deigned to give me such conspicuous marks, I have the honor of submitting to you the following draft:

Article I: Under the supervision of the Intendant-General of the Imperial Household, the First Painter will initiate and direct the execution of all enterprises connected with the arts of design, painting, sculpture, and engraving which are destined for His Majesty's various establishments, such as the Musée Napoleon, the Museum of Versailles, the manufactories of the Gobelins, of Sèvres, Savonnerie, and Beauvais.

Article II: The First Painter will examine all works of art which are proposed for exhibition at the Louvre and at whatever other places His Majesty should designate.

Article III: Whenever His Majesty wishes to have paintings, statues, engravings or tapestries executed, the Intendant-General will transmit his orders to the First Painter who, in collaboration with the Intendant, will designate the artists worthy of carrying out His Majesty's intentions.

Article IV: When it is necessary to advance funds to artists carrying out orders received from the Intendant-General through the agency of the First Painter, the First Painter will notify the Intendant of this fact who will authorize the appropriate sums in response to the First Painter's request.

Article V: The First Painter will be charged with the presentation to the Intendant-General of those paintings, statues, drawings and other works of art the acquisition of which he wishes to propose for the enlargement and completion of His Majesty's collections or the decoration of His Majesty's palaces.

Article VI: The First Painter who is an expert in antiques and in the decorative arts will collaborate with the Intendant-General in presenting to His Majesty projects for the encouragement of the arts and for the improvement of those manufactures which His Majesty deigns to take under his immediate protection.

Article VII: When His Majesty visits exhibitions or the establishments under the control of the administration of the arts, the First Painter will accompany him, as he will do on those occasions when His Majesty on his travels wishes to have a record made of memorable occurrences concerning himself.

Article VIII: The First Painter will be accorded official lodgings as member of the Imperial Household. His stipend. . . .

> I am, Sire,
>
> Your Majesty's submissive and Faithful subject
>
> David.

The Presentation of the Coronation Picture (1807)

David was among the artists whom Napoleon charged with the task of commemorating the notable events of his reign. In 1804, he was commissioned to record the Coronation in a painting of monumental dimensions. Etienne Delécluze (1781–1863) has left the following account of the ceremony which marked the completion of the picture in 1807: [13]

[13] E. Delécluze, *op. cit.,* pp. 312 ff.

David spent nearly four years on the execution of his painting of the Coronation. Toward the end of this time, Napoleon sent frequent messengers to him, to find out how far the work had progressed. When David felt satisfied that he had spent all the resources of his talent on this picture, he went in person to tell the Emperor that he had completed his task. Shortly after, the monarch appointed the day on which he would visit the studio of his First Painter.

When that day came, Napoleon, the Empress Josephine, and their entire family, accompanied by the officers of the court and ministers of state, took the road to the Rue de Saint-Jacques. . . . For some time, there had been much talk in Parisian society about the way in which David had arranged the main part of his composition. The courtiers in particular criticized the position he had given the Emperor, and blamed the artist for having made the Empress the heroine of the picture . . . all who were jealous of David's fame and favor entertained the malicious hope that Napoleon would criticize this arrangement and thus discredit the whole conception of the work. . . . They ought to have relied on the prudence and touchiness of the sovereign, and realized that he had calculated and prearranged everything, in concert with his First Painter. . . .

When the entire court had assembled in front of the painting, Napoleon, his head covered, walked back and forth before the thirty-foot long canvas, examining every detail with the most scrupulous attention, while David and his assistants stood immobile and silent. . . . Finally, still looking at the picture, Napoleon said: "Well done, David, very well done! You have correctly guessed my own intention, in representing me as a French gentleman. I am grateful to you for having given future centuries a proof of my affection for the woman with whom I share the burdens of government." At this moment, the Empress Josephine approached the Emperor from the right, while David stood, listening, on his left. Taking two steps toward David, Napoleon lifted his hat, bowed his head slightly, and said in a strong voice: "David, I salute you." "Sire," replied the painter, deeply moved, "I receive your salute in the name of all the artists, happy to be the one to whom you deign to address it."

Napoleon did not always treat the First Painter so kindly, as the following note by him shows: [14]

Saint-Cloud, July 2, 1806

Monsieur Daru, I have just seen my portrait by David. This portrait is so bad, so full of faults, that I refuse to accept it, and will not

[14] *Correspondance de Napoleon I*[er], Paris, 1862, XII (1806), 617, No. 10432.

have it sent to any city, and in particular not to Italy where it would give a very bad account of the French school.

Napoleon.

CHRISTIAN REVIVAL

Religious art declined in the period of Enlightenment and almost disappeared in the time of the Revolution. It revived in the work of some of the early romantics, notably that of Blake and Runge (see Vol. I, p. 142 ff.) who considered art as a form of worship. Blake wrote in 1820: [15]

A Poet, a Painter, a Musician, an Architect: the Man or Woman
 who is not one of these is not a Christian.
You must leave Father and Mother and House and Lands if they
 stand in the way of Art.
Prayer is the Study of Art.
Praise is the Practice of Art. . . .

The religious content of the work of Runge and Blake was of an altogether unorthodox and original kind, philosophical rather than church-oriented, free from any traditional associations, and expressible only in the forms of new symbols. The passage from Blake, quoted above, continues: "The outward Ceremony is Antichrist." By contrast, the churchly art which reappeared about 1800 drew its inspiration specifically from the historical traditions and ritual of Catholicism. When Goethe wrote of Strassburg Cathedral, in 1772, it was to praise the natural genius *of its builder (see Vol. I, p. 72). The promoters of Christian revival about 1800 saw in the Gothic church a symbol of piety. Their return to traditional Christian forms of art was initially prompted by aesthetic and sentimental, rather than strictly religious considerations. In some ways, it continued the search for sources and origins which had begun with the movement of Storm and Stress. This connection is evident in the writings of Wackenroder which are still free from systematic bias for a particular period, creed, or style, but express a general appreciation of simplicity of feeling and naïve truthfulness of representation.*

Wilhelm Wackenroder (1773–1798)

Wackenroder's short life passed away in flight from the humdrum common-sense of the milieu to which he was born as the son of a high

[15] Part of the inscription of the etching of *Laocoon*, ca. 1820, cf. G. Keynes, *Poetry and Prose of William Blake*, London, Nonesuch, 1927, p. 764.

Prussian official. He was made to study law at the universities of Erlangen and Goettingen, but his interest and feeling inclined him to art, to poetry and to music. On holiday excursions through the Catholic principalities of central Germany, he came under the spell of the surviving Baroque. Italian opera at Bayreuth, orchestral masses at Bamberg and Dresden, the picture galleries in the palaces of Kassel and Pommersfelden roused him to a keen response, undimmed by Protestant puritanism or by the modern, neoclassical taste. Two visits to Nuremberg turned his fantasy to the national Gothic past, and to the world of Albrecht Dürer. He was tempted to try his hand at art, but his sensibility was receptive, rather than creative: he compared himself to the Aeolian harp which only sounds when the animating breeze moves its strings. In 1796, on a visit to Dresden, he surprised his friend, Ludwig Tieck, with a collection of essays on art which he had just composed. Impressed by their original-ity, Tieck persuaded him to have them published, and contributed several improvisations of his own, written in imitation of Wackenroder's man-ner. The Outpourings from the Heart of an Art-Loving Friar *appeared at Christmas of the same year (with the date of 1797). The book was an immediate success, particularly among the younger artists, and its influ-ence continued for a generation. Echoes of the* Art-Loving Friar *occur in the writings of Tieck, Friedrich Schlegel, the Nazarenes and their followers, down to the time of Ludwig Richter (see page 32) and Joseph Führich. Goethe, to whom the style of the book was as disagreeable as its content, had his lieutenant in matters of art, Heinrich Meyer, attack Wackenroder and his imitators in a widely-read article, "Neu-Deutsche religiös-patriotische Kunst" (1817).*[16]

Wackenroder wrote his book for artists, but he formulated no prin-ciples or recipes. Most of his chapters present exemplary lives by means of anecdotes or incidents borrowed from Vasari, Sandrart, and other old sources. Wackenroder's view of art had affinities with that of Blake. Art, according to him, comes from feeling, not from conscious mastery. The ability to create is a special grace, a seed laid by the hand of God into the artist's soul. Analysis and criticism lead nowhere. It is not his will or his skill, but his openness to inspiration which raises the artist above ordinary men. Wackenroder therefore stressed the artist's attitude, his prayerful expectancy and submission, not his knowledge. His friar is not merely a picturesque accessory to the book's message, but, as a man of de-votion, the close relative of the artists whose pieties he recounts.

The archaic tone and stylized simplicity of the book had a strong appeal to young Germans who, similar to the Primitifs *in France (see*

[16] Heinrich Meyer, "Neu-Deutsche religiös-patriotische Kunst," *Kunst und Al-tertum,* 1817, I, Heft 2, 5 ff. and 133 ff. See also Paul Weizsäcker (ed.), *Kleine Schriften zur Kunst,* in *Deutsche Literaturdenkmale des 18. und 19, Jahrhunderts,* XXVII, 97.

Vol. I, p. 136), savored the language of Ossian, the Bible, and the ancient chronicles. Like illuminated pages from an old missal, the stories charm by their naïve brightness of hue—a quality which does not survive translation. But, despite his taste for the archaic, Wackenroder was free from any systematic prejudice for medieval or early Renaissance art. His Art-Loving Friar was not a monk of the middle ages, but of the 18th century, and in Wackenroder's own experience of art the Baroque had played a crucial part. He had come to believe that all true art, including that of the Negro and the Indian, expresses God's design. His collaborator, Ludwig Tieck, even went so far as to insert into the expanded version of the book which appeared after Wackenroder's death an essay on Watteau, heresy to an age which despised Watteau, but of the sort which Wackenroder in his wide tolerance would probably have approved.[17]

From *Outpourings from the Heart of an Art-Loving Friar* (1797)
Some Words on Universality, Tolerance, and the Love of Mankind in Art

Art can be considered as the flower of human feeling. From the different parts of the earth it rises toward Heaven in an everlasting variety of forms, and to our Father, Whose hand holds the globe and all it bears, only a single harmonious fragrance emanates from this seed.

He finds in every work of art, in every part of the world, a trace of that heavenly spark which went out from Him, through the breast of man, into man's own, lesser creations, from which it sends its gleams back to the great Creator. The Gothic is as pleasing to Him as the Greek temple, and to Him the rough war-chant of savages sounds as sweet as the art of choral and church song. . . .

In their foolishness, men do not understand that our sphere holds antipodes, and that they themselves are antipodes. They always think of themselves as being at the center of everything, and their spirit lacks wings on which to circle the globe and embrace its wholeness in one glance.

They think of their feeling as the central point of all beauty in art and pronounce their verdicts without realizing that they have no authority to act as judges, and that those whom they condemn could judge them in their turn.

Why don't you damn the Indian for speaking his language, rather than ours?

And yet you damn the Middle Ages for not having built Greek temples!

Try to enter into the souls of others, and to understand that you

[17] Lambert Schneider (ed.), *Werke und Briefe von Heinrich Wackenroder*, Heidelberg, 1967, pp. 51 ff. ("Some Words on Universality . . . "); pp. 57 ff. ("In Memory of Dürer"); pp. 67 ff. ("Of Two Miraculous Languages").

have received your spirit as a gift from the same hand as those brothers of yours whom you misjudge. Try to understand that every creature can express himself only by means of the powers which it has received from Heaven, and that everyone must create in his own image. . . .

If God's hand had dropped the seed of your soul on African desert sand, you would proclaim to the world, as the very essence of beauty, the glossy black of your skin, your snub-nosed face and curly hair, and you would ridicule or hate the first white man you met. Had your soul flowered a few hundred miles farther east, on Indian soil, you would sense the spirit of those curious, many-armed idols which are a mystery to us, but you would not know what to make of the Medici Venus. . . .

The ABC of reason is subject to the same laws in all nations of the world, though in some places it is applied to a very wide, in others to a narrow, range of subjects. The feeling for art, too, is only one single ray of heavenly light, but in the various parts of the world it is diffracted into a thousand different hues by the many-faceted prism of the senses.

Beauty—strange, marvellous word! One ought to invent new words to describe every particular sensation and every individual work of art. For in each lives a different color, and to each responds a different nerve in man's makeup.

But you want to develop a tight system from this word, by intellectual artifice, and would compel all men to suit their feelings to your prescriptions and rules—and yet you have no feeling yourselves.

Whoever believes in *system* has banished universal love from his heart. Intolerance of feeling is more bearable than intolerance of mind, *superstition* preferable to *belief in system* . . .

Oh, let all mortals and all nations under the sun enjoy their own beliefs and happiness! Be glad when others are glad, even if you cannot sympathize with what they hold dearest and highest.

As sons of this century, we are privileged to stand on the summit of a high mountain from which we survey many countries and periods spread out at our feet. Let us make use of our good fortune, let our gaze sweep serenely over these periods and peoples, and let us try to recognize in their ways of feeling and working the essential, human element.

Every creature strives for the highest beauty, but it cannot leave its self behind, and thus must seek beauty in its own self. Every mortal eye has its particular experience of the rainbow, to each the surrounding world reflects a different image of beauty. But universal, original beauty, which in moments of ecstatic vision we may name, but which we can never explain in words, is only revealed to Him Who created both the rainbow and the seeing eye.

I began my discourse with Him and I now return to Him, just as the spirit of art, just as all spirit emanates from Him and ultimately

returns to Him, rising through the earth's atmosphere like a sacrificial offering.

In Memory of Our Venerable Ancestor, Albrecht Dürer

Nuremberg! city once world-renowned—how I loved to stroll in your winding lanes, with what child-like affection I looked at your old houses and churches, marked with the strong traces of our old, native art! And how dearly I still love the works of those ancient times, and their pungent, honest language! How they lure me back into that grey century when you, Nuremberg, were the teeming school of our national art and a fertile, abundant spirit of art was alive within your walls, when Master Hans Sachs and the sculptor Adam Kraft, and, above all, Albrecht Dürer and his friend Wilibald Pirkheimer, and so many other men of the highest excellence were still alive! How often have I longed to live in those times, how often relived them in my thoughts when, seated in a corner of Nuremberg's venerable library, in the twilight from a window with small round panes, I brooded over Hans Sachs' tomes, or over other yellowed, worm-eaten papers, or when I walked under daring vaults in somber churches where beams of light from stained-glass windows magically illuminate the monuments and paintings of times long past.

You look at me with surprise, faint-hearted unbelievers! Oh, I know them well, those myrtle forests of Italy, I know the ardor and exaltation of the men of the blessed South—why would you call me back to where my soul dwells in its longings, to the homeland of my life's most beautiful hours—you who see boundaries everywhere, even where there are none? Are not Rome and Germany on the same globe? Has the Heavenly Father not laid roads around the globe which lead from north to south, as well as from west to east? Is one man's life too brief? Are the Alps insurmountable?—Surely, it must be possible for more than one love to live in a man's breast. . . .

Why does it seem to me that modern German artists are unlike those praiseworthy men of former times and, particularly, so unlike you, my beloved Dürer? What makes me think that you practiced painting in a more serious and worthy way than these precious artists of our time? I imagine that I see you meditating before your unfinished picture, while the idea which you want to realize becomes vividly present to your soul. I see you reflecting on what expressions and positions would strike the beholder and move his spirit most powerfully, and then transferring these creatures of your vigorous imagination slowly and faithfully to the panel. But our modern artists do not seem to want us to enter seriously into their representations; they labor for noble lords who do not wish to be moved or uplifted by art, but only dazzled and titillated. Their paintings

are virtuoso performances, filled with many lovely and deceptive colors; they outdo themselves in the clever distribution of light and shade; but their figures seem often to exist only as pretexts for these colors and lights; one might call them a necessary evil.

Woe to this age of ours which uses art as a frivolous toy of the senses, rather than as something serious and sublime. . . .

When Albrecht Dürer wielded his brush, a firm, individual character still distinguished the Germans among the peoples of this part of the world. His paintings express this upright seriousness and strength of the German character faithfully, not only in the faces and external traits, but in their innermost spirit. In our time, this strongly marked German character has become lost, and along with it German art itself. Young Germans now learn all the languages of Europe and are expected to assimilate, through judicious selection, something of the spirit of all the nations: the student of art is taught to imitate Raphael's expression and the color of the Venetian School, Dutch truth and Correggio's magic light, and in this way attain supreme perfection.

Oh, wretched sophistry! Oh, blind belief of our time! Why should it be possible to merge all the various kinds of beauty and all the perfections of the world's great artists? What justifies the belief that we can, by studying them or begging from them, unite their manifold talents in ourselves and thus surpass them all? The time of originality and vigor is past; poor imitation and clever combination now make up for the lack of talent. Cold, smooth, characterless work is the result. German art once was like a God-fearing youth, living within the walls of a small town, cared for by blood relations. Now that it has grown older it is like a man of the world who has rid his soul not only of small-town ways, but also of individual feeling and character.

I should not want the magic Correggio, the sumptuous Paolo Veronese, the overpowering Buonarotti to have painted like Raphael. And I do not at all agree with those who say: "If Albrecht Dürer had only lived in Rome for a while, and learned about true beauty and the ideal from Raphael, he would have become a great painter. It is a great pity, though considering his disadvantage it is remarkable that he got as far as he did." I find no cause for pity, but rejoice, rather, that fate gave Germany this genuine, national painter. Abroad, he would not have remained himself; his blood was not Italian blood. He was not made for the ideal and the noble serenity of Raphael. His delight was in representing men as they really existed all around him, and in this he succeeded admirably.

Yet I was struck when, in my youth, I first saw paintings by Raphael and Dürer hung together in a magnificent gallery; I rejoiced in the discovery that of all the painters I knew these two had a quite specially

close affinity with my heart. What I liked particularly in the work of both was their straightforward, clear, and yet soulful presentation of humanity, so unlike the pretty circumlocutions of other painters. But I did not dare then to reveal my opinion, afraid that everybody would laugh at me, since I knew that most people found the work of the older German painters merely stiff and dry. But I was so full of my new insight on that day that, as I fell asleep, a charming dream came to me and confirmed me in my belief. I dreamt that, midnight having struck, I went from the room in the castle in which I slept and, walking alone through dark halls with a torch in my hand, made my way to the picture gallery. At the door, I heard a faint murmuring sound within. I opened, and started back on finding the whole vast hall illuminated by a strange light. Before several of the paintings stood the venerable artists, in full, bodily presence, wearing ancient costumes such as I had seen in their portraits. One of them whom I recognized told me that on some nights they came down from heaven to walk the picture galleries in the stillness of night, to look at the works of their hands which they still loved. I recognized many Italian painters, but saw only a few Netherlanders. Reverently, I walked through their midst, and lo! here stood, apart from the others, Raphael and Dürer, hand in hand, looking with quiet, friendly calm at their paintings hanging side by side. I did not have the courage to address the divine Raphael; a shyness, born of reverence, sealed my lips. But I wanted to greet my Albrecht, and pour out my love for him, when suddenly my sight grew confused, a loud clamor arose, and I awoke in great agitation. . . .

Not under Italian skies only, not only beneath majestic domes and Corinthian columns does true art flourish. It lives also among pointed arches, in buildings teeming with strange ornament, and beneath Gothic towers.

Peace to your ashes, my dear Albrecht Dürer! May you know how much I love you, and hear that I am, in this alien, modern world, the herald of your name.—Blessed by your golden age, Nuremberg! the only time in which Germany could claim a national art of its own.—But the ages of beauty pass across this earth and vanish, like luminous clouds drifting across the vaulted sky. They are past and forgotten; and small is the number of those who try to recall them lovingly from dusty books and enduring works of art.

Of Two Miraculous Languages and of Their Secret Power

The language of words is a great gift of Heaven. It was one of the Creator's eternal blessings to loosen the tongue of the first man, so that

he might name all the things which the Almighty had placed in the world around him and the visions which He had put into his soul, and thus exercise his mind in playing with the abundance of names. Through words we rule the earth; through words we easily acquire all its treasure. Only the *invisible reality which hovers above us* cannot be brought down into our spirit through the power of words.

We control earthly things when we speak their names, but when we hear of God's infinite mercy or the virtues of the Saints, things which should move us to the depths of our being, our ears are filled merely with empty sound, and our spirit is not uplifted as it ought to be.

But I know of *two miraculous languages* through which the Creator has enabled men to grasp and understand heavenly things in all their power, or at least so much of them—to put it more modestly—as mortals can grasp. They enter into us by ways other than words, they move us suddenly, miraculously, seizing our entire self, penetrating into our every nerve and drop of blood. One of these miraculous languages is spoken only by God, the other is spoken by a few chosen men whom he has lovingly anointed. They are: *Nature and Art*.

Since my early youth, when I first learned about God from the ancient sacred books of our faith, *Nature* has seemed to me the fullest and clearest index to His being and character. The rustling in the trees of the forest and the rolling thunder have told me secrets about Him which I cannot put into words. A beautiful valley enclosed by bizarre rocks, a smooth-flowing river reflecting overhanging trees, a pleasant green meadow under a blue sky—all these stirred my innermost spirit more, gave me a more intense feeling of God's power and benevolence, purified and uplifted my soul more than any language of words could have done. Words, I think, are tools too earthly and crude to express the incorporeal as well as they do express material reality.

This gives me a great occasion to praise the might and kindness of our Maker. He has surrounded us human beings with an infinite number of things, each of which has its own essence and transcends our simple understanding. We do not know what is a tree, or what is a meadow, or a rock; we cannot converse with them in our language; we can communicate only with other human beings. But the Creator has put powers of sympathy with these things into the human heart that enable them to reach it in unknown ways with feelings or intimations, or whatever else one might call them, which are more effective than measured words.

The worldly-wise have gone wrong in their quest for knowledge, laudable though this quest might be in itself; they have tried to uncover the secrets of the Heavens and set them among terrestrial things, in a terrestrial light. And, insisting on their rights, they have boldly tried to

expel the *dark intimations* of these secrets from their hearts.—Is it in man's feeble power to unveil the secrets of Heaven? Does he believe himself capable of bringing boldly into the light what God covers with His hand? Can he arrogantly dismiss the obscure *feelings* which descend to him like veiled angels?—I honor them in deep humility, for it is one of God's great mercies to send us these genuine witnesses of the truth. I fold my hands and adore.

Art is a language unlike that of Nature; but Art, too, has a marvellous power over the human heart and exercises it by equally hidden means. It speaks through the image of men, which is to say that it uses hieroglyphic signs which are familiar and comprehensible to us by their appearance. But it endows these visible forms with something spiritual and supersensual in a way so affecting, so admirable that it can stir us to the roots of our being. Certain paintings of Christ's passion, of the Holy Virgin, or of the lives of the Saints have more thoroughly cleansed my soul and instilled in me more virtuous sentiments than any system of morality or spiritual meditation. Thus I remember a picture of Saint Sebastian, magnificently painted, which shows him naked, bound to a tree, with an angel who draws the arrows from his breast, while another angel brings from Heaven a wreath of flowers for his head. I owe to this painting some very penetrating and lasting Christian sentiments, and even now cannot recall it without tears.

The teachings of learned men exercise our brain, only half of our self. But the two miraculous languages whose power I proclaim touch our feelings as well as our mind; they seem to fuse—I cannot find other words to express it—all parts of our unconscious being into a new, single organ which receives and comprehends in this twofold way the miracles of Heaven. . . .

When I step from the sanctuary of our monastery into the open air, having just contemplated the crucified Christ, and the sun shining from the blue sky embraces me with its warmth and life, and the beautiful landscape of mountains, rivers, and trees charms my eyes, then I see God's own world arising before me, and feel in a very special way the emergence of great things within me. And when from the open air I return to the sanctuary and contemplate the painting of the crucified Christ with earnest piety, then I see another world of God opening before me, and feel in a different way the emergence of great things within.

Art gives us the highest human perfection. Nature, so far as the mortal eye can see, resembles a fragmentary, oracular utterance from the mouth of God. One might say, were it allowed to speak of such things, that God looks on all of Nature and the whole world as we look on a work of Art.

Friedrich Schlegel (1772–1829)

Friedrich Schlegel's youthful ambition was to become the "Winckel-mann of Greek literature." The intolerant exclusiveness of his early Graecomania earned him Schiller's irritation and Goethe's sarcasm. In Schlegel's view, only ancient literature and art possessed beauty whole and absolute. By contrast, the work of the "moderns" (under which term he comprised the art and poetry of Dante's, as well as that of Shake-speare's, time) was incomplete, unquiet, and flawed; its peculiar quality was not beauty, but something to which Schlegel at first applied the term the interesting, in order to indicate its dynamic, emotional character, unlike that of true beauty (which, according to Kant's definition, ought to produce disinterested pleasure). In the gallery of Dresden, he admired the casts of antique sculptures and those paintings of the Renaissance which, because of their spacious and harmonious compositions, reminded him of classical art.

But about 1796, he underwent a fairly abrupt change of feeling. Influenced by his reading of medieval poetry, and perhaps also by Schiller's essay on Naïve and Sentimental Poetry (1795–1796), he began to discover in the work of "modern" masters, even in those of Raphael and Correggio, the traces of a profounder spirituality, expressed in the "magic charm of color" and in sentiment more poignant than classical ideality. To this unclassical, modern sentiment, he now applied the term "romantic." Wackenroder's Outpourings from the Heart of an Art-Loving Friar (see page 19) which Schlegel read shortly after its publication in the winter of 1796–1797, confirmed his religious bias, and awakened in him a taste for the bitter-sweetness of archaic style. A stay in Paris, in 1802–1804, finally accomplished his conversion to a Christian aesthetic, and was followed shortly by his conversion to the Catholic faith. At the Louvre, he had the opportunity of studying and comparing the works of early Italian, Flemish, and German masters which Napoleon's looting expeditions had brought together there (see page 7). Confronted by the paintings of Van Eyck, Memling, Dürer, Perugino, and Bellini, he declared his exclusive preference for art of a Christian content and of strongly marked, national character. Unlike Wackenroder, who had pleaded for universal tolerance, Schlegel asserted that the only way to salvation open to modern painters was through the imitation of medieval Christian art. Though his message was the opposite of Winckelmann's (see Vol. I, p. 4), his dogmatism has the familiar ring of that great antiquarian's dictum: "There is but one way for the moderns to become great, and perhaps unequalled; I mean by imitating the ancients." Friedrich

Schlegel recorded his thoughts on Christian art in a series of letters addressed to Wilhelm Tieck in Dresden, Wackenroder's former collaborator. These letters were to have an important influence on the conservative, churchly, and nationalist wing of the German romantic movement. First published in Schlegel's periodical, Europa, *in 1803, their revised and expanded version was included in his* Collected Works *(1823)* [18] *under the title of* Descriptions of Paintings from Paris and the Netherlands, 1802–1804.

From *Descriptions of Paintings from Paris and the Netherlands*, 1802–1804

Before going on, I must make a confession. . . . I am exclusively attuned to the style of the earlier, Christian painters; they are the only ones I understand and comprehend, the only ones of whom I can speak. The French School and the later Italians I do not want to discuss at all; even in the School of the Carracci, I rarely find a painting which affords me a true, artistic experience or an enlargement of my ideas about art. . . . I confess that Guido Reni's often forced and chilly grace does not attract me irresistibly, and that the rosy-red and milky-white flesh tints of Domenichino do not necessarily enchant me. . . . I have no judgment about these painters, unless it be simply this: that painting no longer existed in their time. Titian, Correggio, Giulio Romano, Andrea del Sarto, Palma, and others of their kind were the last of the painters, so far as I am concerned. . . .

No confused heaps of men, but a few, isolated figures, executed with a diligence worthy of the dignity and holiness of that greatest of hieroglyphics, the human body; severe forms, contained in sharp and clearly defined contours; no chiaroscuro of dirt, murk and shadow, but pure relationships and masses of color, like clear accords; garments and clothes which really belong to the figures, and are as simple and naïve as they are; and in the faces, where the light of the divine spirit of painting shines most radiantly . . . that childlike, kindly simplicity which I am inclined to regard as the original character of mankind: this is the style of early painting, the style which pleases me exclusively. . . .

But let us, in conclusion, ask one further question, one which touches intimately on the main purpose of our observations and reflections: is it probable that we shall see in our time the rise or the permanent establishment of a genuinely great and profound school of painting? Outward appearances seem to speak against it, but who is to say that it is impossible? It is true that our period has no painters who can equal the great masters of bygone times, and the reasons for this inferiority seem

[18] The present translation is based on the text as given in Friedrich Schlegel, *Sämmtliche Werke* ("Gemäldebeschreibungen aus Paris und den Niederlanden in den Jahren 1802–1804"), Vienna, 1846, VI, 13 ff. and 164 ff.

fairly clear: one of them is the neglect of technique, particularly in the handling of color, and another, even more important one, the lack of true and deep feeling. Modern artists of a thoughtful and personal bent seem most often to be deficient in productive power, in that certainty and facility of execution which was so wonderful an attribute of earlier artists. When we think of the quantity of great works which Raphael achieved, although he died in early manhood, or consider the iron industry which our honest Dürer displayed in an abundance of inventions and works of various kinds and subjects (although he, too, did not attain old age), we shrink from measuring the art of our time with the standards of that great period. Yet there is an explanation for this difference. Universal education and intellectual versatility are characteristic tendencies of our age. They lead to a scattering of mental energies, and are hard to reconcile with the concentration and sustained intensity which are required for abundant and positive production. This condition affects all intellectual and creative fields in our time, but on the arts it has a particularly decisive influence. Clear senses and deep feeling are the only true sources of high art, yet nearly everything in our time militates against such feeling, pushes it back, splinters it up, buries or sidetracks it, and thus the best part of an artist's life is spent in a preliminary struggle against the spirit of the times and all the unspeakable difficulties which it places in the path of his development. And yet this struggle is necessary in order to uncover the springs of true artistic feeling and to clear them of the rubbish and the distractions of the outer world. . . .

The true source of art and of the beautiful is feeling. Feeling reveals the proper idea and aim of art, and points to the certain knowledge of the artist's intention, though the proof of this lies in practice rather than words. Religious feeling, piety, love and quiet enthusiasm guided the hand of the old masters. Only a few of them possessed in addition, or in its stead, what alone can replace religious feeling in art, namely, profound thought and an earnest philosophical striving. This is quite evident, though in artistic form, in the works of Dürer and Leonardo. It would be vain to attempt the restoration of painting without first reawakening, if not religion itself, at least the idea of religion, through Christian philosophy. But if young artists find this way too long and steep, let them at least study poetry which breathes this spirit. Not Greek poetry—which will only mislead them into strangeness or pedantry, and which they will only read in translations that spoil the ancient grace with the wooden rattle of dactylic meter—it is romantic poetry they ought to read. The best Italian and Spanish poets, in addition to Shakespeare, the more accessible of the older German poets, and those moderns who wrote in the romantic spirit: let these be the constant companions of the young artist. Only they can gradually lead him back into the old land of romance, removing from his vision the blur of prosaic imitation of

the pagan antiquities and of unhealthy art-babble. But the main thing is that the artist be in complete earnest about religious feeling, true piety and living faith. Mere fantasy play with Catholic symbols, lacking in that love which is stronger than death, will never attain the loftiness of Christian beauty.

In what does this Christian beauty consist? It is necessary, above all, to recognize the good and evil in art doctrine. Whoever has not discovered the inward life cannot reveal it gloriously in art. He will float along in the confused, dreamlike stream of a shallow and spiritually vain existence, instead of uplifting us through his art to a higher realm of spirit. He will merely serve false fashion and the empty glitter of illusion, without ever penetrating to the region of true beauty.

Pagan art starts with the perfection of organic form, conceived according to a definite idea of nature. Its development amounts to a vital unfolding of plastic forms; it has the charm of natural, youthful beauty, but this charm is always sensuous, rather than soul-inspired. When ancient art aspires to something higher, it takes on a titanic power and sublimity, or assumes the high seriousness of tragic beauty. This is the extreme limit of its attainment: here it approaches eternity, but here it stops at the closed gate of eternal beauty. Its titanic presumption attempts to storm the heavens and to conquer the divine, but it is forever frustrated, and sinks back in endless sorrow, deeply conscious of its own, hopeless bondage. Pagan art lacks the light of hope; its grief and tragic beauty are a last resort. And it is this light of divine hope, carried on the wings of happy faith and pure love, which gleams from works of Christian art. . . .

It will take a long struggle, and much trial and error, before the way is found on which a reborn art can progress securely toward the goal of religious beauty.

Perhaps we shall fall from one extreme into another: it would not be surprising if the current mania for imitation were to inspire a confident and talented artist to attempt absolute originality. If such an artist would discover that the true purpose of art is the symbolical manifestation of God's secrets, and that everything else is only a means to this end, he might produce remarkable works of an entirely new kind: hieroglyphics, symbolical images, drawn from feelings, insights, or intuitions about nature, arbitrarily put together,* rather than composed according to the

* The meaning of these remarks will be clear to all those who have seen the allegorical drawings of the late Runge. Though these are little more than sketches, they do illustrate the risk which this approach entails; to be sure, it is a risk which only artists of exceptional individuality and ambition are apt to run. All the same, these drawings show what happens when an artist of high talent attempts to paint pure nature-hieroglyphics, in total detachment from time-hallowed traditions, for there is no getting around the fact that these traditions are the firm, maternal soil which artists may desert only at the risk of great danger and irretrievable loss. [Schlegel's note.]

methods of antiquity. A hieroglyphic, a symbol of the divine—this is what every worthwhile painting must be. But should the painter invent his own allegories? Or should he use the old symbols, supplied and sanctified by tradition, which may be all he needs, so long as he understands them well? The first of these alternatives is surely the more dangerous. Its consequences are fairly predictable, especially if it were to be tried by various artists of unequal aptitude; the results would resemble what has lately been happening in poetry. It is safer to follow the old masters completely, particularly the oldest, assiduously imitating the truths and beauties in their works, until these become a second nature to the eye and mind. If, in addition to the most beautiful works of the early Italians, we were also to take the style of the Old German school for a model, mindful of our nationality whose character we should never deny, particularly not in our art, then both possibilities could be realized together: the secure, ancient tradition of comeliness and truth, on the one hand, and the symbolical, spiritually beautiful aspect of art on the other, that aspect to which true poetry and science must lead again when all knowledge of art has been lost. . . . Old German painting is superior to the Italian, not only in its more exact and painstaking technical execution, but also in its longer attachment to the oldest, most marvellous, profound, Christian-Catholic symbols, of which it has preserved a far greater wealth. . . .

There should be no need to insist on the obvious fact that modern artists ought not to imitate the imperfections of the older styles of painting, the emaciated hands, the Egyptian position of the feet, the tight clothing, garish colors, squinting eyes, or the lapses of draftsmanship, and other positive defects and occasional flaws. For to fall from the copying of the antique into the equally insincere imitation of the old German style would merely amount to an exchange of one false mannerism for another. Superficial effects are not the important thing: what matters is the quiet, pious spirit of those old times. This is what should inspire the painter and guide him to pure Christian beauty, so that, like a new dawn, the radiance of this beauty may illuminate the creations of a reviving art.

The Nazarene Brotherhood

Two German students at the Academy of Vienna, Franz Pforr (1788–1812) and Friedrich Overbeck (1789–1869), met in 1808, confided to one another their disgust with the shallow routine of academic instruction, and decided to pursue their further studies together. Soon they were joined by fellow students, Wintergerst, Vogel, Hottinger, and Sutter, artists of modest talent but unlimited idealism, who shared with

them the longing for an ideal, communal life devoted to art, to religion, and to friendship. In many ways, even in certain eccentricities of appearance, they resembled the heretics of French neoclassicism, the Primitifs *(see Vol. I, p. 136). But while their French counterparts had modelled themselves on the heroes of Homer and Ossian, the Viennese group adopted Wackenroder's* Art-Loving Friar *as their guide, and observed the monastic vows of poverty, chastity, and obedience. The two leading personalities of the group presented a striking contrast. Pforr was an irascible, unstable, martial spirit, whose original ambition had been to become a painter of battles and who embodied the Germanic and medievalist strain of the romantic movement. His friends liked to think of him as the reincarnation of Dürer. Overbeck had the mildness and gentle piety which Wackenroder's book had attributed to Raphael. Though born a Lutheran, he perfectly represented the churchly, Catholic strain in German romanticism. The friends thought of him as their "priest" and of Pforr as their "master." In August of 1808, Pforr wrote to his friend Passavant:* [19]

We have founded a little club here which is composed of prospective artists who come together for mutual discussion and criticism of each other's work. We meet three times every two weeks. On Mondays, each of us presents drawings or other work. On Saturdays, everyone must bring along a compositional sketch on an assigned subject. On Wednesdays, we meet again. If there is something to show, that's fine, but it is not necessary. We may talk about art, or take a walk. Our meetings last from half past six until after nine o'clock in the evening.

On July 10, 1809, the anniversary of their first meeting, the friends constituted themselves as the Brotherhood of Saint Luke. Pforr wrote in a report to his guardian, on March 21, 1810: [20]

Until now, we had met in a society which would have been dissolved if fate had separated us. On July 10th of last year, we celebrated our first anniversary with a dinner. We discussed the present state of the arts, and keenly felt their decline; all of us offered, with one voice, to do everything in our power to raise them up again. We held each other by the hand, and formed an association which, we hope, will last forever. We agreed that every painting which we might execute should be

[19] F. H. Lehr, *Die Blütezeit romantischer Bildkunst, Franz Pforr, der Meister des Lukasbundes*, Marburg, Verlag des kunstgeschichtlichen Seminars der Universität Marburg, 1924, p. 74. See also M. Howitt, *Friedrich Overbeck, Sein Leben und Schaffen*, Freiburg, 1886, and K. Andrews, *The Nazarenes, A Brotherhood of German Painters in Rome*, Oxford, Clarendon Press, 1964.

[20] Lehr, *op. cit.*, p. 41.

shown to all the members, if possible, and if it were found worthy
should be marked with a sign. This sign is to be a small sheet of paper,
fastened to the back of the picture, and bearing the image of Saint Luke.

Unlike the Primitifs, *who seem to have spent much of their energy
in theoretical argument, the Brothers worked with the diligence of
medieval artisans, striving to perfect themselves in meticulous craftsman-
ship. They held the facile mannerisms propagated by the Academy in
contempt and looked for instruction to the early Italian and German
masters whose works they found in the Imperial Gallery in the Belvedere.
Pforr reported to his guardian:* [21]

We now began to find our technique unsatisfactory; our work did
not give us the pleasure which our spirit demanded. I expressed the wish
to paint something with the highest possible degree of definition and
finish. Overbeck encouraged me, and I painted several half-figures in this
way. Once one has done a thing thoroughly he loses his taste for superfi-
cial visual effect. We saw the new light, and began to strive for the
clarity of definition which can only be achieved through careful finish
. . . I chose for my subject *Wallenstein in the Battle of Lützen,* . . .
Overbeck, of milder disposition, began a *Raising of Lazarus.* . . .

We were in the midst of our work, when we decided to visit the
Imperial Gallery which we had not seen since the formation of our as-
sociation. On entering, we were struck with amazement: everything
seemed changed. We hurried past many pictures which had formerly
attracted us, and were irresistibly fascinated by others which had once
left us cold. Neither of us dared to tell the other his thoughts, fearing
that our judgment might have been warped by a kind of vanity. But
when we finally confided in each other, we found to our surprise that we
were in full agreement! Paintings by Tintoretto, Paolo Veronese, Maratti,
and even works by the Carracchi, by Correggio, Guido, and Titian at
which we had once gaped in admiration now made a feeble impression
on us. We sensed the cold heart hidden behind the bold brush strokes
and the beautiful colors, or found that the artists had aimed no higher
than at a stimulation of the senses. But we could hardly tear ourselves
away from a *St. Justina* by Pordenone, from several paintings by Michel-
angelo, Perugino, and the School of Raphael. We found with delight
that they confirmed us in our feelings about style. The Netherlandish
painters seemed to us to have chosen low subjects, or to have given a
low treatment to lofty subjects. What had once seemed natural in their
work now looked almost like caricature. We hurried on to the early
German masters. How happily they surprised us, with what loveliness

[21] Lehr, *op. cit.,* pp. 36 ff.

and purity their every feeling spoke to us! Much in these paintings had formerly struck us as stiff and awkard. Now we realized that the constant sight of pictures in which every action, however ordinary, was represented by means of the most exaggerated and ridiculously mannered postures had misled our judgment, and had caused us to regard gestures taken from nature as stiff and insufficiently animated. Noble simplicity and definite character now spoke loudly to our hearts: no virtuoso brush work, no bold handling was to be seen; everything presented itself simply, like something grown, rather than painted. We stayed a long time, and finally left the room with a feeling of reverence. Now we came to the hall where the copyists work. What a difference! With wide brushes they systematically applied their colors, mixed according to formula. Brilliance of color was their highest aim, nature their least concern. We were not pleased, and soon hurried on.

These impressions of paintings gave rise to various reflections. We concluded that our conception of art must be correct, since it had brought us closer to the truly great masters. As brush strokes are only a necessary evil and a means to an end, we found it ridiculous to use them ostentatiously and to prize boldness of handling for its own sake. . . . We had confined ourselves for a long time to each other's company, and seen next to nothing of the Academic teachers and other local artists. Now we sought them out, to find someone to follow. But, to our regret, we sought in vain. We only found artists imprisoned in habit and prejudice, too weak to attempt anything which their teachers had not already done. We found a certain manner dominating all which, though varied slightly in the work of this artist or that, always amounted to a deviation from the nature through which artists must strive to attain the ideal. And we could not understand how painters working on sacred subjects could lead such dissolute lives, how they could present the wisdom of Salomon or Socrates in their paintings, while behaving like thoroughly prejudiced, uncivilized people. We marvelled that artists should have the impudence of believing that they were entitled to a style of living which, in other people, would have been considered animal-like depravity. . . .

The equation of life and art, conduct and style, constantly preoccupied the Brothers of Saint Luke. In forming their own lives, they consciously imitated the pure simplicity of line which they admired in early art. Pforr wrote to his friend Passavant, on January 6, 1809: [22]

I feel that I am unfit for the unquiet, large life. A small room, my easel, a few friends, and the necessities of existence satisfy all my wishes.

[22] Lehr, *op. cit.,* pp. 269 ff.

I must confess to you that I should like to achieve something in art, but this is best done in the midst of a quiet, retiring life. I find that the way today's artists rove from one big city to another is quite incompatible with art's need for peace. A quiet, middle class life is best. I know you will not blame me for holding this opinion. . . .

Painters formerly encouraged a devotional attitude by representing pious subjects . . . and now?—A naked Venus and her Adonis, a Diana in her bath, what good can come of such ideas? And why choose subjects so remote that they scarcely hold any interest for us? Why not treat more relevant subjects? The ancient history of the Israelites offers more material than any other. Tell me what other history gives us a more beautiful picture of courage and wisdom, moderation and justice, and of sacrifice for the sake of virtue and the common good than *Maccabees* with its story of the priest Mattathias and his sons. And don't we find in medieval history subjects worthy of being transmitted to eternity? But who will represent them?

In May of 1809, Pforr, Overbeck, Vogel and Hottinger left Vienna to go to Rome. After a brief stay at the Villa Malta on the Pincian Hill, they settled in the nearby monastery of San Isidoro which had recently been secularized. Here they were able to put into practice their ideal of a cloistered community of artists. Pforr wrote about this time: [23]

If you think of me, you will have to look for me in your thoughts in my cell or in the cloister. The monastery has a beautiful location, lonely and quiet, well suited for study. . . . The little cell in which I shall work has a magnificent view across gardens and a thicket of olive trees toward the Apennines; further to the left lies Rome in its grandeur, St. Peter, the Castle of the Angel, and the Vatican in which I can make out the loggias where Raphael painted.

I should like to ask those who would dedicate themselves to art, as one asks those who want to become monks: can you give and keep the vows of poverty, chastity, and obedience? then be welcome.—Poverty! what artist is ever really rich? Chastity in speech and deed he must observe so that his work may be pure, and full obedience he must ever give to art. Art will command him to do one thing, or to avoid another, and gladly he must obey the command, for nothing can replace the joy which art gives him.

It was during the monastic idyll in Rome that, because they wore their hair long and parted in the middle, the Brothers came to be called "Nazarenes," by which nickname they are still known. Pforr died in

[23] Lehr, *op. cit.*, p. 166.

1812. His place was taken by new arrivals from the North, the brothers Schadow and Veit, Peter Cornelius, Julius Schnorr von Carolsfeld, and Friedrich Olivier. In September of 1812, the artists left the convent of Isidoro; the community gradually dispersed. Overbeck remained, as the most constant and, in the end, most influential artists of the group to which he gave the stamp of his personality, although his extreme piety and mellifluously Raphaelite style do not fully represent the range of so-called Nazarene painting. The following essay on The Three Ways of Art, *written about 1810 as a contribution to the Brothers' program of study, characterizes his approach to art and carries a suggestion of his temperament and manner:* [24]

From *The Three Ways of Art* (1810)

Three roads traverse the Land of Art, and, though they differ from one another, each has its peculiar charm, and all eventually lead the tireless traveller to his destination, the Temple of Immortality. Which of these three a young artists should chose ought therefore to be determined by his personal inclination, guided and fortified by reflection.

The first is the straight and simple Road of Nature and Truth. An uncorrupted human being will find much to please his heart and satisfy his curiosity along this road. It will lead him, for better or for worse, through fair, productive country, with many a beautiful view to delight him, though he may occasionally have to put up with monotonous stretches of wasteland as well. But, above these, the horizon will usually be bright, and the sun of Truth will never set. Of the three roads, this is the most heavily travelled. Many Netherlanders have left their footprints on it, and we may follow the older ones among them with pleasure, observing the steadiness of their direction which proves that these travellers advanced imperturbably on their road: not one of these tracks stops short of the goal.—But the most recent footprints are another matter; most of them run in zig-zags to the right and the left, indicating that those who made them looked this way and that, undecided, wondering whether or not to turn back and take another road. Many of these tracks, in fact, disappear into the surrounding wastes and deserts, into impenetrable country. What the traveller on this road must chiefly guard against are the bogs along one side where he may easily sink into mud over his ears, and the sandy wastes on the other side which may lead him away from the road and from his destination. But if he manages to continue along the straight, marked path, he cannot fail to reach his destination. The level country makes this road agreeable to travel, there are no mountains to climb, and the walking is easy, so

[24] Lehr, *op. cit.,* pp. 303 ff.

long as he does not stray to one side or the other, into bog or desert. Besides, there is plenty of company to be found on this road, friendly people, representing all nationalities. And the sky above this country is usually serene. The careful observer will find here everything the earth offers, he need never be bored on this road. And yet, I must warn the young artist not to raise his expectation too high, for, frankly, he will see neither more, nor less than what other people also see, every day, in every lane.

The second road is the Road of Fantasy which leads through a country of fable and dream. It is the exact opposite of the first. On it, one cannot walk more than a hundred steps on level ground. It goes up and down, across terrifying cliffs and along steep chasms. The wanderer must often dare to take frightening leaps across the bottomless abyss. If he does not have the nerve for it, he will become dizzy at the first step. Only men of very strong constitution can take this road and follow it to the end.—Strange are its environs, usually steeped in night; only sudden lightning flashes intermittently illuminate the terrible, looming cliffs. The road often leads straight to a rock face and enters into a dark crevice, alive with strange creatures. Suddenly, a ray of light pierces the darkness from afar, the light increases as one follows it through the narrow crevice, until abruptly the rocks recede and the brightness of a thousand suns envelops the traveller. Then he is seized, as if by heavenly powers, he eagerly plunges into the bright sea of joy, drinking its luminous waters with wild desire, then, intoxicated and full of fresh ardor, he tears himself from the depths and soars upward like an eagle, his eyes on the sun, until he vanishes from sight. Thus joy and terror succeed each other in sharpest contrast. Not the faintest glimmer of the light of Truth penetrates into these chasms, insurmountable mountains enclose the land, and only rarely do fleeting shadows or dream visions which can bear the light of Truth venture to drift across the barriers, where they then seem to stride like giants from peak to peak.

Just as this land is the opposite of the land of Nature in every feature, it is its opposite also with respect to population. In the other land, the road is constantly thronged with travellers; here it is usually empty. Few dare to enter this region, and even these few have little in common with one another, they go their separate ways, each sufficient to himself, none paying attention to the others. Michelangelo's luminous trace shines above all in this darkness. What distinguishes this road from the other is the colossal and sublime. Never is anything common or ordinary seen here, everything is rare, new, unique. Never is the wanderer's mind at peace: wild joy and terror, fear and expectation beset him in turn.

Let those who love strong emotion and lawless freedom travel this road, and let them walk boldly, it is sure to take them most directly to their destination. But those who love gentler impressions, who can neither grasp the colossal, nor bear the humdrum, and who like neither the bright midday light of the land of Nature, nor the stormy night of the land of Fantasy, but would prefer to walk in the gentle twilight, my advice to them is to take the third road which lies midways between the other two: the Road of the Ideal or of Beauty. Here he will find a paradise spread before him where the flower-fragrance of spring combines with autumn's fruitfulness.—To his right rise the mountains of Fantasy, to his left the view sweeps across fertile vineyards to the beautiful plain of the Land of Nature. From this side, the setting sun of Truth sheds its light; from the other, the morning light of Beauty rises from behind the golden mountains of Fantasy and bathes the entire countryside in its rosy haze. Thus sunrise and sunset, Truth and Beauty alternate here, and combine, and from their union rises the Ideal. Here even Fantasy appears in the light of Truth, and naked Truth is clothed in the rose-fragrance of Beauty.

This road, besides, is neither so populous as the first, nor so deserted as the second, and the travellers on it differ from those of the second road by their sociability. One sees them walking in pairs, and friendship and love, their constant companions and guides, strew flowers on their way. Then, too, this road is neither so definitely marked as the first, nor so unkempt as the second. It runs, in beautiful variety of setting, from hill to meadow, from lake shore to orange grove. Every imaginable loveliness contributes to this variety. But in the very charm of this road there lies a danger to the traveller, for it may cause him to forget his destination, and cause him to lose all desire for the Temple of Immortality. Thus it happens that some of the travellers are overtaken by death before they reach the Temple. A loving companion may then carry their body to the Temple's threshold, where it will at once return to life and everlasting youth.

These then, dear brothers in art, are the three roads; chose between them according to your inclination, but test your powers first, by using reason. Whichever road you chose, I should advise you to go forward on it without looking too much to the left or right. . . . the proof that each of the three roads leads to the goal is given by three men who went separate ways and whose names are equally respected by posterity: Michelangelo took the road of Fantasy, Raphael the road of Beauty, and Dürer that of Nature, though he not infrequently crossed over into the land of Beauty.

NATURE-PHILOSOPHY

The revival of orthodox Catholicism and traditional church art
was one of the characteristic manifestations of the spirit of Restoration in
the early decades of the 19th century. The more liberal, or Protestant,
counterpart of that essentially conservative current was the emergence
of a philosophy of nature bordering on the one hand on mysticism and
pantheism and extending on the other to a point close to the natural
sciences. The philosopher F. W. J. von Schelling (see page 42) was its
most influential spokesman. To artists in search of a language of pictorial
symbols, nature-philosophy opened new ways of expression. It was of
special importance to landscape painters, because it promised an op-
portunity for extending the scope of landscape and raising it from its
traditional low rank in the hierarchy of subject matter to the dignity
of religious or historical painting. It is noteworthy that C. D. Friedrich
painted his first symbolical landscape, the altarpiece for Tetschen Castle
(1808), the year after Schelling's widely-read address on the Creative Arts
and Nature was published.

Johann Wolfgang Goethe (1749–1832) on Art and Nature

Goethe's personal bent was strongly pragmatic and inclined him to
scientific investigation, rather than metaphysical speculation. His writings
on art, nevertheless, influenced the nature philosophers through their
emphasis on the need for a penetrating study of nature, not confined to
its visual aspect, but extending to internal functions. Compared to his
own earlier writings (see Vol. I, p. 72), in which he had tended to equate
art and nature, and had made of the artist an agent of natural energies,
Goethe's later, didactic statements on art, such as the Introduction to the
Propyläen (1798), from which the following excerpts are taken, stressed
the essential difference between art and nature, and imposed on the
artist the obligation to study nature, guided by an awareness of the
separate values of art. The Propyläen was a periodical founded in 1798,
by Goethe and a group of friends, for the purpose of propagating Goethe's
ideas on art.[25]

[25] J. W. Goethe, "Einleitung in die Propyläen," in Goethes Werke (Sophien
Ausgabe), Weimar, 1896, I Abtheilung, XLVII, 27 ff. The translation here used is the
anonymous one published in Prefaces and Prologues (The Harvard Classics, Charles W.
Eliot, ed.), New York, Collier and Son, 1910, pp. 255 ff.

From *Introduction to the Propyläen* (1798)

The highest demand that is made on an artist is this: that he be true to Nature, study her, imitate her, and produce something that resembles her phenomena. How great, how enormous, this demand is, is not always kept in mind; and the true artist himself learns it by experience only, in the course of his progressive development. Nature is separated from Art by an enormous chasm, which genius itself is unable to bridge without external assistance.

All that we perceive around us is merely raw material; if it happens rarely enough that an artist, through instinct and taste, through practice and experiment, reaches the point of attaining the beautiful exterior of things, of selecting the best from the good before him, and of producing at least an agreeable appearance, it is still more rare, particularly in modern times, for an artist to penetrate into the depths of things as well as into the depths of his own soul, in order to produce in his works not only something light and superficially effective, but, as a rival of Nature, to produce something spiritually organic, and to give his work of art a content and a form through which it appears both natural and beyond Nature.

Man is the highest, the characteristic subject of plastic art; to understand him, to extricate oneself from the labyrinth of his anatomy, a general knowledge of organic nature is imperative. The artist should also acquaint himself theoretically with inorganic bodies and with the general operations of Nature, particularly if, as in the case of sound and color, they are adaptable to the purposes of art; but what a circuitous path he would be obliged to take if he wanted to seek laboriously in the schools of the anatomist, the naturalist, and the physicist, for that which serves his purposes! It is, indeed, a question whether he would find there what must be most important for him. . . .

The human figure cannot be understood merely through observation of its surface; the interior must be laid bare, its parts must be separated, the connections perceived, the differences noted, action and reaction observed, the concealed, constant, and fundamental elements of the phenomena impressed on the mind, if one really wishes to contemplate and imitate what moves before our eyes in living waves as a beautiful, undivided whole. A glance at the surface of a living being confuses the observer; we may cite here, as in other cases, the true proverb, "One sees only what one knows." For just as a short-sighted man sees more clearly an object from which he draws back than one to which he draws

near, because his intellectual vision comes to his aid, so the perfection of observation really depends on knowledge. How well an expert naturalist, who can also draw, imitates objects by recognizing and emphasizing the important and significant parts from which is derived the character of the whole!

Just as the artist is greatly helped by an exact knowledge of the separate parts of the human figure, which he must in the end regard again as a whole, so a general view, a side glance at related objects, is highly advantageous, provided the artist is capable of rising to ideas and of grasping the close relationship of things apparently remote. Comparative anatomy has prepared a general conception of organic creatures; it leads us from form to form, and by observing organisms closely or distantly related, we rise above them all to see their characteristics in an ideal picture. If we keep this picture in mind, we find that in observing objects our attention takes a definite direction, that scattered facts can be learned and retained more easily by comparison, that in the practice of art we can finally vie with Nature only when we have learned from her, at least to some extent, her method of procedure in the creation of her works.

Friedrich Wilhelm Joseph von Schelling (1775–1854)

Schelling's nature-philosophy was derived in part from Kant and Fichte, in part from the mystical writings of Jacob Boehme. It strongly influenced the later, naturalist phase of the romantic movement, both in Germany and in England, where Coleridge assimilated and spread many of Schelling's ideas. The special appeal which this philosophy held for artists lay, perhaps, in the central emphasis which it gave to art in the economy of man's intellectual life. Schelling believed that one creative spirit pervades both the physical world and the individual consciousness. Outside man's awareness this spirit is not conscious of itself. It operates mutely and blindly in nature, it becomes reflective in man, and in the artist it becomes consciously productive. Art, in fact, requires that the two opposite components of the mind, the conscious and the unconscious, come together and be reconciled. Of the two, the unconscious is the more important, for the reflective and critical part of the mind, that which is reached by education and academic training, cannot itself produce art. The source of the artist's creativity, "the eternal sun in the realm of the mind," is the unconscious energy which he shares with nature, and which drives him to produce, even against his will. It is his bond with nature which enables him to express or represent things which he does not entirely understand, and to produce forms in his art which, like the forms of nature, have life and carry meaning. His work is not a

calculated abstraction from nature, but a genuine parallel creation. Schelling's debt to the earlier writers on organic creation or "natural genius" is evident (see Vol. I, p. 71), but what they had described as a mysterious and exceptional manifestation was in his view an inevitable fact of psychology. The nature-philosophy of Schelling had special relevance for the painters and theorists of landscape, such as Friedrich and Carus. In discounting the neoclassical demand for idealized representation, it encouraged a closer attention to visual reality and to the vital processes occurring in nature.

The following passage is taken from a lecture which Schelling delivered before the Royal Academy of Sciences of Munich, on October 12, 1807, on the occasion of the name-day of Ludwig I, King of Bavaria.[26]

From *On the Relationship of the Creative Arts to Nature* (1807)

Art, according to the most ancient expression, is silent poetry. The inventor of this definition no doubt meant thereby that the former, like the latter, is to express spiritual thoughts—conceptions whose source is the soul; only not by speech, but, like silent nature, by shape, by form, by corporeal, independent works. Art, therefore, evidently stands as a uniting link between the soul and nature, and can be apprehended only in the living center of both. Indeed, since pictorial art has its relation to the soul in common with every other art, and particularly with poetry, that by which it is connected with nature, and, like nature, a productive force, remains as its sole peculiarity; so that to this alone can a theory relate which shall be satisfactory to the understanding, and helpful and profitable to art itself.

We hope, therefore, in considering art in relation to its true prototype and original source, nature, to be able to contribute something new to its theory—to give some additional exactness or clearness to the conceptions of it; but, above all, to set forth the coherence of the whole structure of art in the light of a higher necessity.

But has not science always recognized this relation? Has not indeed every theory of modern times taken its departure from this very position, that art should be the imitator of nature? Such has indeed been the case. But what should this broad general proposition profit the artist, when the notion of nature is of such various interpretation, and when there are almost as many differing views of it as there are various modes of life? Thus, to one, nature is nothing more than the lifeless aggregate of an

[26] F. W. J. von Schelling, "Über das Verhaltnis der bildenden Künste zu der Natur," in *Sämmtliche Werke,* Stuttgart, 1860, VII, 291 ff. The translation used is by J. Elliot Cabot, published in *The German Classics of the 19th and 20th Century,* Albany, German Publication Society, 1913, pp. 106 ff.

indeterminable crowd of objects, or the space in which, as in a vessel, he imagines things placed; to another, only the soil from which he draws his nourishment and support; to the inspired seeker alone, the holy, ever-creative original energy of the world, which generates and busily evolves all things out of itself. The proposition would indeed have a high significance, if it taught art to emulate this creative force; but the sense in which it was meant can scarcely be doubtful to one acquainted with the universal condition of science at the time when it was first brought forward. Singular enough that the very persons who denied all life to nature should set it up for imitation in art!

Nature was to them not merely a dumb, but an altogether lifeless image, in whose inmost being no living word dwelt; a hollow scaffolding of forms, of which as hollow an image was to be transferred to the canvas, or hewn out of stone.

But is the disciple of nature to copy everything in nature without distinction?—and, of everything, every part? Only beautiful objects should be represented; and, even in these, only the beautiful and perfect. Thus the principle was further defined, but it was asserted, at the same time, that in nature the perfect is mingled with the imperfect, the beautiful with the unbeautiful. Now, how should he who stands in no other relation to nature than that of servile imitation, distinguish the one from the other? It is the way of imitators to appropriate the faults of their model sooner and easier than its excellences, since the former offer handles and tokens more easily grasped; and thus we see that imitators of nature in this sense have imitated oftener, and even more affectionately, the ugly than the beautiful.

If we regard in things, not their principle, but the empty abstract form, they will say nothing to our soul; we must put our own heart, our own spirit to it, so that they may answer us. But what is the perfection of a thing? Nothing else than the creative life in it, its power to exist. Never, therefore, will he, who fancies that nature is altogether dead, be successful in that profound process (analogous to the chemical) whence proceeds, purified as by fire, the pure gold of beauty and truth.

There was no change in the main view of the relation of art to nature, even when the unsatisfactoriness of the principle began to be more generally felt; no change, even by the new views and new knowledge so nobly established by Johann Winckelmann. He indeed restored to the soul its full efficiency in art, and raised it from its unworthy dependence into the realm of spiritual freedom. Powerfully moved by the beauty of form in the works of antiquity, he taught that the production of ideal nature, of nature elevated above the actual, together with the expression of spiritual conceptions, is the highest aim of art.

But if we examine in what sense this surpassing of the actual by art

has been understood by most, it turns out that, with this view also, the notion of nature as mere product, of things as lifeless existence still continued; and the idea of a living creative nature was not all awakened by it. Thus these ideal forms could not be animated by positive insight into their nature; and if the forms of the actual were dead for the dead beholder, these were not less so. Were no independent production of the actual possible, neither would there be of the ideal. The object of the imitation was changed; the imitation remained. In the place of nature were substituted the sublime works of antiquity, whose outward forms the pupils busied themselves in imitating, but without the spirit that fills them. These forms, however, are as unapproachable, or more so, than the works of nature, and leave us even colder if we do not bring to them the spiritual eye to penetrate through the veil and feel the stirring energy within.

. . . While the previous method in art produced bodies without soul, this view taught only the secret of the soul, but not that of the body. The theory had, as usual, passed with one hasty stride to the opposite extreme; but the vital mean it had not yet found.

Who can say that Winckelmann had not penetrated into the highest beauty? But with him it appeared in its dissevered elements only: on the one side as beauty in idea, and flowing out from the soul; on the other, as beauty of forms. But what is the efficient link that connects the two? Or by what power is the soul created together with the body, at once and as if with one breath? If this lies not within the power of art, as of nature, then it can create nothing whatever. This vital connecting link, Winckelmann did not determine; he did not teach how, from the idea, forms can be produced.

Nature meets us everywhere, at first with reserve, and in form more or less severe. . . . How can we spiritually melt this apparently rigid form, so that the pure energy of things may flow together with the force of our spirit and both become one united mold? We must transcend form, in order to gain it again as intelligible, living, and truly felt. Consider the most beautiful forms; what remains behind after you have abstracted from them the creative principle within? Nothing but mere unessential qualities, such as extension and the relations of space. . . . It is not mere contiguous existence, but the manner of it, that makes form; and this can be determined only by a positive force, which is opposed to separateness, and subordinates the manifoldness of the parts to the unity of one idea—from the force that works in the crystal to the force which, comparable to a gentle magnetic current, gives to the particles of matter in the human form that position and arrangement among themselves, through which the idea, the essential unity and beauty, can become visible.

Not only as active principle, but as spirit and effective science, must the essence appear to us in the form, in order that we may truly apprehend it. For all unity must be spiritual in nature and origin; and what is the aim of all investigation of nature but to find science therein? For that where there is no understanding cannot be the object of understanding; the unknowing cannot be known. The science by which nature works is not, however, like human science, connected with reflection upon itself; in it, the conception is not separate from the act, nor the design from the execution. Therefore, rude matter strives, as it were, blindly, after regular shape, and unknowingly assumes pure stereometric forms, which belong, nevertheless, to the realm of ideas, and are something spiritual in the material.

The sublimest arithmetic and geometry are innate in the stars, and unconsciously displayed by them in their motions. More distinctly, but still beyond their grasp, the living cognition appears in animals; and thus we see them, though wandering about without reflection, bring about innumerable results far more excellent than themselves: the bird that, intoxicated with music, transcends itself in soul-like tones; the little artistic creature, that, without practice or instruction, accomplishes light works of architecture; but all directed by an overpowering spirit that lightens in them already with single flashes of knowledge, but as yet appears nowhere as the full sun, as in man.

This formative science in nature and art is the link that connects idea and form, body and soul.

It was long ago perceived that in art, not everything is performed with consciousness; that, with the conscious activity, an unconscious action must combine; and that it is of the perfect unity and mutual interpenetration of the two that the highest in art is born. Works which do not have the mark of unconscious science are recognized by the evident absence of life self-supported and independent of the producer; while, on the contrary, where this acts, art imparts to its work, together with the utmost clearness to the understanding, that unfathomable reality in which it resembles a work of nature.

It has often been attempted to make clear the position of the artist in regard to nature, by saying that art, in order to be such, must first withdraw itself from nature, and return to it only in the final perfection. The true sense of this saying, it seems to us, can be no other than this— that in all things in nature, the living idea shows itself only blindly active; if it were the same in the artist, he would be in nothing distinct from nature. But, should he attempt consciously to subordinate himself altogether to the actual, and render with servile fidelity the already existing, he would produce empty masks, but no works of art. He must therefore withdraw himself from the product, from the creature, but only

in order to raise himself to the creative energy and to seize them spiritually. Thus he ascends into the realm of pure ideas; he forsakes the creature, to regain it with thousandfold interest, and in this sense to return to nature. This spirit of nature working at the core of things, and speaking through form and shape as by symbols only, the artist must follow with emulation; and only so far as he seizes this with vital imitation has he himself produced anything genuine. For works produced by aggregation, even of forms beautiful in themselves, would still be destitute of all beauty, since that through which the work on the whole is truly beautiful cannot be mere form. It is above form—it is essence, the universal, the look and expression of the indwelling spirit of nature.

Now it can scarcely be doubtful what is to be thought of the so-called idealizing of nature in art, so universally demanded. This demand seems to arise from a way of thinking, according to which not truth, beauty, goodness, but the contrary of all these, is the actual. Were the actual indeed opposed to truth and beauty, it would be necessary for the artist, not to elevate or idealize it, but to get rid of and destroy it, in order to create something true and beautiful. But how should it be possible for anything to be actual except the true; and what is beauty, if not full, complete being? . . .

If, according to the remark of a discerning critic, every growth in nature has only an instant of truly complete beauty, we may also say that it has, too, only an instant of full existence. In this instant it is what it is in all eternity; besides this, it has only a coming into and a passing out of existence. Art, in representing the thing at that instant, removes it out of time, and sets it forth in its pure being, in the eternity of its life.

Karl Gustav Carus (1789–1859)

Personal physician to the kings of Saxony, Carus was one of the leading men of science in his time. In his intellectual career, the profession of natural science and the love of art intimately complemented one another. His researches in comparative anatomy and in psychiatry sharpened his insight into the symptomatic significance of visual form. With Goethe, he investigated the morphological evolution of plant life; through Goethe, he learned of Luke Howard's systematic study of cloud formation; and from the nature-philosophy of Schelling, he derived the metaphysical framework which allowed him to integrate his scientific, philosophical, and artistic ideas. But it was his long friendship with C. D. Friedrich which caused him to discover in landscape painting the central expression of his diverse interests. He made himself a competent painter and was one of the few close disciples of Friedrich. In 1831 he

published Nine Letters on Landscape Painting, Written in 1815–1824 *in which he applied Schelling's philosophy to Friedrich's practice of landscape painting, and contributed to this his own awareness of natural phenomena. The pamphlet is an important document in the history of early naturalism. Grounded in romantic philosophy, it states a new view of landscape painting as an art concerned with process and change, with the significant behavior of matter, rather than the appearance of inert objects.*[27]

A timeless, limitless, perfect unity underlies all our feeling and thought, underlies every form of existence and every part of our self. We know this through a deep, inner awareness for which we can give no explanation or proof, because it is itself the source of all knowledge, proof, and explanation. Depending on our degree of personal development, this awareness in us may be obscure or clear. In common speech, we hint at this infinity within us with the word God.—In reason and in nature this highest reality appears to us in its internal and external manifestations. We feel ourselves to be a part of this reality. As creatures both of nature and of reason, we constitute an entity which contains both nature and reason, and thus partakes of the divine. This opens two different directions to our mental life. We may, on the one hand, try to reduce the multiplicity and infinity of nature and reason to their original, divine unity. Or we may try to represent the inner creative unity of our selves in an external multiplicity. In doing the latter, we exercise capability, in doing the former we show insight. Insight produces knowledge and science. Capability produces art. In science, man feels himself as being within God, in art he feels God within himself. . . .

When man, sensing the immense magnificence of nature, feels his own insignificance, and, feeling himself to be in God, enters into this infinity and abandons his individual existence, then his surrender is gain rather than loss. What otherwise only the mind's eye sees, here becomes almost literally visible: the oneness in the infinity of the universe. . . .

In considering landscape representations, we must distinguish between their various kinds in accordance with what they contain of truth, meaning, and subject.—It is natural that we should consider truth of representation first, for it furnishes the body of the work of art, so to speak; only through it is the work realized, transposed from the realm of arbitrary creation into that reality within which art should function. What are your feelings when you find in a well executed painting the faithful representation of the wide, clear distance, a calm or ruffled sheet of water, the flutter of tender foliage in shrub and tree, and all the

[27] C. G. Carus, *Neun Briefe über Landschaftsmalerei, geschrieben in den Jahren 1815 bis 1824*, Dresden, W. Jess Verlag, 1955, pp. 22 ff.

other forms in which the inexhaustible richness of landscape nature presents itself? . . . You will certainly feel yourself transported into those regions, you will imagine breathing their pure air, you will long to walk beneath those trees, you will imagine hearing the rush of water. Drawn into the sacred sphere of nature's mysterious life, your mind will expand. You will feel the eternally active life of creation, and as everything recedes which is merely individual and weak, you are strengthened and uplifted by this immersion into a higher realm, like Achilles rendered invulnerable by dipping into the Stygian river. But mere truth can never be the highest and most attractive quality of a picture. Consider the example of the mirror: look at nature reflected in its surface, you will find in this reflection all of nature's charms, colors, and forms, and yet, if you compare your impression of the mirror's image with that of a fine landscape painting, what do you find?—Clearly, the latter is inferior in point of truth; the painting does not equal the mirror in the attractiveness of natural forms and the brilliance of colors. And yet, a genuine work of art strikes us as a microcosm, as something existing in and for itself. The mirror image, by comparison, is always only a part, a mere fragment of infinite nature, torn from its organic context, and compressed into an unnaturally narrow compass. It is not, like the work of art, the complete creation of an intellectual energy which is related and comprehensible to us. It is, instead, only a note taken from an infinite harmony. It constantly calls for completion, and therefore never grants us that inward calm which we gain from surrendering ourselves freely to nature or from contemplating a fine work of art.

This explains why simple truth in landscape representation is not sufficient to give us the satisfaction which we demand. . . . We must, therefore, consider yet another requirement, namely that art be expressive of the fact that it owes its existence to the creative activity of the human spirit, and that, sprung from a unity, it must itself be a complete, coherent, and quasi-organic whole. If we grant this, we must also recognize that when the soul experiences a work of art this happens necessarily in a particular state or mood. The work therefore must also express a particular state. We can only achieve this in landscape painting if we approach and interpret nature in a way which is congenial to that mood. This takes us one step further: since a particular significance can be expressed only through the representation of objects, we must conclude that the expression of meanings depends on the proper choice of objects, and formulate the main aim of landscape painting more concretely as *the representation of certain moods of the spirit (significance) by means of the representation of corresponding states in the life of nature (truth)*. . . .

What are the special moods expressed in the manifold changes of natural landscape? When we reflect on the fact that these changes are

manifestations of nature's life, we realize that the various moods expressed in them are nothing but the life-states of nature. Life itself is infinite in essence, only its forms are subject to constant change. . . . Every form of individual life exhibits four states which can be defined as: unfolding, maturity, decay, and destruction. Various hybrid states appear when these four basic ones are combined, or when natural development is frustrated by abnormality, when maturity resists approaching destruction, or when from destruction a new development begins. These states can be found in the various manifestations of the life of nature which appear in landscape. The most obvious are the changes of the seasons and of the times of day; morning, noon, evening, and night; spring, summer, autumn, and winter show them very clearly. We also find in landscape the combined states mentioned above, thus in the dimming of the morning light, in a frost on flowering trees, the drying up of plants in the burning sun, a thunderstorm at noon, the moon rising in the night, the bursting of fresh buds from half-dead branches, and countless others which might be mentioned.

Just as the vibration of a string may cause another, similarly tuned, though of lower or higher pitch, to vibrate in unison, congenial states in nature and in the human spirit may interact. Here again we see man's individuality as an integral part of a larger whole. A responsive sensibility will be stirred by the quickening life of nature, by the pure morning light, and the joyous world of spring. It will be gladdened by the serene blue sky of summer and the quiet of the forest's foliage; it will be downcast by the slow death of nature in autumn, and oppressed by the white shrouds of the winter night. . . .

The clear sky, quintessence of air and light, is the true image of infinity, and since our feeling has a tendency toward the infinite, the image of the sky strongly characterizes the mood of any landscape beneath its lofty vault. The sky is, indeed, the most essential and magnificent part of landscape. When clouds or towering mountains restrict the view of this infinity more and more, and finally obscure it altogether, we sense a growing oppression. But when these heavy layers dissolve into small silvery clouds, or when they are pierced by the calm, clear light of the rising moon or sun, then our gloom vanishes, and gives way to thoughts of the victory of the infinite over the finite. . . .

. . . I believe my thoughts about the present state of landscape painting were prompted by a reading of Goethe's observations about the shapes of clouds and his beautiful poem in honor of Luke Howard.[28]

[28] Goethe's poem, *"Howards Ehrengedächtnis"* ("To the Honored Memory of Howard"), published in 1820, celebrated the systematic classification of cloud shapes devised by the British chemist Luke Howard (1772–1864); cf. Howard's *Essay on the Modification of Clouds,* London, 1804.

If you were to ask me what it was about this poem which moved me so powerfully, I should explain it in the following manner: we discover in the course of our lives that perfection occurs only under two circumstances. It may come about, on the one hand, in the state of our original simplicity, when we are directed to the good by an obscure awareness of the divinity in us. And it may occur again when, after having committed many errors, we at last reach a clear understanding of our relationship with God and the world, and, on this basis, consciously achieve that perfection which formerly remained unconscious. This suggests the possibility that art, too, may contain two different kinds of perfection. The first, an original, naïve perfection, I have dealt with in earlier letters. Goethe's poem gave me the idea of the second kind of artistic beauty, namely that which is based on deeper insight. Goethe has left us several other, similar poems, dating from his late period. They express the purest and most perfect, scientific insight into certain processes of life which, having deeply impressed themselves on the poet's soul, were translated by him into poetic perceptions and ideas.

For his poem about the clouds to be written, it was necessary that he undertake long and serious studies concerning atmospheric phenomena. He had to observe, judge, and classify the evidence, until he had gained, not only such knowledge of the formation of clouds as is yielded by simple visual observation, but also those deeper insights which are the real product of scientific inquiry. After he had done this, the eye of his intellect concentrated all the separate strands of the phenomenon, and raised them to the level of art.—Seen in this way, art appears as the highest form of science. In perceiving clearly the secrets of science and clothing them in beauty, it becomes in truth mystical, or, as Goethe would put it, Orphic.

What makes landscape painting possible, if not the vast, material nature all around us?—and what could be more sublime than to capture the secret life of this nature? And is it not true that an artist, deeply moved by his insight into the mysterious interaction of earth and fire, sea and air, will express himself more nobly, will address the beholder's soul with greater clarity and vigor? Let artists impart to us their sense of the secrets of life in nature, so that we, too, will understand that there is nothing lawless, insignificant, or accidental in the drift of clouds, the shapes of mountains, the anatomy of trees, and the motion of the wave, but that there lives in all of them a high significance and eternal meaning.

. . . I have clearly explained how I conceive the ideal of a new kind of landscape painting, but I must add one further remark about the name by which this new art should be known. Considered from the point of view which we have reached, the trivial name of landscape no

longer seems adequate. It suggests a routine of work which I find distaste-
ful. We need another word, and I should like to propose *Erdlebenbild*
(Picture of the Life of the Earth) or *Erdlebenbildkunst* (Pictorial Art
of the Life of the Earth). These terms convey more of the ideal which I
sought to describe than does the older one of landscape.

But as I read what I have written, it occurs to me that there is yet
another possible misunderstanding which I ought to eliminate. One
might suppose, after what I have written about paintings of the life of
the earth, that I have in mind dramatic scenes of monumental size,
pictures of the Alps, of storms at sea, of forests in the mountains, vol-
canoes, and waterfalls. But this is not at all my intention. Such dramatic
scenes, properly interpreted, could give us the most sublime form of this
new art of the life of the earth. But I maintain that the quietest and
simplest aspects of terrestrial life, if only we seize their meaning and the
divine spirit in them, can be worthy and beautiful subjects for art.

Caspar David Friedrich (1774–1840)

*Friedrich's background resembles that of Runge: he was born in
the harbor town of Greifswald on the Baltic Sea, into a large, Protestant,
solidly middle-class family. He began his studies at the Academy of
Copenhagen (1794–1798) and finished them in Dresden. He met Runge
in 1801, and through him entered the romantic circle around Ludwig
Tieck. Like Runge, Friedrich showed little curiosity about the world
beyond the confines of his North German milieu, and in particular had
no desire to visit Italy. His earliest works were careful landscape studies,
drawn with thin contours and washed with light sepia tones. Their
quiet subtlety of line, their bareness, and their lack of color reveal the
share which neoclassicism had in the formation of his style. He began
to paint in oil about 1806. In 1808, his* Cross in the Mountains, *an altar-
piece in the form of a landscape, aroused controversy; in 1810, the year
of Runge's death, the exhibition of his* Monk at the Sea *by the Academy
of Berlin brought Friedrich passing fame and recognition.*

*Friedrich shared with Runge the belief in the priority of spiritual
over material reality. The nature which he represented in his landscapes
was to him only the physical manifestation of an inward life, a con-
tinuous activity which corresponded to the agitation in the artist's mind.
In contrast to Runge's arbitrary compositions, in which shreds of reality,
torn from different contexts and detached from direct experience, are
placed side by side like words in a sentence, Friedrich's landscapes are
topographically and psychologically coherent. They record actual ex-
perience from a single point of view in space, time, and awareness. In this
sense, they are historical, rather than symbolical: they record events oc-*

*curring in nature, usually phenomena of change in atmosphere and light,
and relate these to events in the spectator's inward life*

Friedrich can hardly have been influenced directly by the art doctrines of Runge which remained unpublished until 1840. Nor did he ever formulate a coherent doctrine of his own. It is characteristic of his meditative and receptive bent, in contrast to Runge's active philosophizing, that the fullest expression of his views should be contained in a series of aphoristic or critical statements, the Observations on a Collection of Paintings by Living or Recently Deceased Artists (1830), which were occasioned by his reaction to particular works by contemporary painters. While this circumstance limits the range of his discussion, it focuses it on an important issue and defines Friedrich's position toward the end of his life, about 1830, when these notes were written. The polemic which runs through the Observations is directed against two opposite factions of the romantic movement, against the archaizing traditionalist of the Nazarene stamp, whom Runge had also condemned, and against the naturalists who represented the most advanced modernity of the period. Friedrich's Observations remained unpublished during his life. Excerpts from them were published by his friend Carus in 1841; the full text was edited by K. K. Eberlein in 1924.[29]

I am always disgusted when I find a multitude of paintings hung or piled up in a room or hall; the viewer can never see a picture by itself, with portions of four other pictures impinging on his sight. Such a piling up of art treasures must surely lower the value of individual works in the estimation of all who see them thus, particularly when paintings which contradict one another are placed side by side (sometimes intentionally, it seems) in such a way that they defeat, or at least hurt, one another and the effect of all is diminished. . . .

* * *

Close your eye, so that your picture will first appear before your mind's eye. Then bring to the light of day what you first saw in the inner darkness, and let it be reflected back into the minds of others.

* * *

Art is comparable to a child, science to a man.

* * *

[29] "Aeusserungen bei Betrachtung einer Sammlung von Gemälden . . . ," K. K. Eberlein, *C. D. Friedrich, Bekenntnisse*, Leipzig, Klinkhardt und Bierman, 1924, pp. 106 ff.

The heart is the only true source of art, the language of a pure, child-like soul. Any creation not sprung from this origin can only be artifice. Every true work of art is conceived in a hallowed hour and born in a happy one, from an impulse in the artist's heart, often without his knowledge.

* * *

The artist's feeling is his law. Pure sensibility can never be unnatural; it is always in harmony with nature. But the feelings of another must never be imposed on us as our law. Spiritual relationship produces artistic resemblance, but this relationship is very different from imitation. Whatever one may say about X.'s paintings, and however much they may resemble Y.'s, they originated in him and are his own.

* * *

This man is honored as a painter of great ability and skill, and also as a teacher who has produced many clever pupils on whom he has put his unmistakable stamp. Whether this last is a reason for praise seems questionable. I believe that it could be taken for a criticism, of the stamper as well as of the stamped. It would have been praiseworthy, I think, if the master had not put his stamp on his pupils, but had restrained his vanity and observed and respected, with wise moderation, the inborn individuality and inclination of each of his students. For that which nature has given to each of us in particular is the talent which we must cultivate, and I should like to call out to these students: "Respect the voice of nature in yourselves!"

* * *

Does it not take immense obtuseness and conceit to believe that we can force our ideas and opinions on the young? Is it not truly bestial, stupid, and intolerant to put down, or deny to others, whatever happens to be contrary to our ideas? Let everybody express himself in his own way; back up your pupils with advice, do not confront them with orders! For all of us can and should do only those things for which God has equipped our bodies and minds. Heavy-handed instruction slows the mind's progress and disturbs the student's growth and individuality. Lessons unwillingly learned may save us from crude mistakes, but there is the danger that untimely meddling will discourage the quiet growth of true genius.

* * *

A painter should not merely paint what he sees in front of him, he ought to paint what he sees within himself. If he sees nothing within, he should not paint what he sees before him, lest his paintings resemble those screens behind which we expect to find the sick or the dead. Mr. X has seen only what all but the blind can see; one should expect artists to see more than that.

* * *

We are fond of the pious simplicity in early paintings, but we do not want to become simple ourselves, as has happened to some who aped only the faults of these paintings; we want to become pious, and imitate their virtues.

* * *

. . . To be quite frank: isn't there something disgusting, not to say unappetizing, in the sight of those dried-up Maries holding starved Infant Jesuses and wearing papery garments? They often look as if they had been deliberately ill drawn and put intentionally in faulty foreshortening and perspective. Painters copy all the defects of that period, but the good qualities in its art, the profound, devout, childlike sentiment, cannot be imitated mechanically. This the hypocrites will never get right, even if they carry deception to the extreme of turning themselves into Catholics. What our ancestors did in childlike simplicity, we cannot do against our better knowledge. When grownups shit into the living room like infants, to prove their innocence and lack of guile, people will neither be convinced nor pleased.

* * *

It is the taste of our time to relish strong colors. Painters outdo one another in applying make-up to cheeks and lips in their paintings; the landscape painters carry exaggeration even further and put make-up on trees, rocks, water and air. . . . By way of contrast, I remember the time when color was almost completely neglected and when oil paintings looked like sepia drawings, because brown was their one, dominant hue. Later, brown was replaced by blue, and this in turn by violet, and finally it was the turn of green, a color which landscape painters had formerly suppressed almost entirely, despite its prominence in nature. Just now, all the colors are being used together. It took about thirty years for men's minds to run through this cycle, and we may be ready to go through another just like it. It is hard on those who can't run along; their work is being overlooked and neglected, for the time being, at any rate.

* * *

Landscape painting these days no longer aims for a spiritual con-
ception of its subject, not even if this were to be combined with the most
scrupulous and faithful imitation of nature. The modern demand is for
the exact aping of bodies, in other words of lengths, widths, heights,
shapes, and colors. For these, in the opinion of modern gentlemen,
actually comprehend the spirit, since the spirit can express itself only
through them. This is called pure, humble, childlike submission, and
sacrifice of personal will. In other words, the painter ought not to have
a will, he should simply paint. Even that which the inner eye per-
ceives through the physical eye is considered presumption and reckoned
a sin.

* * *

I am far from wanting to resist the demands of my time, except
when they are purely a matter of fashion. Instead, I continue to hope
that time itself will destroy its own offspring, perhaps quite soon. But
I am not so weak as to submit to the demands of the age when they
go against my convictions. I spin a cocoon around myself; let others do
the same. I shall leave it up to time to show what will come of it: a
brilliant butterfly or a maggot.

4

Twilight of Humanism

INTRODUCTION

It is possible to regard the middle decades of the 19th century as the final phase of Renaissance humanism. The great issues which had agitated artists and theorists since the 15th century were still alive, but seemed settled and unproductive of further innovation. In a last recapitulation, the artists of the time passed in review once again the main themes and styles which tradition had sanctified. These artists had by now achieved complete intellectual emancipation; they were free to cultivate their individuality, unhampered by any official dogma. But they chose to express their originality in a language not yet quite their own. Without fearing to compromise his personal integrity, Delacroix could still imitate Rubens or paint Apollo. Without diminishing his freedom, Constable could submit to the discipline of faithful nature study. The worlds of historical tradition and of timeless nature still comprised the whole horizon of the arts. Beyond it, the fantasy dared not yet to reach out in search of that absolute modernity which was beginning to haunt the minds of some few artists and poets.

ART AND NATURE

The origins of early 19th century naturalism go back to the visual illusionism of the Baroque, to Dutch landscape above all. What was novel in the particular form of naturalism which began, about 1815–1825, to replace neoclassicism as the leading modern style, was the quasi-scientific objectivity with which its practitioners tried to rid themselves of preconceptions and old schemata, including those of perspectival projection and balanced composition, along with a host of stereotypes which had formerly suggested rock, foliage, and cloud. In contrast to classicism, with its use of conceptual abstraction, the new naturalist style was based entirely on immediate observation. It carried a note of privacy and intimacy, and in its stress on actual experience avoided the emotional tension and self-conscious pathos which characterized both classicism and the more dramatic forms of romantic art. Its truth was psychological, or even physiological, rather than philosophical.

How severely the older devices, not merely of style, but even of working technique, had cramped the free exercise of the artist's powers

is suggested by the following excerpt from the article on "Drawing," in the Encyclopedia Britannica *(edition of 1797), which advises the painter.*[30]

If he is to draw a landscape from Nature, let him take his station on a rising ground, when he will have a large horizon, and mark his tablet into three divisions downwards from the top to the bottom, and divide in his own mind the landscape he is to take, into three divisions also. Then let him turn his face directly opposite to the midst of the horizon, keeping his body fixed, and draw what is directly before his eyes upon the middle division of the tablet; then *turn his head, but not his body* to the left hand, and delineate what he views there, joining it properly to what he had done before; and, lastly, do the same by what is to be seen upon his right hand, laying down everything exactly, both with respect to distance and proportion.

But the naturalism of the early 19th century was also a reaction against the fashion of the Picturesque, *a creation of the late 18th century which is often, falsely considered as an early manifestation of roman- ticism. With its recipes for assembling natural scenery from ready-made stage props and ornaments, it was actually an outgrowth of the Academy's curriculum, though unlike other products of the Academy it could be brought to a kind of life. The picturesque inventions of the studio were capable of being translated into actual shrubbery and rockery in the form of English gardens, and it was possible to look at genuine nature as if it were a picturesque composition. To help Englishmen accomplish this feat of the imagination, specialists in picturesque beauty wrote books of guidance. One of these books, the Rev. William Gilpin's* Observations on the River Wye *(1770), contains the following characteristic passages:* [31]

After sailing four miles from Ross, we came to Goodrich-castle; where a grand view presented itself; and we rested on our oars to examine it. A reach of the river, forming a noble bay, is spread before the eye. The bank on the right is steep, and covered with wood; beyond which a bold promontory shoots out, crowned with a castle among trees.

This view, which is one of the grandest on the river, I should not scruple to call *correctly picturesque;* which is seldom the character of a purely natural scene.

Nature is always great in design. She is an admirable colourist also;

[30] E. T. Cook and Alexander Wedderburn, *The Works of John Ruskin,* VI, *Modern Painters,* III, London, G. Allen, 1903, 358.

[31] William Gilpin, *Observations on the River Wye . . . Made in the Summer of the Year 1770* (5th edition), London, 1800, pp. 30 ff.

and harmonizes tints with infinite variety and beauty: but she is seldom so correct in composition, as to produce an harmonious whole. Either the foreground or the background is disproportioned; or some awkward line runs across the piece; or a tree is ill-placed; or a bank is formal; or something or other is not exactly what it should be.—Hence, therefore, the painter who adheres strictly to the composition of nature, will rarely make a good picture. In general, however, he may obtain views of such parts of nature, as with the addition of a few trees or a little alteration in the foreground may be adapted to his rules. . . .

Against this artistic perversion of nature, the romantic naturalists asserted the importance of objectivity; against this slovenly romance, they reacted with close, and sometimes pedantic, attention to fact. Their sobriety was a protest against facile emotionality. The revulsion from the picturesque was felt throughout Europe, and perhaps most strongly in England from where the fashion had originally spread.

John Constable (1776–1837)

Ruskin said of Constable that he "perceives in a landscape that the grass is wet, the meadow flat and the bough shady; that is to say, about as much as, I suppose, might in general be apprehended, between them, by an intelligent fawn and a sky lark"—a remark which perhaps expressed a secret appreciation. Ruskin also wrote that "Unteachableness seems to have been a main feature of his character," paying Constable another unintentional compliment. But he was wrong in concluding that Constable was "nothing more than an industrious and innocent amateur," [32] *for Constable was, in fact, a reflective artist, the most profound of the naturalists, who accomplished the difficult feat of combining in his landscape paintings a scientific penetration into natural phenomena with an undimmed freshness of perception. He professed no systematic doctrine, but his scattered writings reflect a view of the relationship of art to nature which bears some resemblance to Schelling's natural philosophy and to the ideas of Friedrich, his close contemporary (see page 52). In contrast to the Germans, Constable refrained from dramatizing the life of spirit which he, like them, sensed in nature, through outright symbolism or stylistic devices. Instead, he expressed it through a minute observation of the forces which move water and clouds, which govern light and the growth of plants, and whose activity he felt within his own body and mind. The empathic experience which underlay his naturalism*

[32] E. T. Cook and Alexander Wedderburn, *The Works of John Ruskin,* III, *Modern Painters,* I, London, G. Allen, 1903, pp. 172 and 191.

was strikingly similar to that which the chemist Sir Humphry Davy (1778–1829) recorded in a notebook jotting, some time after 1800: [33]

Today, for the first time in my life, I have had a distinct sympathy with nature. I was lying on the top of a rock to leeward; the wind was high, and everything in motion; the branches of an oak tree were waving and murmuring to the breeze; yellow clouds, deepened by grey at the base, were rapidly floating over the western hills; the whole sky was in motion; the yellow stream below was agitated by the breeze; everything was alive, and myself part of the series of visible impressions; I should have felt pain in tearing a leaf from one of the trees.

In feeling and in the quality of observation, this is very close to Constable's sketches, many of which bear notations such as the following:

5th September 1822. 10:00 o'clock Morning. Looking S.E., brisk wind at W. Very bright and fresh grey clouds running fast over yellow bed about half way in the sky.

Constable's letters and lecture notes were collected by his friend and biographer, C. R. Leslie, who wove them into his Memoir of the Life of John Constable, Esq., R.A., *London, 1843 (second, definitive edition 1845), from which the following excerpts are taken.*

"A Pure and Unaffected Manner"

London, May 29th, 1802. My dear Dunthorne, I hope I have now done with the business that brought me to town with Dr. Fisher. It is sufficient to say that had I accepted the situation offered, it would have been a death-blow to all my prospects of perfection in the art I love. For these few weeks past, I believe I have thought more seriously of my profession than at any other time of my life; of that which is the surest way to excellence. I am just returned from a visit to Sir George Beaumont's pictures with a deep conviction of the truth of Sir Joshua Reynolds' observation, that "there is no easy way of becoming a good painter." For the last two years I have been running after pictures, and seeking the truth at second hand. I have not endeavoured to represent nature with the same elevation of mind with which I set out, but have rather tried to make my performances look like the work of other men. I am come to a determination to make no idle visits this summer, nor to give up my time

[33] *Memoirs of the Life of Sir Humphry Davy,* edited by John Davy, London, 1839, quoted in G. Grigson, *The Romantics,* Cleveland, G. Routledge and Sons, 1962, 128.

to commonplace people. I shall return to Bergholt, where I shall en-
deavour to get a pure and unaffected manner of representing the scenes
that may employ me. There is little or nothing in the exhibition worth
looking up to. *There is room enough for a natural painter.* The great
vice of the present day is *bravura,* an attempt to do something beyond
the truth. Fashion always had, and will have, its day; but truth in all
things only will last, and can only have just claims on posterity. I have
reaped considerable benefit from exhibiting; it shows me where I am,
and in fact tells me what nothing else could.

Hampstead, October 23rd, 1821. My dear Fisher, . . . I am most
anxious to get into my London painting-room, for I do not consider
myself at work unless I am before a six-foot canvas. I have done a good
deal of skying, for I am determined to conquer all difficulties, and that
among the rest. And now talking of skies, it is amusing to us to see how
admirably you fight my battles; you certainly take the best possible ground
for getting your friend out of a scrape (the example of the old masters).
That landscape painter who does not make his skies a very material part
of his composition, neglects to avail himself of one of his greatest aids.
Sir Joshua Reynolds, speaking of the landscapes of Titian, of Salvator,
and of Claude, says: "Even their *skies* seem to sympathise with their
subjects." I have often been advised to consider my sky as *"a white sheet
thrown behind the objects."* Certainly, if the sky is obtrusive, as mine are,
it is bad; but if it is evaded, as mine are not, it is worse; it must and
always shall with me make an effectual part of the composition. It will be
difficult to name a class of landscape in which the sky is not the key note,
the standard of scale, and the chief organ of sentiment. You may conceive,
then, what a "white sheet" would do for me, impressed as I am with these
notions, and they cannot be erroneous. The sky is the source of light in
nature, and governs everything; even our common observations on the
weather of every day are altogether suggested by it. The difficulty of
skies in painting is very great, both as to composition and execution;
because, with all their brilliancy, they ought not to come forward, or,
indeed, be hardly thought of any more than extreme distances are; but
this does not apply to phenomena or accidental effects of sky, because
they always attract particularly. I may say all this to you, though *you*
do not want to be told that I know very well what I am about, and that
my skies have not been neglected, though they have often failed in execu-
tion, no doubt, from an over-anxiety about them, which will alone destroy
that easy appearance which nature always has in all her movements.

How much I wish I had been with you on your fishing excursion
in the New Forest! What river can it be? But the sound of water escaping
from mill-dams, etc., willows, old rotten planks, slimy posts, and brick-
work, I love such things. Shakespeare could make everything poetical;

he tells us of poor Tom's haunts among "sheep cotes and mills." As long as I do paint, I shall never cease to paint such places. They have always been my delight, and I should indeed have been delighted in seeing what you describe, and in your company, "in the company of a man to whom nature does not spread her volume in vain." Still I should paint my own places best; painting is with me but another word for feeling, and I associate "my careless boyhood" with all that lies on the banks of the Stour; those scenes made me a painter, and I am grateful; that is, I had often thought of pictures of them before I ever touched a pencil, and your picture is the strongest instance of it I can recollect; but I will say no more, for I am a great egotist in whatever relates to painting. Does not the Cathedral look beautiful among the golden foliage? its solitary grey must sparkle in it.

[1823]

May 9th. I had many interruptions in my works for the Exhibition, as you know, so that I have no large canvas there. My Cathedral looks uncommonly well; it is much approved of by the Academy. . . . It was the most difficult subject in landscape I ever had on my easel. I have not flinched at the windows, buttresses, etc.; but I have still kept to my grand organ colour, and have, as usual, made my escape in the evanescence of the chiaroscuro. . . . Callcott admires my Cathedral; he says I have managed it well. Wilkie's pictures are the finest in the world. Perhaps the outdoor scene is too black. Fuseli came up to him and said, "Vell, vat dis? is dis de new vay, de Guercina style?" Speaking of me, he says, "I like de landscapes of Constable; he is always picturesque, of a fine colour, and de lights always in de right places; but he makes me call for my greatcoat and umbrella." This may amuse you, when contemplating this busy but distant scene; however, though I am here in the midst of the world, I am out of it, and am happy, and endeavour to keep myself unspotted. I have a kingdom of my own, both fertile and populous —my landscape and my children. I have work to do, and my finances must be repaired if possible. I have a face now on my easel, and may have more.

[1832]

. . . My "Lock" is now on my easel; it is silvery, windy, and delicious; all health, and the absence of everything stagnant, and is wonderfully got together; the print will be fine. . . . I am so harassed and interrupted that I must now conclude almost as abruptly as I did my last. . . .

[1832]

I am much interested with your account of the pictures at Petworth. I remember most of Turner's early works; amongst them was one of

singular intricacy and beauty; it was a canal with numerous boats making thousands of beautiful shapes, and I think the most complete work of genius I ever say. The Claude I well know; grand and solemn, but cold, dull and heavy; a picture of his old age. Claude's exhilaration and light departed from him when he was between fifty and sixty, and he then became a professor of the "higher walks of art," and fell in a great degree into the manner of the painters around him; so difficult it is to be natural, so easy to be superior in our own opinion. . . . Hobbema, if he misses colour, is very disagreeable, as he has neither shapes nor composition. Your mention of a solemn twilight by Gainsborough has awakened all my sympathy; do pray make me a sketch of it of some kind or other, if it is only a slight splash.

As to meeting you in these grand scenes, dear Leslie, remember the Great were not made for me, nor I for the Great; things are better as they are. My limited and abstracted art is to be found under every hedge and in every lane, and therefore nobody thinks it worth picking up; but I have my admirers, each of whom I consider an host. My kindest regards to Mrs. Leslie.

[Undated]

The world is wide; no two days are alike, nor even two hours; neither were there ever two leaves of a tree alike since the creation of the world; and the genuine productions of art, like those of nature, are all distinct from each other.

In such an age as this, painting should be *understood,* not looked on with blind wonder, nor considered only as a poetic aspiration, but as a pursuit, *legitimate, scientific,* and *mechanical.*

From Constable's *Fourth Lecture* (1836)

It was said by Sir Thomas Lawrence, that "we can never hope to compete with nature in the beauty and delicacy of her separate forms or colours—our only chance lies in selection and combination." Nothing can be more true—and it may be added, that selection and combination are learned from nature herself, who constantly presents us with compositions of her own, far more beautiful than the happiest arranged by human skill. I have endeavoured to draw a line between genuine art and mannerism, but even the greatest painters have never been wholly untainted by manner.—Painting is a science, and should be pursued as an inquiry into the laws of nature. Why, then, may not landscape painting be considered as a branch of natural philosophy, of which pictures are but the experiments?

Art and Nature

[1822]

The art will go out; there will be no genuine painting in England in thirty years. This will be owing to pictures driven into the empty heads of the junior artists by their owners, the directors of the British Institution, etc. In the early ages of the fine arts, the productions were more affecting and sublime, for the artists, being without human exemplars, were forced to have recourse to nature; in the latter ages, of Raphael and Claude, the productions were more perfect, less uncouth, because the artists could then avail themselves of the experience of those who were before them, but they did not take them at their word, or as the chief objects of imitation. Could you but see the folly and ruin exhibited at the British Gallery, you would go mad. Vander Velde, and Gaspar Poussin, and Titian, are made to spawn multitudes of abortions: and for what are the great masters brought into this disgrace? only to serve the purpose of sale. Hofland has sold a shadow of Gaspar Poussin for eighty guineas, and it is no more like Gaspar than the shadow of a man on a muddy road is like himself.

[1829]

In art, there are two modes by which men aim at distinction. In the one, by a careful application to what others have accomplished, the artist imitates their works, or selects and combines their various beauties; in the other, he seeks excellence at its primitive source, nature. In the first, he forms a style upon the study of pictures, and produces either imitative or eclectic art; in the second, by a close observation of nature, he discovers qualities existing in her which have never been portrayed before, and thus forms a style which is original. The results of the one mode, as they repeat that with which the eye is already familiar, are soon recognised and estimated, while the advances of the artist in a new path must necessarily be slow, for few are able to judge of that which deviates from the usual course, or are qualified to appreciate original studies.

[Found on a scrap of paper among his memoranda:] My art flatters nobody by *imitation,* it courts nobody by *smoothness,* it tickles nobody by *petiteness,* it is without either *fal de lal* or *fiddle de dee,* how then can I hope to be popular?

From Constable's *Second Lecture* (1836)

But the climax of absurdity to which the art may be carried, when led away from nature by fashion, may be best seen in the works of

Boucher. Good temper, suavity, and dissipation characterised the per-
sonal habits of this perfect specimen of the French School of the time of
Louis XV, or the early part of the last century. His landscape, of which he
was evidently fond, is pastoral; and such pastorality! the pastoral of the
opera-house. But at this time, it must be remembered, the court were in
the habit of dispersing into the country, and duchesses were to be seen
performing the parts of shepherdesses, milkmaids, and dairymaids, in
cottages; and also brewing, baking, and gardening, and sending the pro-
duce to market. These strange anomalies were played off on the canvases
of Boucher. His scenery is a bewildered dream of the picturesque. From
cottages adorned with festoons of ivy, sparrow pots, etc., are seen issuing
opera dancers with mops, brooms, milk pails, and guitars; children with
cocked hats, queues, bag wigs, and swords—and cats, poultry, and pigs.
The scenery is diversified with winding streams, broken bridges, and
water wheels; hedge stakes dancing minuets—and groves bowing and
curtsying to each other; the whole leaving the mind in a state of be-
wilderment and confusion, from which laughter alone can relieve it.—
Boucher told Sir Joshua Reynolds "that he never painted from the life,
for that nature put him out."

It is remarkable how nearly, in all things, opposite extremes are
allied, and how they succeed each other. The style I have been describing
was followed by that which sprung out of the Revolution, when David
and his contemporaries exhibited their stern and heartless petrifactions
of men and women—with trees, rocks, tables, and chairs, all equally bound
to the ground by a relentless outline, and destitute of chiaroscuro, the soul
and medium of art.

[1822]

I have been to see David's picture of "The Coronation of the Em-
press Josephine." It does not possess the common language of the art,
much less anything of the oratory of Rubens or Paul Veronese, and in
point of execution it is below notice; still I prefer it to the productions
of those among our historical painters who are only holding on to the
tail of the shirt of Carlo Maratti, simply because it does not remind me
of the *schools*. I could not help feeling as I did when I last wrote to
you of what I saw at the British Institution. Should there be a National
Gallery (which is talked of) there will be an end of the art in poor old
England, and she will become, in all that relates to painting, as much a
nonentity as every other country that has one. The reason is plain; the
manufacturers of pictures are then made the criterions of perfection,
instead of nature.

[1835]

. . . I have seen David's pictures; they are indeed loathsome, and

the room would be intolerable but for the urbane and agreeable manners of the colonel. David seems to have formed his mind from three sources, the scaffold, the hospital, and a brothel. . . .

From Constable's *Last Lecture* (1836)

The decline of painting, in every age and country, after arriving at excellence, has been attributed by writers who have not been artists to every cause but the true one. The first impression and a natural one is, that the fine arts have risen or declined in proportion as patronage has been given to them or withdrawn, but it will be found that there has often been more money lavished on them in their worst periods than in their best, and that the highest honours have frequently been bestowed on artists whose names are scarcely now known. Whenever the arts have not been upheld by the good sense of their professors, patronage and honours so far from checking their downward course, must inevitably accelerate it.

The attempt to revive old styles that have existed in former ages may for a time appear to be successful, but experience may now surely teach us its impossibility. I might put on a suit of Claude Lorrain's clothes and walk into the street, and the many who know Claude but slightly would pull off their hats to me, but I should at last meet with some one more intimately acquainted with him, who would expose me to the contempt I merited.

It is thus in all the fine arts. A new Gothic building, or a new missal, is in reality little less absurd than a *new ruin*. The Gothic architecture, sculpture, and painting, belong to peculiar ages. The feelings that guided their inventors are unknown to us, we contemplate them with associations, many of which, however vague and dim, have a strong hold on our imaginations, and we feel indignant at the attempt to cheat us by any modern mimicry of their peculiarities.

It is to be lamented that the tendency of taste is at present too much towards this kind of imitation, which, as long as it lasts, can only act as a blight on art, by engaging talents that might have stamped the Age with a character of its own, in the vain endeavour to reanimate deceased Art, in which the utmost that can be accomplished will be to reproduce a body without a soul.

The Voice of God in Nature

[From a letter written to Mrs. Constable in May 1819, while he was on a short visit to Bergholt:] Everything seems full of blossom of some kind and at every step I take, and on whatever object I turn my eyes, that sublime expression of the Scriptures, "I am the resurrection and the life," seems as if uttered near me.

John Ruskin (1819–1900)

An attack on Turner which appeared in Blackwood's Magazine *in 1836 moved Ruskin, aged seventeen and about to enter college, to compose an angry and eloquent reply. This letter remained unpublished but it started Ruskin on his career as a polemical writer on art. Six years later, a similar circumstance prompted him to begin his first great work of art criticism.*

The summer before last, [*he wrote to his former teacher, the Rev. Osborne Gordon in 1844* [34]]—it was on a Sunday, I remember, at Geneva— we got papers from London containing a review of the Royal Academy; it put me in a rage, and that forenoon in church . . . I determined to write a pamphlet and blow the critics out of the water. On Monday, we went to Chamonix, and on Tuesday I got up at four in the morning, expecting to have finished my pamphlet by eight. I set to work, but the red light came on the Dome du Goute—I couldn't sit it—and went out for a walk. Wednesday, the same thing happened, and I put off my pamphlet till I should get a wet day. The wet day didn't come—and consequently, before I began to write, I had got more materials together than were digestible in an hour or two. I put off my pamphlet till I got home. I meditated all the way down the Rhine, found that demonstration in matters of art was no such easy matter, and the pamplet turned into a volume. Before the volume was half way dealt with it hydra-ized into three heads, and each head became a volume. Finding that nothing could be done except on such enormous scale, I determined to take the hydra by the horns, and produce a complete treatise on landscape art. Then came the question, what is the real end of landscape art? and then the conviction that it had been entirely degraded and mistaken, that it might become an instrument of gigantic moral power, and that the demonstration of this high function, and the elevation of the careless sketch or conventional composition into the studied sermon and inspired poem, was an end worthy of my utmost labor—and of no short expenditure of life.

What had begun as a pamphlet swelled into the five massive tomes of Modern Painters, *of which the first volume appeared in 1843, and the remainder in successive installments in 1846, 1856, and 1860. Ruskin's bold claim was, initially, that the modern English painters of landscape,*

34 E. T. Cook and Alexander Wedderburn, *The Works of John Ruskin,* III, *Modern Painters,* I, London, G. Allen, 1903, 666. Compare Ruskin's views with those of Caspar David Friedrich, p. 52, as well as those of Philipp Otto Runge, Vol. I, p. 143.

and in particular Turner, the greatest among them, had surpassed the old masters in truth to nature, in beauty, and in moral significance. This stand on behalf of contemporary art seems to invite comparison with Stendhal's and Baudelaire's advocacy of the modern spirit in art (see page 154), but Ruskin's notion of "modernity" was, unlike theirs, linked to timeless nature and to God, rather than to the historical present. His argument remained painfully suspended between several kinds of truth. A strong, naturalist bias drew him into minute studies of rock, plant, water, and cloud, but his need to moralize experience made him search for values and meanings beyond "low" reality, and he was, in addition, aware of the presence in art of purely formal or expressive qualities which are independent of external nature and moral law. His mind was divided between knowledge and inspiration, plain observation and noble thought, material fact and celestial intimations. This accounted in part for the excessive complexity and richness with which he burdened his writings; he used passages of gorgeous, descriptive poetry to cover the fissure that separated his sense of nature from his convictions about art. The beauty of these passages won him many friends and caused the book to go rapidly through several editions. But his sweeping and, from the pen of so young an author, arrogant condemnation of the old masters caused surprise, even among the English artists whom the book was meant to please. Turner, who held a very different view of Claude Lorrain (see page 94), received Ruskin's tribute with reserve.

In the later volumes of Modern Painters, *the flow of Ruskin's eloquence gradually carried his argument into channels quite different from those along which it had moved at the start. From modern Englishmen, he turned to Titian and Tintoretto, and to the painters of medieval Italy, Fra Angelico, Benozzo Gozzoli, and Giotto. He began to tire of descriptions of natural scenery, and to feel even that "our love of nature had been partly forced on us by mistakes in our social economy." Henceforth he was to devote himself, in such works as the* Seven Lamps of Architecture *(1849) and* Stones of Venice *(1851–1853), to the more formal aspects of art, and to art's religious and social function. But this later phase of Ruskin's thought is beyond our scope. The following excerpts are taken, unless otherwise indicated, from the first volume of* Modern Painters *(1843).[35]*

The Inferiority of the Old Masters

The course of study which has led me reverently to the feet of Michael Angelo and Da Vinci, has alienated me gradually from Claude

[35] E. T. Cook and Alexander Wedderburn, *The Works of John Ruskin*, III, *Modern Painters*, I–V, London, G. Allen, 1903. Reference to the various passages from *Modern Painters* in the following notes will be made under the abbreviation *MP*.

and Gaspar; I cannot at the same time do homage to power and pettiness —to the truth of consummate science, and the mannerism of undisciplined imagination. And let it be understood that whenever hereafter I speak depreciatingly of the old masters as a body, I refer to none of the historical painters, for whom I entertain a veneration which is almost superstitious in degree. Neither, unless he be particularly mentioned, do I intend to include Nicholas Poussin. . . . Speaking generally of the elder masters, I refer only to Claude, Gaspar Poussin, Salvator Rosa, Cuyp, Berghem, Both, Ruysdael, Hobbema, Teniers (in his landscapes), P. Potter, Canaletto, and the various Van somethings and Back somethings, more especially and malignantly those who have libelled the sea.[36]

No doubt can, I think, be reasonably entertained as to the utter inutility of all that has been hitherto accomplished by the painters of landscape. No moral end has been answered, no permanent good effected, by any of their works. . . . Landscape art has never taught us one deep or holy lesson; it has not recorded that which is fleeting, nor penetrated that which was hidden, nor interpreted that which was obscure; it has never made us feel the wonder, nor the power, nor the glory of the universe. . . . That which ought to have been a witness to the omnipotence of God, has become an exhibition of the dexterity of man. . . .

I speak not only of the works of the Flemish school, I wage no war with their admirers; they may be left in peace to count the spicula of haystacks and the hairs of donkeys; it is also of works of real mind that I speak, works in which there are evidences of genius and workings of power, works which have been held up as containing all of the beautiful that art can reach or man conceive. And I assert with sorrow, that all hitherto done in landscape, by those commonly conceived its masters, has never prompted one holy thought in the minds of nations. It has begun and ended in exhibiting the dexterities of individuals, and conventionalities of systems. Filling the world with the honour of Claude and Salvator, it has never once tended to the honour of God.

Does the reader start in reading these last words, as if they were those of wild enthusiasm, as if I were lowering the dignity of religion by supposing that its cause could be advanced by such means? His surprise proves my position. It does sound like wild, like absurd enthusiasm to expect any definite moral agency in the painters of landscape; but ought it so to sound? Are the gorgeousness of the visible hue, the glory of the realized form, instruments in the artist's hand so ineffective, that they can answer no nobler purpose than the amusement of curiosity, or the engagement of idleness? Must it not be owing to gross neglect or misapplication of the means at his command, that while words and tones (means of representing nature surely less powerful than lines and colours) can kindle and purify the very inmost souls of men, the painter can only

36 *MP* I, p. 84.

hope to entertain by his efforts at expression, and must remain for ever brooding over his incommunicable thoughts?

The cause of the evil lies, I believe, deep-seated in the system of ancient landscape art; it consists, in a word, in the painter's taking upon him to modify God's works at his pleasure, casting the shadow of himself on all he sees, constituting himself arbiter where it is honour to be a disciple, and exhibiting his ingenuity by the attainment of combinations whose highest praise is that they are impossible. . . . Now there is but one grand style, in the treatment of all subjects whatsoever, and that style is based on the perfect knowledge, and consists in the simple unencumbered rendering of the specific characters of the given object, be it man, beast, or flower. Every change, caricature, or abandonment of such specific character is as destructive of grandeur as it is of truth, of beauty as of propriety. Every alteration of the features of nature has its origin either in powerless indolence or blind audacity; in the folly which forgets, or the insolence which desecrates, works which it is the pride of angels to know, and their privilege to love.[37]

The True Ideal of Landscape

Is there then no such thing as elevated ideal character of landscape? Undoubtedly; and Sir Joshua, with the great master of this character, Nicolo Poussin, present to his thoughts, ought to have arrived at more true conclusions respecting its essence. . . . The true ideal of landscape is precisely the same as that of the human form; it is the expression of the specific—not of the individual, but the specific—characters of every object, in their perfection. There is an ideal form of every herb, flower, and tree, it is that form to which every individual of the species has a tendency to arrive, freed from the influence of accident or disease. Every landscape painter should know the specific character of every object he has to represent, rock, flower, or cloud. . . .

In his observation on the foreground of the *San Pietro Martire,* Sir Joshua advances, as a matter of praise, that the plants are discriminated "just as much as was necessary for variety, and no more." Had this foreground been occupied by a group of animals, we should have been surprised to be told that the lion, the serpent, and the dove, or whatever other creatures might have been introduced, were distinguished from each other just as much as was necessary for variety, and no more. . . . If the distinctive forms of animal life are meant for our reverent observance, is it likely that those of vegetable life are made merely to be swept away? . . . But Sir Joshua is as inaccurate in fact, as false in principle. . . . The great masters of Italy, almost without exception,

[37] *MP* I, pp. 21 ff.

and Titian perhaps more than any (for he had the highest knowledge of landscape), are in the constant habit of rendering every detail of their foregrounds with the most laborious botanical fidelity: witness the *Bacchus and Ariadne,* in which the foreground is occupied by the common blue iris, the aquilegia, and the wild rose; *every stamen* of which latter is given, while the blossoms and leaves of the columbine (a difficult flower to draw) have been studied with the most exquisite accuracy.

It is not detail sought for its own sake, not the calculable bricks of the Dutch house-painter, nor the numbered hairs and mapped wrinkles of Denner, which constitute great art, they are the lowest and most contemptible art; but it is detail referred to a great end, sought for the sake of the inestimable beauty which exists in the slightest and least of God's works, and treated in a manly, broad, and impressive manner. There may be as much greatness of mind, as much nobility of manner, in a master's treatment of the smallest features, as in his management of the most vast; and this greatness of manner chiefly consists in seizing the specific character of the object, together with all the great qualities of beauty which it has in common with higher orders of existence.

Again, it does not follow that, because accurate knowledge is *necessary* to the painter, it should constitute the painter; nor that such knowledge is valuable in itself, and without reference to high ends. This is the difference between the mere botanist's knowledge of plants, and the great poet's or painter's knowledge of them. The one notes their distinction for the sake of swelling his herbarium, the other that he may render them vehicles of expression and emotion. . . .

That generalization then is right, true, and noble, which is based on knowledge of the distinctions and observance of the relations of individual kinds. That generalization is wrong, false and contemptible, which is based on ignorance of the one, and disturbance of the other. It is indeed no generalization, but confusion and chaos; it is the generalization of a defeated army into undistinguishable impotence, the generalization of the elements of a dead carcass into dust.[38]

Truth

The word Truth, as applied to art, signifies the faithful statement, either to the mind or senses, of any fact of nature. We receive an idea of truth, then, when we perceive the faithfulness of such a statement. The difference between ideas of truth and of imitation lies chiefly in the following points:

First, Imitation can only be of something material, but truth has reference to statements both of the qualities of material things, and of

[38] *MP* I, pp. 27 ff. For Reynolds' view, see Vol. I, p. 36 above.

emotions, impressions, and thoughts. There is a moral as well as material truth—a truth of impression as well as of form—of thought as well as of matter; and the truth of impression and thought is a thousand times the more important of the two. Hence, truth is a term of universal application, but imitation is limited to that narrow field of art which takes cognizance only of material things.

Secondly, Truth may be stated by any signs or symbols which have a definite signification in the minds of those to whom they are addressed, although such signs be themselves no image nor likeness of anything. Whatever can excite in the mind the conception of certain facts, can give ideas of truth, though it be in no degree the imitation or resemblance of those facts. If there be—we do not say there is—but if there be in painting anything which operates, as words do, not by resembling anything, but by being taken as a symbol and substitute for it, and thus inducing the effect of it, then this channel of communication can convey uncorrupted truth, though it do not in any degree resemble the facts whose conception it induces. But ideas of imitation, of course, require the likeness of the object. They speak to the perceptive faculties only: truth to the conceptive.

Thirdly, and in consequence of what is above stated, an idea of truth exists in the statement of *one* attribute of anything, but an idea of imitation requires the resemblance of as many attributes as we are usually cognizant of in its real presence. A pencil outline of the bough of a tree on white paper is a statement of a certain number of facts of form. It does not yet amount to the imitation of anything. The idea of that form is not given in nature by lines at all, still less by black lines with a white space between them. But those lines convey to the mind a distinct impression of a certain number of facts, which it recognizes as agreeable with its previous impressions of the bough of a tree; and it receives, therefore, an idea of truth. . . . The last and greatest distinction between ideas of truth and of imitation—[is] that the mind, in receiving one of the former, dwells upon its own conception of the fact, or form, or feeling stated, and is occupied only with the qualities and character of that fact or form, considering it as real and existing, being all the while totally regardless of the signs or symbols by which the notion of it has been conveyed. These signs have no pretence, nor hypocrisy, nor legerdemain about them;—there is nothing to be found out, or sifted, or surprised in them;—they bear their message simply and clearly, and it is that message which the mind takes from them and dwells upon, regardless of the language in which it is delivered. But the mind, in receiving an idea of imitation, is wholly occupied in finding out that what has been suggested to it is not what it appears to be: it does not dwell on the suggestion, but on the perception that it is a false suggestion: it derives its pleasure, not from the contemplation of a truth, but from the discovery of a falsehood.

Hence, ideas of truth are the foundation, and ideas of imitation, the destruction, of all art.[39]

Beauty

Any material object which can give us pleasure in the simple contemplation of its outward qualities without any direct and definite exertion of the intellect, I call in some way, or in some degree, beautiful. Why we receive pleasure from some forms and colours, and not from others, is no more to be asked or answered than why we like sugar and dislike wormwood. The utmost subtlety of investigation will only lead us to ultimate instincts and principles of human nature, for which no farther reason can be given than the simple will of the Deity that we should be so created. . . . On these primary principles of our nature, education and accident operate to an unlimited extent; they may be cultivated or checked, directed or diverted, gifted by right guidance with the most acute and faultless sense, or subjected by neglect to every phase of error and disease. He who has followed up these natural laws of aversion and desire, rendering them more and more authoritative by constant obedience, so as to derive pleasure always from that which God originally intended should give him pleasure, and who derives the greatest possible sum of pleasure from any given object, is a man of taste.

This, then, is the real meaning of this disputed word. Perfect taste is the faculty of receiving the greatest possible pleasure from those material sources which are attractive to our moral nature in its purity and perfection. He who receives little pleasure from these sources wants taste; he who receives pleasure from any other sources has false or bad taste.

And it is thus that the term "taste" is to be distinguished from that of "judgment," with which it is constantly confounded. Judgment is a general term, expressing definite action of the intellect, and applicable to every kind of subject which can be submitted to it. There may be judgment of congruity, judgment of truth, judgment of justice, and judgment of difficulty and excellence. But all these exertions of the intellect are totally distinct from taste, properly so called, which is the instinctive and instant preferring of one material object to another without any obvious reason, except that it is proper to human nature in its perfection so to do. . . .

Ideas of beauty are among the noblest which can be presented to the human mind, invariably exalting and purifying it according to their degree; and it would appear that we are intended by the Deity to be constantly under their influence, because there is not one single object in nature which is not capable of conveying them, and which, to the rightly perceiving mind, does not present an incalculably greater number

[39] *MP* I, pp. 104 ff.

of beautiful than of deformed parts; there being in fact scarcely anything, in pure undiseased nature, like positive deformity, but only degrees of beauty, or such slight and rare points of permitted contrast as may render all around them more valuable by their opposition—spots of blackness in creation, to make its colours felt.

But although everything in nature is more or less beautiful, every species of object has its own kind and degree of beauty; some being in their own nature more beautiful than others, and few, if any, individuals possessing the utmost degree of beauty of which the species is capable. This utmost degree of specific beauty, necessarily coexistent with the utmost perfection of the object in other respects, is the ideal of the object.

Ideas of beauty, then, be it remembered, are the subjects of moral, but not of intellectual perception. By the investigation of them we shall be led to the knowledge of the ideal subjects of art.[40]

Greatness in Art

Painting, or art generally, as such, with all its technicalities, difficulties, and particular ends, is nothing but a noble and expressive language, invaluable as the vehicle of thought, but by itself nothing. He who has learned what is commonly considered the whole art of painting, that is, the art of representing any natural object faithfully, has as yet only learned the language by which his thoughts are to be expressed . . . all those excellences which are peculiar to the painter as such, are merely what rhythm, melody, precision, and force are in the words of the orator and the poet, necessary to their greatness, but not the test of their greatness. It is not by the mode of representing and saying, but by what is represented and said, that the respective greatness either of the painter or the writer is to be finally determined.

Speaking with strict propriety, therefore, we should call a man a great painter only as he excelled in precision and force in the language of lines, and a great versifier, as he excelled in precision and force in the language of words. A great poet would then be a term strictly, and in precisely the same sense, applicable to both, if warranted by the character of the images or thoughts which each in their respective languages conveyed.

It is not, however, always easy, either in painting or literature, to determine where the influence of language stops, and where that of thought begins. Many thoughts are so dependent upon the language in which they are clothed, that they would lose half their beauty if otherwise expressed. But the highest thoughts are those which are least dependent on language, and the dignity of any composition, and praise to which it is entitled, are in exact proportion to its independency of language or

40 *MP* I, pp. 109 ff.

expression. . . . We are more gratified by the simplest lines or words which can suggest the idea in its own naked beauty, than by the robe and the gem which conceal while they decorate.

There is therefore a distinction to be made between what is ornamental in language and what is expressive. That part of it which is necessary to the embodying and conveying of the thought is worthy of respect and attention. . . . But that part of it which is decorative has little more to do with the intrinsic excellence of the picture than the frame or the varnishing of it. And this caution in distinguishing between the ornamental and the expressive is particularly necessary in painting; for in the language of words it is nearly impossible for that which is not expressive to be beautiful. . . . But the beauty of mere language in painting is not only very attractive and entertaining to the spectator, but requires for its attainment no small exertion of mind and devotion of time by the artist. Hence, in art, men have frequently fancied that they were becoming rhetoricians and poets when they were only learning to speak melodiously, and the judge has over and over again advanced to the honour of authors those who were never more than ornamental writing masters.

Most pictures of the Dutch school, for instance, excepting always those of Rubens, Vandyke, and Rembrandt, are ostentatious exhibitions of the artist's power of speech, the clear and vigorous elocution of useless and senseless words; while the early efforts of Cimabue and Giotto are the burning messages of prophecy, delivered by the stammering lips of infants.

The picture which has the nobler and more numerous ideas, however awkwardly expressed, is a greater and a better picture than that which has the less noble and less numerous ideas, however beautifully expressed. No weight, nor mass, nor beauty of execution can outweigh one grain or fragment of thought. Three penstrokes of Raphael are a greater and a better picture than the most finished work that ever Carlo Dolci polished into inanity.

Yet although in all our speculations on art, language is thus to be distinguished from, and held subordinate to, that which it conveys, we must still remember that there are certain ideas inherent in language itself, and that, strictly speaking, every pleasure connected with art has in it some reference to the intellect. . . . The term idea, according to Locke's definition of it, will extend even to the sensual impressions themselves as far as they are "things which the mind occupies itself about in thinking"; that is, not as they are felt by the eye only, but as they are received by the mind through the eye. So that, if I say that the greatest picture is that which conveys to the mind of the spectator the greatest number of the greatest ideas, I have a definition which will include as subjects of comparison every pleasure which art is capable of conveying.

If I were to say, on the contrary, that the best picture was that which most closely imitated nature, I should assume that art could only please by imitating nature; and I should cast out of the pale of criticism those parts of works of art which are not imitative, that is to say, intrinsic beauties of colour and form.[41]

The Superiority of the Modern Masters of Landscape

It is strange that, with the great historical painters of Italy before them, the succeeding landscape painters should have wasted their lives in jugglery: but so it is, and so it will be felt, the more we look into their works, that the deception of the senses was the great and first end of all their art. There is, of course, more or less accuracy of knowledge and execution combined with this aim at effect, according to the industry and precision of eye possessed by the master. Claude had, if it had been cultivated, a fine feeling for beauty of form, and is seldom ungraceful in his foliage; but his picture, when examined with reference to essential truth, is one mass of error from beginning to end. Cuyp, on the other hand, could paint close truth of everything except ground and water, with decision and success, but he had no sense of beauty. Gaspar Poussin, more ignorant of truth than Claude, and almost as dead to beauty as Cuyp, has yet a perception of the feeling and moral truth of nature, which often redeems the picture; but yet in all of them, everything that they can do is done for deception, and nothing for the sake or love of what they are painting.

Modern landscape painters have looked at nature with totally different eyes, seeking not for what is easier to imitate, but for what is most important to tell. Rejecting at once all idea of *bona fide* imitation, they think only of conveying the impression of nature into the mind of the spectator. And there is, in consequence, a greater sum of valuable, essential, and impressive truth in the works of two or three of our leading modern landscape painters, than in those of all the old masters put together, and of truth too, nearly unmixed with definite or avoidable falsehood; while the unimportant and feeble truths of the old masters are choked with a mass of perpetual defiance of the most authoritative laws of nature.[42]

Clouds

Nothing can be more painfully and ponderously opaque than the clouds of the old masters universally. However far removed in aerial distance, and however brilliant in light, they never appear filmy or

[41] *MP* I, pp. 87 ff.
[42] *MP* I, pp. 166 ff.

evanescent, and their light is always on them, not in them. And this effect is much increased by the positive and persevering determination on the part of their outlines not to be broken in upon, nor interfered with in the slightest degree, by any presumptuous blue, or impertinent winds. There is no inequality, no variation, no losing or disguising of line, no melting into nothingness, no shattering into spray; edge succeeds edge with imperturbable equanimity, and nothing short of the most decided interference on the part of tree tops, or the edge of the picture, prevents us from being able to follow them all the way round, like the coast of an island.

And be it remembered that all these faults and deficiencies are to be found in their drawing merely of the separate masses of the solid cumulus, the easiest drawn of all clouds. But nature scarcely ever confines herself to such masses; they form but the thousandth part of her variety of effect. She builds up a pyramid of their boiling volumes, bars this across like a mountain with the grey cirrus, envelopes it in black, ragged, drifting vapour, covers the open part of the sky with mottled horizontal fields, breaks through these with sudden and long sunbeams, tears up their edges with local winds, scatters over the gaps of blue the infinity of multitude of the high cirri, and melts even the unoccupied azure into palpitating shades. And all this is done over and over again in every quarter of a mile. Where Poussin or Claude has three similar masses, nature has fifty pictures, made up each of millions of minor thoughts; fifty aisles, penetrating through angelic chapels to the Shechinah [Divine Glory] of the blue; fifty hollow ways among bewildered hills, each with its own nodding rocks, and cloven precipices, and radiant summits, and robing vapours, but all unlike each other, except in beauty, all bearing witness to the unwearied, exhaustless operation of the Infinite Mind.

And now let us, keeping in memory what we have seen of Poussin and Salvator, take up one of Turner's skies, and see whether *he* is as narrow in his conception, or as niggardly in his space. It does not matter which we take; his sublime *Babylon* is a fair example for our present purpose. Ten miles away, down the Euphrates, where it gleams last along the plain, he gives us a drift of dark elongated vapour, melting beneath into a dim haze which embraces the hills on the horizon. It is exhausted with its own motion, and broken up by the wind in its own mass into numberless groups of billowy and tossing fragments, which beaten by the weight of storm down to the earth, are just lifting themselves again on wearied wings, and perishing in the effort. Above these, and far beyond them, the eye goes back to a broad sea of white illuminated mist, or rather cloud melted into rain, and absorbed again before that rain has fallen, but penetrated throughout, whether it be vapour or whether it be dew, with soft sunshine, turning it as white as snow. Gradually, as

it rises, the rainy fusion ceases. You cannot tell where the film of blue on the left begins, but it is deepening, deepening still; and the cloud, with its edge first invisible, then all but imaginary, then just felt when the eye is not fixed on it, and lost when it is, at last rises, keen from excessive distance, but soft and mantling in its body as a swan's bosom fretted by faint wind; heaving fitfully against the delicate deep blue, with white waves, whose forms are traced by the pale lines of opalescent shadow, shade only because the light is within it, and not upon it, and which break with their own swiftness into a driven line of level spray, winnowed into threads by the wind, and flung before the following vapour like those swift shafts of arrowy water which a great cataract shoots into the air beside it, trying to find the earth. Beyond these, again, rises a colossal mountain of grey cumulus, through whose shadowed sides the sunbeams penetrate in dim, sloping, rain-like shafts; and over which they fall in a broad burst of streaming light, sinking to the earth, and showing through their own visible radiance the three successive ranges of hills which connect its desolate plain with space. Above, the edgy summit of the cumulus, broken into fragments, recedes into the sky, which is peopled in its serenity with quiet multitudes of the white, soft, silent cirrus; and, under these, again, drift near the zenith disturbed and impatient shadows of a darker spirit, seeking rest and finding none.

Now this is nature! It is the exhaustless living energy with which the universe is filled; and what will you set beside it of the works of other men? Show me a single picture, in the whole compass of ancient art, in which I can pass from cloud to cloud, from region to region, from first to second and third heaven, as I can here, and you may talk of Turner's want of truth.[43]

Turner's Image of the Sea

Of one thing I am certain; Turner never drew anything that could be *seen,* without having seen it. That is to say, though he would draw Jerusalem from some one else's sketch, it would be, nevertheless, entirely from his own experience of ruined walls: and [when] . . . he, in the year 1818, introduces a shipwreck, I am perfectly certain that, before the year 1818, he had *seen* a shipwreck, and, moreover, one of that horrible kind—a ship dashed to pieces in deep water, at the foot of an inaccessible cliff. Having once seen this, I perceive, also, that the image of it could not be effaced from his mind. It taught him two great facts, which he never afterwards forgot; namely, that both ships and sea were things that broke to pieces. *He never afterwards painted a ship quite in fair order.* There is invariably a feeling about his vessels of strange awe and danger;

[43] *MP* I, pp. 381 ff.

the sails are in some way loosening, or flapping as if in fear; the swing of the hull, majestic as it may be, seems more at the mercy of the sea than in triumph over it; the ship never looks gay, never proud, only warlike and enduring.

But he had seen more than the death of the ship. He had seen the sea feed her white flames on souls of men; and heard what a storm-gust sounded like, that had taken up with it, in its swirl of a moment, the last breaths of a ship's crew. He never forgot either the sight or the sound. . . . He hardly ever painted a steep rocky coast without some fragment of a devoured ship, grinding in the blanched teeth of the surges, —just enough left to be a token of utter destruction. Of his two most important paintings of definite shipwreck I shall speak presently.

I said that at this period he first was assured of another fact, namely, that the *Sea* also was a thing that broke to pieces. The sea up to that time had been generally regarded by painters as a liquidly composed, level-seeking consistent thing, with a smooth surface, rising to a water-mark on sides of ships; in which ships were scientifically to be embedded, and wetted, up to said water-mark, and to remain dry above the same. But Turner found during his Southern Coast tour that the sea was *not* this: that it was, on the contrary, a very incalculable and un-horizontal thing, setting its "water-mark" sometimes on the highest heavens, as well as on sides of ships;—very breakable into pieces; half of a wave separable from the other half, and on the instant carriageable miles inland;—not in any wise limiting itself to a state of apparent liquidity, but now striking like a steel gauntlet, and now becoming a cloud, and vanishing, no eye could tell whither; one moment a flint cave, the next a marble pillar, the next a mere white fleece thickening the thundery rain. He never forgot those facts; never afterwards was able to recover the idea of positive distinction between sea and sky, or sea and land. Steel gauntlet, black rock, white cloud, and men and masts gnashed to pieces and disappearing in a few breaths and splinters among them;—a little blood on the rock angle, like red sea-weed, sponged away by the next splash of the foam, and the glistering granite and green water all pure again in vacant wrath. So stayed by him, for ever, the Image of the Sea.

One effect of this revelation of the nature of ocean to him was not a little singular. It seemed that ever afterwards his appreciation of the calmness of water was deepened by what he had witnessed of its frenzy, and a certain class of entirely tame subjects were treated by him even with increased affection after he had seen the full manifestation of sublimity. . . . Thenceforward his work which introduces shipping is divided into two classes; one embodying the poetry of silence and calmness, the other of turbulence and wrath. Of intermediate conditions he gives few examples; if he lets the wind down upon the sea at all, it is

nearly always violent, and though the waves may not be running high, the foam is torn off them in a way which shows they will soon run higher. On the other hand, nothing is so perfectly calm as Turner's calmness. . . . The surface of quiet water with other painters becomes FIXED. With Turner it looks as if a fairy's breath would stir it, but the fairy's breath is not there.[44]

Turner's Greatness

And now but one word more, respecting the great artist whose works have formed the chief subject of this treatise. I think there is enough, even in the foregoing pages, to show that these works are, as far as concerns the ordinary critics of the press, above all animadversion, and above all praise; and that, by the public, they are not to be received as in any way subjects or matters of opinion, but of faith. We are not to approach them to be pleased, but to be taught; not to form a judgment, but to receive a lesson. Our periodical writers, therefore, may save themselves the trouble either of blaming or praising: their duty is not to pronounce opinions upon the work of a man who has walked with nature threescore years; but to impress upon the public the respect with which they are to be received, and to make request to him, on the part of the people of England, that he would now touch no unimportant work, that he would not spend time on slight or small pictures, but give to the nation a series of grand, consistent, systematic, and completed poems. We desire that he should follow out his own thoughts and intents of heart, without reference to any human authority. But we request, in all humility, that those thoughts may be seriously and loftily given; and that the whole power of his unequalled intellect may be exerted in the production of such works as may remain for ever, for the teaching of the nations. In all that he says, we believe; in all that he does, we trust. It is therefore that we pray him to utter nothing lightly; to do nothing regardlessly. He stands upon an eminence, from which he looks back over the universe of God and forward over the generations of men. Let every work of his hand be a history of the one, and a lesson to the other. Let each exertion of his mighty mind be both hymn and prophecy; adoration to the Deity, revelation to mankind.[45]

The Lesson of the Elgin Marbles

The British ambassador in Constantinople, Robert Bruce, Earl of Elgin, obtained permission from the Ottoman government in 1801 to remove to England a large portion of the sculptures of the Athenian

[44] E. T. Cook and Alexander Wedderburn, *The Works of John Ruskin*, XVIII, *The Harbours of England* (1856), London, G. Allen, 1904, pp. 42 ff.
[45] *MP* I, p. 629.

Parthenon. The fragments which Lord Elgin's agents had brought to-gether reached London in successive shipments during the years between 1802 and 1812. The first group of sculptures was arranged for public exhibition in 1807, in a large shed near Picadilly.

Lord Elgin's plan for providing England with a collection of some of the finest works of classical art had probably been influenced by the spectacular foundation of the Musée Napoleon in Paris. He had formed his collection at great personal expense, and in strenuous competition with French agents. But the reception accorded to his marbles in England turned out tò be distinctly less triumphant than had been the entry of the Apollo *of Belvedere and the* Laocoon *into the Louvre a few years earlier (see page 7). Lord Elgin was denounced as a plunderer, and his sculptures dismissed as inferior Roman copies by Payne Knight, the foremost British antiquarian. Most of the opposition came from amateurs and scholars who found that the sculptures from the Parthenon offended against the rules of Ideal Art. The sculptures did, in fact, discredit neo-classicism. Their vigorous characterization of anatomical detail, their subtly modulated surfaces and strong movement were in sharp contrast to the smoothness, generality, and abstract symmetry of what passed for Greek style. If they were, indeed, Greek works of the best period, then neoclassical art could not be called truly Greek. In the controversy which the marbles aroused, the artists proved to be better judges, on the whole, than the scholars. Even such arch-classicists as Flaxman and Canova acknowledged them to be masterworks; and other artists of reputation, less committed to strict classicism, men such as the aged West and the fiery Haydon, praised them as the greatest works of art ever seen in the British Isles. To their defenders, the Elgin marbles gave proof that the best Greek art, like all truly beautiful art, was oriented to nature, rather than to an abstractly ideal form. The trend toward naturalist art was about to begin throughout Europe, and its first stirrings were felt espe-cially strongly in England. The arrival of the Parthenon sculptures at this moment, far from arresting this development, strengthened it. To every-one's surprise, the authority of genuine Greek art discredited the neo-classical school, and encouraged those who favored the straightforward imitation of nature, unfettered by conventions of style.*[46]

Benjamin Robert Haydon (1786–1846)

Haydon typifies failed genius; the English painter's lofty ambition and precocious self-confidence recall Runge, but his powers as an artist fell tragically short of his ideal (see page 144). He had decided, when still almost a child, to raise history painting to an unprecedented height, and

[46] For an account of the controversy aroused by the marbles, see William St. Clair, *Lord Elgin and the Marbles,* London, Oxford University Press, 1967.

in his Autobiography *relates how, at the age of twenty, he began his first monumental painting:* [47]

Ordered the canvas for my first picture (six feet by four) of "Joseph and Mary resting on the road to Egypt"; and on October 1st, 1806, setting my palette and taking brush in hand, I knelt down and prayed to God to bless my career, to grant me energy to create a new era in art, and to rouse the people and patrons to a just estimate of the moral value of historical painting . . . I arose . . . and looking fearlessly at my unblemished canvas in a species of spasmodic fury I dashed down the first touch.

In 1808, Haydon was engaged on a vast and turgid classical composition of the Assassination of Dentatus. *He wanted his principal figure to be "heroic and the finest specimen of the species I could invent." The obvious model to follow would have been classical sculpture, but Haydon "desired more of nature than I could find in any of the antique figures." It was at this point that the sight of the Elgin marbles in their shed at Lord Elgin's house in Park Lane revealed to him the naturalism in genuine Greek art, in total contrast to the abstract stereotypes of neoclassicism.*[48]

To Park Lane then we went, and after passing through the hall and thence into an open yard, entered a damp dirty pent-house where lay the marbles ranged within sight and reach. The first thing I fixed my eyes on was the wrist of a figure in one of the female groups, in which were visible, though in a feminine form, the radius and ulna. I was astonished, for I had never seen them hinted at in any female wrist in the antique. I darted my eye to the elbow, and saw the outer condyle visibly affecting the shape as in nature. I saw that the arm was in repose and the soft parts in relaxation. That combination of nature and idea which I had felt was so much wanting for high art was here displayed to mid-day conviction. My heart beat! If I had seen nothing else I had beheld sufficient to keep me to nature for the rest of my life. But when I turned to the Theseus and saw that every form was altered by action or repose —when I saw that the two sides of his back varied, one side stretched from the shoulder blade being pulled forward, and the other side compressed from the shoulder blade being pushed close to the spine as he rested on his elbow, with the belly flat because the bowels fell into the pelvis as he sat—and when, turning to the Ilyssus, I saw the belly pro-

[47] *Autobiography of Benjamin Robert Haydon,* ed. Edmund Blunden, London, Oxford University Press, 1927, p. 51.
[48] *Idem.,* pp. 85 ff.

truded, from the figure living on its side—and again, when in the figure
of the fighting metope I saw the muscle shown under the one arm-pit
in that instantaneous action of darting out, and left out in the other
arm-pits because not wanted—when I saw, in fact, the most heroic style of
art combined with all the essential detail of actual life the thing was
done at once and for ever.

Here were principles which the common sense of the English
people would understand; here were principles which I had struggled for
in my first picture with timidity and apprehension; here were the prin-
ciples which the great Greeks in their finest time established, and here
was I, the most prominent historical student, perfectly qualified to ap-
preciate all this by my own determined mode of study under the influence
of my old friend the watchmaker—perfectly comprehending the hint at
the skin by knowing well what was underneath it!

Oh, how I inwardly thanked God that I was prepared to understand
all this! Now I was rewarded for all the petty harassings I had suffered.

I felt the future, I foretold that they would prove themselves the
finest things on earth, that they would overturn the false beau-ideal,
where nature was nothing, and would establish the true beau-ideal, of
which nature alone is the basis.

I shall never forget the horses' heads—the feet in the metopes! I felt
as if a divine truth had blazed inwardly upon my mind and I knew
that they would at last rouse the art of Europe from its slumber in the
darkness. . . . I passed the evening in a mixture of torture and hope; all
night I dozed and dreamed of the marbles. I rose at five in a fever of
excitement, tried to sketch the Theseus from memory, did so and saw
that I comprehended it. I worked that day and another and another,
fearing that I was deluded. At last I got an order for myself; I rushed
away to Park Lane; the impression was more vivid than before. I drove
off to Fuseli, and fired him to such a degree that he ran up stairs, put on
his coat and away we sallied. I remember that first a coal-cart with eight
horses stopped us as it struggled up one of the lanes of the Strand; then
a flock of sheep blocked us up; Fuseli, in a fury of haste and rage, burst
into the middle of them, and they got between his little legs and jostled
him so much that I screamed with laughter in spite of my excitement. He
swore all along the Strand like a little fury. At last we came to Park
Lane. Never shall I forget his uncompromising enthusiasm. He strode
about saying, "De Greeks were godes! de Greeks were godes!"

It is curious that the god-like length of limb in the Greek produc-
tions put me in mind of Fuseli's general notions of the heroic, and
there is justice in the idea. But as he had not nature for his guide his
indefinite impressions ended in manner and bombast. . . .

I drew at the marbles ten, fourteen, and fifteen hours at a time;

staying often till twelve at night, holding a candle and my board in one hand and drawing with the other; and so I should have staid till morning had not the sleepy porter come yawning in to tell me it was twelve o'clock, and then often have I gone home, cold, benumbed and damp, my clothes steaming up as I dried them; and so, spreading my drawings on the floor and putting a candle on the ground, I have drank my tea at one in the morning with ecstacy as its warmth trickled through my frame, and looked at my picture and dwelt on my drawings, and pondered on the change of empires and thought that I had been contemplating what Socrates looked at and Plato saw—and then, lifted up with my own high urgings of soul, I have prayed God to enlighten my mind to discover the principles of those divine things—and then I have had inward assurances of future glory, and almost fancying divine influence in my room have lingered to my mattress bed and soon dozed into a rich, balmy slumber.

The Elgin Marbles before the House of Commons

In 1816, Lord Elgin was at last able to persuade the government to consider the purchase of the Parthenon sculptures for the British nation. A Select Committee of the House of Commons was appointed, on February 15, 1816, to take expert testimony concerning the value of the sculptures. The following are excerpts from the testimony given by artists, the sculptors Joseph Nollekens (1737–1823), John Flaxman (1755–1826), and the painters Sir Thomas Lawrence (1769–1830) and Benjamin West (1738–1820). The marbles were in the end purchased for £35,000, or about half of what they had cost Lord Elgin.[49]

CHAIRMAN OF THE COMMITTEE.—"Mr. Nollekens, are you well acquainted with the collection of Marbles brought to England by Lord Elgin?"—"I am."

"What is your opinion of those Marbles, as to the excellency of the work?"—"They are very fine—the finest things that ever came to this country."

"In what class do you place them, as compared with the finest Marbles which you have seen formerly in Italy?"—"I compared them to the finest in Italy."

"Which of those of my Lord Elgin's do you hold in the highest estimation?"—"I hold the Theseus and the Neptune to be two of the finest things;—finer than any thing in this country."

"In what class do you place the bas-reliefs?"—"They are very fine— among the first class of bas-relief work."

[49] Reprinted in J. T. Smith, *Nollekens and his Time,* ed. W. Whitten, London, John Lane, 1917, p. 241 ff.

"Do you think that the bas-reliefs of the Centaurs are in the finest class of Art?"—"I do think so."

"Do you think the bas-relief of the frieze, representing the Procession, also in the first class of the art?"—"In the first class of the art." . . .

"To which of the works you have seen in Italy do you think the Theseus bears the greatest resemblance?"—"I compare that to the Apollo Belvedere and Laocoon."

"Do you think the Theseus of as fine sculpture as the Apollo?"—"I do."

"Do you think it has more or less of ideal beauty than the Apollo?"—"I cannot say it has more than the Apollo."

"Has it as much?"—"I think it has as much."

"Do you think that the Theseus is a closer copy of fine nature than the Apollo?"—"No; I do not say it is a finer copy of nature than the Apollo."

"Is there not a distinction among artists, between a close imitation of nature, and ideal beauty?"—"I look upon them as ideal beauty, and closeness of study from nature."

"Have the Elgin Collection gained in general estimation and utility since they have been more known and studied?"—"Yes."

JOHN FLAXMAN, ESQ., R.A., called in, and examined.

"Are you well acquainted with the Elgin Collection of Marbles?"—"Yes, I have seen them frequently, and I have drawn from them; and I have made such inquiries as I thought necessary concerning them respecting my art."

"In what class do you hold them, as compared with the first works of Art, which you have seen before?"—"The Elgin Marbles are mostly basso-relievos, and the finest works of Art I have seen. . . . and I have every reason to believe that they were executed by Phidias, and those employed under him, they are superior to almost any works of antiquity, excepting the Laocoon and Torso Farnese; because they are known to have been executed by the artists whose names are recorded by the ancient authors. With respect to the beauty of the basso-relievos, they are as perfect nature as it is possible to put into the compass of the marble in which they are executed, and that of the most elegant kind. There is one statue also, which is called a Hercules, or Theseus, of the first order of merit. The fragments are finely executed; but I do not, in my own estimation, think their merit is as great."

"What fragments do you speak of?"—"Several fragments of women; the groups without their heads."

"You do not mean the Metopes?"—"No; those statues which were in the east and west pediments originally."

"In what estimation do you hold the Theseus, as compared with the Apollo Belvedere and the Laocoon?"—"If you would permit me to compare it with a fragment I will mention, I should estimate it before the Torso Belvedere."

"As compared with the Apollo Belvedere, in what rank do you hold the Theseus?"—"For two reasons I cannot at this moment very correctly compare them in my own mind. In the first place, the Apollo Belvedere is a divinity of a higher order than Hercules. . . . In the next place, the Theseus is not only on the surface corroded by the weather; but the head is in that impaired state, that I can scarcely give an opinion upon it; and the limbs are mutilated. To answer the question, I should prefer the Apollo Belvedere certainly, though I believe it is only a copy."

"Does the Apollo Belvedere partake more of ideal beauty than the Theseus?"—"In my mind, it does decidedly; I have not the least question of it."

"Do you think that increases its value?"—"Yes, very highly. The highest efforts of art in that class have always been the most difficult to succeed in, both among ancients and moderns, if they have succeeded in it."

"Supposing the state of the Theseus to be perfect, would you value it more as a work of art than the Apollo?"—"No; I should value the Apollo for the ideal beauty, before any male statue I know."

"Although you think it a copy?"—"I am sure it is a copy; the other is an original, and by a first-rate artist."

"Do you think it of great consequence to the progress of Art in Britain, that this collection should become the property of the public?" —"Of the greatest importance, I think; and I always have thought so as an individual."

"Do you conceive practically, that any improvement has taken place in the state of the Arts in this country since this collection has been open to the public?"—"Within these last twenty years, I think, Sculpture has improved in a very great degree, and I believe my opinion is not singular; I think works of such prime importance could not remain in the country, without improving the public taste and the taste of the artists." . . .

SIR THOMAS LAWRENCE, KNT., R.A., called in, and examined.

"Are you well acquainted with the Elgin Marbles?"—"Yes, I am."

"In what class of art do you consider them?"—"In the very highest."

"In your own particular line of art, do you consider them of high importance as forming a national school?"—"In a line of art which I have very seldom practised, but which it is still my wish to do, I consider that they would; namely, Historical-painting."

"Do you conceive any of them to be of a higher class than the Apollo Belvedere?"—"I do; because I consider that there is in them an union of fine composition, and very grand form, with a more true and natural expression of the effect of action upon the human frame than there is in the Apollo, or in any of the other most celebrated statues."

"You have stated, that you thought these Marbles had great truth and imitation of nature; do you consider that that adds to their value?" —"It considerably adds to it, because I consider them as united with grand form. There is in them that variety that is produced in the human form by the alternate action and repose of the muscles, that strikes one particularly. I have myself a very good collection of the best casts from the antique statues, and was struck with that difference in them, in returning from the Elgin Marbles to my own house."

BENJAMIN WEST, ESQ., R.A.
Questions sent to the President of the Royal Academy, his health not permitting him to attend the Committee; with his Answers thereto.

"Are you well acquainted with the Elgin Collection?"—"I am; having drawn the most distinguished of them, the size of the original marbles."

"In what class of art do you rank the best of these Marbles?"—"In the first of dignified art, brought out of nature upon uncertain truths, and not on mechanical principles, to form systematic characters and systematic art."

"Do they appear to you the work of the same artists?"—"One mind pervades the whole, but not one hand has executed them."

"As compared with the Apollo Belvedere, the Torso of the Belvedere, and the Laocoon, how do you estimate the Theseus or Hercules, and the River God or Ilissus?"—"The Apollo of the Belvedere, the Torso, and the Laocoon, are systematic art; the Theseus and the Ilissus stand supreme in art."

William Hazlitt (1778–1830)

"The true lesson to be learned by our students and professors from the Elgin marbles," Hazlitt wrote in the Examiner, *in 1816, "is that the chief excellence of the figures depends on their having been copied from nature, and not from the imagination." He went on to make the extraordinary claim that Phidias' sculptures "have every appearance of absolute* fac-similes *or casts taken from nature."*

Before he found his vocation as a writer, Hazlitt had studied to be a portrait painter. Throughout his life, he continued to occupy himself

with questions of art, and frequently contributed art criticism to the journals. His long essay on Fine Arts *written for the* Encyclopaedia Britannica *in 1816 (not 1824, as has been supposed) reflects the profound impression made on him by the Elgin marbles, and constitutes at the same time one of the most radical statements of the nascent anti-idealist, naturalist current in the art of the period.*[50]

The great works of art at present extant, and which may be regarded as models of perfection in their several kinds, are the Greek statues—the pictures of the celebrated Italian masters—those of the Dutch and Flemish schools—to which we may add the comic productions of our own countryman, Hogarth. These all stand unrivalled in the history of art; and they owe their pre-eminence and perfection to one and the same principle—*the immediate imitation of nature.* This principle predominated equally in the classical forms of the antique, and in the grotesque figures of Hogarth: the perfection of art in each arose from the truth and identity of the imitation with the reality; the difference was in the subjects—there was none in the mode of imitation. Yet the advocates for the *ideal system of art* would persuade their disciples that the difference between Hogarth and the antique does not consist in the different forms of nature which they imitated, but in this, that the one is like, and the other unlike, nature. This is an error.

What has given rise to the common notion of the *ideal,* as something quite distinct from *actual* nature, is probably the perfection of the Greek statues. Not seeing among ourselves anything to correspond in beauty and grandeur, either with the feature or form of the limbs in these exquisite remains of antiquity, it was an obvious, but a superficial, conclusion that they must have been created from the idea existing in the artist's mind, and could not have been copied from anything existing in nature. The contrary, however, is the fact. The general form both of the face and figure, which we observe in the old statues, is not an ideal abstraction, is not a fanciful invention of the sculptor, but is as completely local and national (though it happens to be more beautiful) as the figures on a Chinese screen, or a copper-plate engraving of a Negro chieftain in a book of travels. It will not be denied that there is a difference of physiognomy as well as of complexion in different races of men. The Greek form appears to have been naturally beautiful, and they had, besides, every advantage of climate, of dress, of exercise, and modes of life to improve it. . . .

50 A. R. Waller and A. Glover, *Collected Works of William Hazlitt,* London, J. M. Dent, 1903, p. 326 (*Examiner* article) and p. 377 (*Encyclopedia* article). It is instructive to compare Hazlitt's views of the imitation of nature with those of Winckelmann, see Vol. I, p. 6, and of Reynolds, see Vol. I, p. 36.

In general, then, I would be understood to maintain that the beauty and grandeur so much admired in the Greek statues were not a voluntary fiction of the brain of the artist, but existed substantially in the forms from which they were copied, and by which the artist was surrounded. A striking authority in support of these observations, which has in some measure been lately discovered, is to be found in the *Elgin Marbles,* taken from the Acropolis at Athens, and supposed to be the works of the celebrated Phidias. The process of fastidious refinement and indefinite abstraction is certainly not visible there. The figures have all the ease, the simplicity, and variety, of individual nature. Even the details of the subordinate parts, the loose hanging folds in the skin, the veins under the belly or on the sides of the horses, more or less swelled as the animal is more or less in action, are given with scrupulous exactness. This is true nature and true art. In a word, these invaluable remains of antiquity are precisely like casts taken from life. The *ideal* is not the preference of that which exists only in the mind to that which exists in nature; but the preference of that which is fine in nature to that which is less so. There is nothing fine in art but what is taken almost immediately, and, as it were, in the mass, from what is finer in nature. Where there have been the finest models in nature, there have been the finest works of art.

As the Greek statues were copied from Greek forms, so Raphael's expressions were taken from Italian faces, and I have heard it remarked that the women in the streets of Rome seem to have walked out of his pictures in the Vatican.

Sir Joshua Reynolds constantly refers to Raphael as the highest example in modern times (at least with one exception) of the grand or ideal style; and yet he makes the essence of that style to consist in the embodying of an abstract or general idea, formed in the mind of the artist by rejecting the peculiarities of individuals, and retaining only what is common to the species. Nothing can be more inconsistent than the style of Raphael with this definition. In his Cartoons, and in his groups in the Vatican, there is hardly a face or figure which is any thing more than fine individual nature finely disposed and copied.

There is more an appearance of abstract grandeur of form in Michael Angelo. He has followed up, has enforced, and expanded, as it were, a preconceived idea, till he sometimes seems to tread on the verge of caricature. His forms, however, are not *middle,* but *extreme* forms, massy, gigantic, supernatural. They convey the idea of the greatest size in the figure, and in all the parts of the figure. Every muscle is swollen and turgid. This tendency to exaggeration would have been avoided if Michael Angelo had recurred more constantly to nature, and had proceeded less on a scientific knowledge of the structure of the human body;

for science gives only the positive form of the different parts, which the imagination may afterwards magnify as it pleases, but it is nature alone which combines them with perfect truth and delicacy, in all the varieties of motion and expression. It is fortunate that I can refer, in illustration of my doctrine, to the admirable fragment of the Theseus at Lord Elgin's, which shows the possibility of uniting the grand and natural style in the highest degree. The form of the limbs, as affected by pressure or action, and the general sway of the body, are preserved with the most consummate mastery. I should prefer this statue, as a model for forming the style of the student, to the Apollo, which strikes me as having something of a theatrical appearance; or to the Hercules, in which there is an ostentatious and overladen display of anatomy. This last figure, indeed, is so overloaded with sinews, that it has been suggested as a doubt, whether, if life could be put into it, it would be able to move.

[Reynolds] lays it down, as a general and invariable rule, that *"the great style in art, and the most* PERFECT IMITATION OF NATURE, *consists in avoiding the details and peculiarities of particular objects."* This sweeping principle he applies almost indiscriminately to *portrait, history,* and *landscape;* and he appears to have been led to the conclusion itself from supposing the imitation of particulars to be inconsistent with general rule and effect. It appears to me that the highest perfection of the art depends, not on separating, but on uniting general truth and effect with individual distinctness and accuracy. . . .

It might be shown, if there were room in this place, that Sir Joshua has constructed his theory of the *ideal* in art upon the same mistaken principle of the negation or abstraction of a *particular nature.* The *ideal* is not a negative, but a positive thing. The leaving out the details or peculiarities of an individual face does not make it one jot more ideal. To paint history is to paint nature as answering to a general, predominant, or pre-conceived idea in the mind, of strength, beauty, action, passion, thought, etc.; but the way to do this is not to leave out the details, but to incorporate the general idea with the details: that is, to show the same expression actuating and modifying every movement of the muscles, and the same character preserved consistently through every part of the body. Grandeur does not consist in omitting the parts, but in connecting all the parts into a whole, and in giving their combined and varied action; abstract truth, or ideal perfection does not consist in rejecting the peculiarities of form, but in rejecting all those which are not consistent with the character intended to be given, and in following up the same *general idea* of softness, voluptuousness, strength, activity, or any combination of these, through every ramification of the frame.

But these modifications of form or expression can only be learnt from nature, and therefore the perfection of art must always be sought in nature.

INDIVIDUALITY AND TRADITION

With the exception of purely naturalistic landscape painting, nearly all of the art produced in the decades of 1820–1850 derived, in style and theme, from the art of earlier periods. The greatest artists of the time, as well as numberless mediocrities, drew so heavily on traditional material that their work cannot be understood apart from the work of their models or guides. Claude was to Turner, Raphael to Ingres, Rubens to Delacroix far more than a brief stimulus or passing influence. Such dependence on tradition was not unprecedented in the history of art, but what distinguished the particular situation of 19th century art from that of earlier periods of eclecticism was the modern artist's claim to originality and individual freedom. How to reconcile the need for self-expression with the necessity of working within the range of established forms and subjects was a problem which every artist of the time had to face. Personal expression came to be regarded as the individual artist's particular choice, combination, and arrangement of suggestions from the vast repertory of tradition. This accounts for the stylistic disunity of the period which was a serious burden even to the strongest artists, and a fatal handicap to the weak.

Joseph Mallord William Turner (1775–1851)

That an artist of such powerful individuality as Turner should profess academic principles is reason for surprise. But there can be no doubt about Turner's ardent loyalty to the Royal Academy to which, as he said, "I owe everything; for I cannot look back but with pride and pleasure to that time, the halcyon perhaps of my days, when I received instruction within these walls." *After his appointment as Professor of Perspective in 1807, it fell to his lot to present the annual short course in his subject, speaking from the same platform from which he had heard Sir Joshua Reynolds deliver his last presidential* Discourse *in 1790. By all accounts, Turner was a boring and confused lecturer. It was his custom to treat of perspective in a series of five lectures, to which he added, in 1811, a sixth dealing with* "Backgrounds, Introductions of Architecture and Landscape." *In making this addition (which he dropped from the course in 1816 or 1818), he may have hoped that it might persuade the Academy to establish for him a professorship in landscape painting. The main burden of the lecture on* Backgrounds *is the importance of landscape, not merely as an adjunct to history painting, but*

as an independent branch of the art. There are passages in the lecture in which Turner sheds his usual labored manner and speaks with eloquence and warmth of the great colorists of the Baroque, and of Titian and Claude whom he regarded as his ancestors.[51]

From *Backgrounds, Introductions of Architecture and Landscape* (1811)

. . . The highest honour that landscape has as yet, she received from the hands of Titian, which proves how highly he considered its value not only in employing its varieties of contrast, colour and dignity in most of his Historical Pictures; but the triumph even of Landscape may be safely said to exist in his divine picture of St. Peter Martyr. No thought of narrow subservience enters the Idea or appears in the arrangement of that truly great specimen of his powers and of art.

Amplitude, quantity and space appear in this picture given by the means of Trees opposed to a blue sky and deep sunk Horizon not more than one-sixth of the height of the picture, across which rush the knotted stems of trees with dark brown and yellow foliage, stretching far their leafy honours. And their heads [are] lost in the effulgence of the angels descending to crown the dying Martyr, whose looks are directed upwards, as likewise [are] the flowing garments of the companion endeavouring to escape. Its [the picture's] apparent immensity arises from the quantity of sky, the continual line of trees and last, tho' not least, the low sunk horizon to which the eye always supports itself equal. And therefore the figure as it were rushes out of the picture impelled forward upon you.

To Nicolas Poussin let me direct your observation. His love for the antique prompted his exertion and that love for the antique emanates through all his works. It clothes his figures, rears his buildings, disposes of his materials, arranges the whole of his picture and landscape and gives, whether from indifference or strength of his ground, a colour that often removes his works from truth.

To these proofs of his abilities of Historic grandeur and pastoral subjects we possess another truly sublime in the picture at Ashburnham House of Pyramus and Thisbe. . . . whether we look upon the dark, dark sky sparingly illumined at the right-hand corner by lightening there rushing behind the bending trees and at last awfully gleaming, her power [?] is reborn, its dying efforts upon some antique buildings on the left, while all beneath amid gloom scatter'd foliage and broken ground lies the dying figure of Pyramus. And in the depth and doubt of darkness all is lost but returning Thisbe.

[51] Turner's "Backgrounds" lecture was first published in its entirety by J. Ziff, " 'Backgrounds, Introductions of Architecture and Landscape,' a Lecture by J. M. W. Turner," *Journal of the Warburg and Courtauld Institutes,* 1963, XXVI, 133 ff.

From this effort of conception of contending elements let us con-
sider one where Nature struggles for existence and the last twisting to
the overwhelming waters of the Deluge, bearing along Earth's perishable
materials under one tone and the residue of Earthy matter is the impres-
sion of this famous picture. Richelieu is said to have declared that it
absorbed his mind from all worldly concerns and that he could remain
before it for hours as his only pleasure. This picture is now in the Louvre
and called the Deluge.

For its colour it is admirable. It is singularly impressive, awfully
appropriate, just fitted to every imaginative conjecture of such an event.
But [it is] deficient in every requisite of line, so ably display'd in his
other works, inconsistent in his introductions in the colouring of the
figures, for they are positively red, blue, and yellow, while the sick and
wan sun is not allow'd to shed one ray but tears.

Pure as Italian air, calm, beautiful and serene springs forward the
works and with them the name of Claude Lorrain. The golden orient or
the amber-coloured ether, the midday ethereal vault and fleecy skies,
resplendent valleys, campagnas rich with all the cheerful blush of fer-
tilization, trees possessing every hue and tone of summer's evident heat,
rich, harmonious, true and clear, replete with all the aerial qualities of
distance, aerial lights, aerial colour, where through all these comprehen-
sive qualities and powers can we find a clue towards his mode of practice?
As beauty is not beauty until defin'd or science science until reveal'd,
we must consider how he could have attained such powers but by con-
tinual study of parts of nature. Parts, for, had he not so studied, we
should have found him sooner pleased with simple subjects of nature,
and [would] not [have], as we now have, pictures made up of bits, but
pictures of bits. Thus may be traced his mode of composition, namely,
all he could bring in that appear'd beautifully dispos'd to suit either the
side scene or the large trees in the centre kind of composition. Thus his
buildings, though strictly classical and truly drawn from the Campo
Vaccino and Tivoli, are so disposed of as to carry with them the air
of composition.

But in no country as in England can the merits of Claude be so
justly appreciated, for the choicest of his work are with us, and may
they always remain with us in this country. The walls of the Louvre
can only boast of two by name, which two may with more propriety be
called Swanevelt, the plodding tho' not the mean or humble imitator or
élève, whose best works have in other countries besides France been
honour'd, if honour it can be call'd in depriving him of his just need of
merit in calling them Claudes, a compliment that steals from him a good
name and leaves him poor indeed.

The Flemish school approaches to individual nature, and only two,

Rembrandt and Rubens, ever dared to raise her above commonality. Rembrandt depended upon his chiaroscuro, his bursts of light and darkness to be *felt*. He threw a mysterious doubt over the meanest piece of Common; nay more, his forms, if they can be called so, are the most objectionable that could be chosen, namely, the Three Trees and the Mill, but over each he has thrown that veil of matchless colour, that lucid interval of Morning dawn and dewy light on which the Eye dwells so completely enthrall'd, and it seeks not for its liberty, but as it were, thinks it a sacrilege to pierce the mystic shell of colour in search of form.

No painter knew so well the extent of his own powers and his own weakness. Conscious of the power as well as the necessity of shade, he took the utmost boundaries of darkness and allow'd but one-third of light, which light dazzles the eye thrown upon some favourite point, but where his judgment kept pace always with his choice surrounded with impenetrable shade still remains.

Rubens, Master of every power of handicraft and mechanical excellence, from the lily of the field to animated nature, disdained to hide, but threw around his tints like a bunch of flowers. Such is the impression excited in his Fête in the Louvre, wholly without shadow compar'd to Rembrandt's mode, obtaining everything by primitive colour, form and execution, and so abundantly supplied by the versatility of his genius with forms and lines, could not be happy with the bare simplicity of pastoral scenery or the immutable laws of nature's light and shade, feeling no compunction in making the sun and full moon as in the celebrated picture of the Landscape with the Waggon, or introducing the luminary in the Tournament, while all the figures in the foreground are lighted in different directions. These trifles about light are so perhaps in Historical compositions, but in Landscape they are inadmissible and become absurdities destroying the simplicity, the truth, the beauty of pastoral nature in whose pursuit he always appears lavish of his powers. Full of colour, the rapidity of his pencil bears down all before it in multitudes of forms, not the wild incursions full of Grandeur as Salvator Rosa, but [the] swampy vernality of the Low Countries.

Without affecting to do anything, Teniers has given us that individuality, which the great genius of Rubens in his Flemish Fête and pastorals always seem'd in search of. Artfully arrang'd and exquisitely touched tho' looking careless, bearing a freshness and silvery tone pervading everywhere thro' all the diversity of colours, tho' scatter'd upon the innumerable figures of the Flemish Marriage Feast at Louther Castle, yet all the tones tend by his consummate management, concentrated, to one figure in white and grey which binds the whole together.

Cuyp, Paul Potter and Adrian van der Velde sought for simplicity below commonality which too often regulated their choice and alas their

introductions, yet for colour and minuteness of touch of every weed and briar long bore away the palm of labour and execution. But Cuyp to a judgment so truly qualified knew where to blend minutiae in all the golden colour of ambient vapour.

Gainsborough, our countryman, rais'd their beauties by avoiding their defects, the mean vulgarisms of common low life and disgusting incidents of common nature. His first efforts were in imitation of Hobbema, but English nature supplied him with better materials of study. The pure and artless innocence of the Cottage Door now in the possession of Sir John Leicester may be esteemed as possessing this class, as possessing truth of forms arising from his close contact with nature, expression, full-toned depth of colours and a freedom of touch characteristically varied with the peculiarities of the vigorous foliage or of decaying nature.

Turner on Varnishing Day

In 1835, Turner exhibited the first version of his Burning of the House of Parliament *at the galleries of the British Institution in London. One of his fellow exhibitors, E. V. Rippingille (1798–1859), has left a description of Turner finishing his picture in the exhibition gallery:* [52]

He was there and at work before I came, having set to at the earliest hour allowed. Indeed it was quite necessary to make the best of his time, as the picture when sent in was a mere dab of several colours, and "without form and void," like chaos before the creation. The managers knew that a picture would be sent there, and would not have hesitated, knowing to whom it belonged, to have received and hung up a bare canvas, than which this was but little better. Such a magician, performing his incantations in public, was an object of interest and attraction. Etty was working at his side [on his picture "The Lute Player"] and every now and then a word and a quiet laugh emanated and passed between the two great painters. Little Etty stepped back every now and then to look at the effect of his picture, lolling his head on one side and half closing his eyes, and sometimes speaking to some one near him, after the approved manner of painters: but not so Turner; for the three hours I was there—and I understood it had been the same since he began in the morning—he never ceased to work, or even once looked or turned from the wall on which his picture hung. All lookers-on were amused by the figure Turner exhibited in himself, and the process he was pursuing with his picture. A small box of colours, a few very small brushes, and a

[52] A. J. Finberg, *The Life of J. M. W. Turner,* Oxford, Clarendon Press, 1961, p. 351.

vial or two, were at his feet, very inconveniently placed; but his short figure, stooping, enabled him to reach what he wanted very readily. Leaning forward and sideways over to the right, the left hand metal button of his blue coat rose six inches higher than the right, and his head buried in his shoulders and held down, presented an aspect curious to all beholders, who whispered their remarks to each other, and quietly laughed to themselves. In one part of the mysterious proceedings Turner, who worked almost entirely with his palette knife, was observed to be rolling and spreading a lump of half-transparent stuff over his picture, the size of a finger in length and thickness. As Callcott was looking on I ventured to say to him, "What is that he is plastering his picture with?" to which inquiry it was replied, "I should be sorry to be the man to ask him." . . .

Presently the work was finished: Turner gathered his tools together, put them into and shut up the box, and then, with his face still turned to the wall, and at the same distance from it, went sideling off, without speaking a word to anybody, and when he came to the staircase, in the centre of the room, hurried down as fast as he could. All looked with a half-wondering smile, and Maclise, who stood near, remarked, "There, that's masterly, he does not stop to look at his work; he *knows* it is done, and he is off."

Theodore Géricault (1791–1824)

From Géricault's early years, about 1810–1815, a schedule of exercises and good intentions survives which gives an insight into his private studies and state of mind: [53]

Draw and paint after the great masters of antiquity.
Read and compose.—Anatomy.—Antiquities.—Music.—Italian.
Take the courses in ancient art, Tuesdays and Saturdays, at two o'clock.
December.—Paint a figure at Dorcy's.—In the evenings, draw after the antique and compose a few subjects.—Occupy yourself with music.
January.—Go to M. Guérin to paint from life.
February.—Occupy yourself solely with the style of the masters and compose, without going out, and always alone.

Though he wrote little and was not at all inclined to theoretical speculation, Géricault left behind a manuscript fragment of observations on the state of painting in France. It is probable that these pages, which

[53] Charles Clément, *Géricault, étude biographique et critique,* Paris, 1868, p. 29.

Géricault evidently intended to develop into a publishable essay or pamphlet, were written during the long months of his fatal illness, in 1822–1824. The diatribe against academic training and the praise of genius which form a major part of the preserved fragment strike a familiar note. But they are more than a rehearsal of notions widely current since the 18th century (see Vol. I, p. 71); they reflect personal experience. Géricault's formal training was irregular and brief, but he had sampled the conditions which he describes. For somewhat less than two years, during 1810–1812, he had taken instruction from Pierre Guérin, one of the luminaries of the French school whom he mentions in his essay. Later, in 1816, he had competed unsuccessfully for the academic Rome Prize. But he was essentially a self-taught artist, as were nearly all the best painters of his generation, and in the enthusiasm with which he speaks of the irrepressible self-realization of genius there is a tinge of personal pride.[54]

Academy and Genius

The government has established schools of art which it maintains at great expense and which admit all young people. These schools keep their students in a state of constant emulation by means of frequent competitions, and it would seem, at first sight, as if they were extremely useful institutions, the surest devices for the encouragement of the arts. Neither at Athens nor at Rome did citizens possess better facilities for the study of the sciences and the arts than are offered in France by our numerous schools of all kinds. But I observe with regret that, from the time of their establishment, these schools have had a quite unforeseen effect: instead of giving service, they have done real harm, for while they have produced a thousand mediocre talents, they cannot claim to have formed the best of our painters. These, on the contrary, were among the founders of the schools, or at least were the first to spread the principles of taste.

David, the first among our artists, the regenerator of the French school, owes only to his own genius the successes which have attracted to him the attention of the world. He has borrowed nothing from the schools. On the contrary, they would have been his undoing, if his taste had not shielded him at an early date from their influence, and enabled him to become the radical reformer of the absurd and monstrous system of Van Loo, Boucher, Restout, and the many other painters who in those days were powerful in an art which they only profaned. Italy and the study of the great masters inspired in him the grand style which he has always given to his historical compositions; he became the model and

[54] Charles Clément, *op. cit.*, pp. 242 ff.

leader of a new school. His principles soon stimulated the development of new talent which had only been waiting to be fertilized, and several celebrated names soon proclaimed the glory and shared the laurel of their master.

After this first surge, this impetus toward a pure and noble style, enthusiasm was bound to wane, though the excellent lesson already learned was not altogether lost, and the government's efforts tended to prolong the favorable momentum as long as possible. But the sacred fire which alone can produce great things grows every day more dim, and the exhibitions, though numerous—all too numerous—become less interesting every year. We no longer find in them those noble talents which once excited general enthusiasm and to which the public—ever ready to appreciate the beautiful and grand—so eagerly paid its respect. No worthy rivals have yet arisen to confront Gros, Gerard, Guérin and Girodet, and it is to be feared that though these masters are charged with the education of a young and ardently competitive generation, they will take with them, at the end of their long and honorable careers, the regret of not having produced worthy successors. It would be unjust, however, to accuse them of having failed to give all possible care to their pupils. Where, then, lies the blame for this aridity, this want, despite all the medals, Rome Prizes and Academy competitions? I have always believed that a good education must be the necessary basis for the exercise of any profession, and that it alone can give us true distinction in whatever career we may choose. It serves to mature our mind, it enlightens us, and shows us the goal toward which we must strive. We cannot choose a profession without having weighed its advantages and drawbacks. Except in a few, precocious temperaments, our inclinations seldom become definite before the age of sixteen: it is only then that we begin to know what we really want to do and gain the ability to study for the profession which we have chosen because it suited our convenience or because we felt passionately attracted to it. For this reason, I should want the Academy to accept only those who have at least reached the age of sixteen. It should not be the purpose of this institution to create a race of painters, rather, it ought simply to provide true genius with the means for self-development. But, instead, we seem to be raising an entire population of artists. The lure of the Rome Prize and the facilities of the Academy have attracted a crowd of competitors whom the love of art alone would never have made painters, but who might have gained honor in other professions. Thus they waste their youth and time in the pursuit of a success which is bound to elude them, while they could have been more usefully employed on their own or on their country's behalf.

The man of true avocation does not fear obstacles, because he feels

in himself the strength to overcome them. Often they are an additional stimulus to him. The fever which they excite in his soul is not lost, it may enable him to do astounding work.

It is toward men of this kind that the solicitude of enlightened governments should be directed; it is by encouraging, by appreciating, and by using their abilities that we can assure the nation's glory; it is men such as these who will make memorable the century which has discovered them and called them to their task.

But even assuming that all the young people admitted to the schools were gifted with all the qualities which make a painter, is it not dangerous for them to study together for years, subjected to the same influences, copying the same models, and following the same route? How can we expect them to retain any kind of originality? Will they not unconsciously submerge whatever individual qualities they may possess, adapting their own ways of conceiving nature's beauty to one uniformity of sentiment?

The traces of individuality which survive this sort of merging are imperceptible. Thus we come with real disgust upon ten or twelve compositions every year which are of approximately identical execution, are painted from one end to the other with maddening perfection, and contain no originality whatever. Since every one of these competitors has for years denied his own sensations, none has preserved his individuality. A single way of drawing, one kind of color, and arrangements which all conform to one system, down to particulars of gesture and facial expression: everything in these sad productions of our school seems to have sprung from the same source and been inspired by the same soul, assuming that a soul could have perserved its faculties in the midst of such depravity and influenced a work of this kind.

I shall even go further and assert that obstacles and difficulties which repel mediocre men are a necessity and nourishment to genius. They mature and elevate it, when in an easier road it would have remained cold. Everything which opposes the irresistible advance of genius irritates it, and gives it that fevered exaltation which conquers and dominates all, and which produces masterworks. Such are the men who are their nation's glory. External circumstance, poverty, or persecution will not slow their flight. Theirs is like the fire of a volcano which must absolutely burst into the open, because its nature absolutely compels it to shine, to illuminate, to astonish the world. Do you hope to produce men of this race? The Academy, unfortunately, does more than that: it extinguishes those who, to begin with, had a spark of the sacred fire; it stifles them by keeping nature from developing their faculties at its own speed. By fostering precocity, it spoils the fruit which would have been made delicious by a slower maturation.

Géricault at Work on the Raft of the Medusa

The painter Antoine Alphonse Montfort (1802–1884), a pupil of Gros and Horace Vernet, was among the young artists who befriended Géricault when he was painting the Raft of the Medusa, *during the winter of 1818–1819.*[55]

Fortunate enough to have been admitted to Géricault's studio in order to copy a few sketches, at the time when he was executing his picture, I was impressed, first of all, by the intensity with which he worked, and also by the quiet and reflection which he needed. He generally started work as soon as there was enough light and continued without interruption until nightfall. He was often forced to do this by the size of the part which he had begun in the morning and which he had to finish on the same day. This was particularly necessary for him because of his use of a fatty, fast-drying oil which made it impossible for him to continue on the morrow what he had begun the previous day. . . . I was very vividly impressed by the care with which Géricault worked. Being still quite young (I was only seventeen years old), I found it hard to remain still for several hours in succession, without getting up and quite unintentionally making a little noise with my chair. In the midst of the absolute silence which reigned in the studio, I felt that this small noise must have disturbed Géricault. I turned my eyes toward the table on which he stood to reach the height of his figures, working without uttering a word. He would give me a slightly reproachful smile and assure me that the sound of a mouse was enough to keep him from painting.

His manner of working was quite new to me, and surprised me no less than his profound concentration. He painted directly on the white canvas, without a rough sketch or preparation of any sort, except for a firmly traced contour, and yet the solidity of the work was none the worse for it. I noted also with what intense attention he examined the model before touching the brush to the canvas, seeming to advance slowly, when in reality he executed very rapidly, putting one touch after the other in its place, rarely having to go over his work twice. No movement was visible in his body or arms. His expression was perfectly calm; only his slightly flushed face betrayed his mental concentration. Witnessing this external calm, one was all the more surprised by the verve and energy

[55] Charles Clément, *op. cit.,* pp. 138 ff.

of his execution. What salience! Especially in their half-finished state, the various parts of the picture had the look of roughly blocked-out sculpture. Seeing the breadth of this manner, one might have supposed that Géricault used very thick brushes, but this was not at all the case. His brushes were small, compared to those used by various other artists of my acquaintance. This can easily be verified by an examination of several figures in the picture which are entirely executed in hatchings.

When evening came, Géricault laid aside his palette and took advantage of the last rays of daylight to examine his work. It was then that, seated by the stove and his eyes turned toward the canvas, he spoke to me of his hopes and disappointments. Usually he was very little satisfied, but on some days he believed that he had found a way of modeling, i.e., of giving proper relief to his figures, and seemed content. The following day, after a day of work equally well-spent as the previous one, he would confess to us that he was not on the right track and must make fresh efforts. One day, he had gone to see [David's] *Sabines* and *Leonidas*. He returned discouraged. His own work seemed "round" [*rond*] to him, and speaking of the figures of the young warriors, at the right of *Leonidas,* who are shown rushing forward to get their shields, he said to me: "Ah, well! Those are wonderful figures!"—and averted his eyes from his picture.

Eugène Delacroix (1798–1863)

In the entire literature of modern art, Delacroix' Journals and Letters occupy a special place as the most extensive, continuous, and profound record of a great artist's thought. They constitute a human document of the highest significance, which reveals incomparably more about art, the artist, and his period than any merely historical or philosophical account.

Delacroix' activity spanned the interval of forty years between the last works of David and the earliest of Cézanne. When he began, neoclassicism was already moribund, although its lifeless productions still cluttered the Salons. History painting, conventionally regarded as the noblest branch of art, languished for lack of a vital style and of significant themes. The future seemed to lie with the pseudo-romantics, the specialists in sentimental anecdotes, picturesque vignettes, and exotic trifles. Artists lacked a pictorial form in which to express modern experience. David, Gros, and Géricault had experimented with devices borrowed from the Baroque, and particularly from Rubens. Delacroix actually restored the link with tradition. He was the last great European painter to use the repertory of humanistic art with conviction and originality. In his

hands, antique myth and medieval history, the barricade and Golgotha, Faust and Hamlet, Scott and Byron, royal tiger and Odalisque yielded images of equal power. As he grew older, he felt increasingly drawn to the great Venetians and Flemings, to Veronese and Rubens above all. His preoccupation with them was not a retreat into the past, but an acknowledgment that his direction continued the line of a long tradition. He considered himself not as an imitator, but as the legitimate heir of Rubens.

Delacroix' writings reveal a thorough acquaintance with the theoretical literature of art. But his own work was not guided by a systematic theory, and his practical debt to the theoreticians was small. His speculation tended to be afterthought, rather than program. Late in his life, he formed the plan of gathering some scattered notes into an alphabetic Dictionary of Art. He abandoned this project, but its form is revealing. His observations and opinions owe their consistency to the particular quality of his mind, not to any coherent doctrine, least of all a doctrine of Romantic art. Romanticism, throughout most of his mature life, was a late and feeble strain with which Delacroix, understandably enough, disliked to be associated. After the deaths of Géricault and Bonington, the romantic movement in France numbered only one painter of consequence—Delacroix himself. His fellow veterans of the "romantic battle," the Devérias, the Scheffers, Schnetz, Lami, Nanteuil and Boulanger, had declined to insignificance by 1835. Delacroix outgrew this affiliation and continued on his personal way. Living in an age of rapid urbanization and industrialization, among men who believed in progress and regarded him as a rebel, he was a pessimist, suspicious of railways and revolutions, a conservative in his habits and an aristocrat in his tastes. He suffered the strange fate of being both misunderstood and celebrated. He felt alienated from the spirit of his time, and yet represented it more fully than any other artist. Outwardly, he resembled the stereotype of the romantic egoist, but he had a strong sense of cultural responsibility, and his work, while private in some aspects, was grandly monumental and didactic in others. His interests were eclectic in the extreme. In matters of religion and philosophy, he sympathized with the rational scepticism of the Enlightenment. His reading included Virgil, Dante, Shakespeare, Racine, and Voltaire. His knowledge of past art was extensive; he wrote articles on Raphael, Michelangelo, Poussin, and Puget among the older artists, on Prud'hon, Gros, and Charlet among the moderns.

His entire life span is documented by a vast correspondence which began in his childhood and extended to his last days. The preserved Journals *only cover the years of 1822–1824 and 1847–1863. In addition to these private writings, Delacroix produced 14 published articles be-*

tween 1829 and 1862. The following excerpts are taken from the Journals *and the* Letters.[56]

On Life and Work

SATURDAY, 27 MARCH [1824]

Went early to the studio. Lopez. Pierret came in. Dined with him; read Horace. Longing for poetry but not because of Horace. Allegories. Meditations. Strange condition of man! Inexhaustible subject. Create, create!

WEDNESDAY, 31 MARCH [1824]

I must not eat much in the evening, and I must work alone. I think that going into society from time to time, or just going out and seeing people, does not do much harm to one's work and spiritual progress, in spite of what many so-called artists say to the contrary. Associating with people of that kind is far more dangerous; their conversation is always commonplace. I must go back to being alone. Moreover, I must try to live austerely, as Plato did. How can one keep one's enthusiasm concentrated on a subject when one is always at the mercy of other people and in constant need of their society? . . .

SUNDAY, 4 APRIL [1824]

Everything tells me that I need to live a more solitary life. The loveliest and most precious moments of my life are slipping away in amusements which, in truth, bring me nothing but boredom. The possibility, or the constant expectation, of being interrupted is already beginning to weaken what little strength I have left after wasting my time for hours the night before. When memory has nothing important to feed on, it pines and dies. My mind is continually occupied in useless scheming. Countless valuable ideas miscarry because there is no continuity in my thoughts. They burn me up and lay my mind to waste. The enemy is within my gates, in my very heart; I feel his hand everywhere. Think of

[56] The excerpts from Delacroix' diaries are taken from the translation by Lucy North, *The Journal of Eugène Delacroix*, edited by H. Wellington, London, Phaidon Press, Ltd., 1951, reprinted by permission of the publisher. The passages from Delacroix' letters written in Tangiers were translated from *Eugène Delacroix, Correspondance Générale*, edited by A. Joubin, Paris, Plon, 1936, I, 310 ff. The notes on color were translated from *Eugène Delacroix, sa vie et ses oeuvres*, edited by E. A. Piron, Paris, 1865, pp. 416 ff. For recent studies of Delacroix' theories of art, see C. Sieber-Meier, *Untersuchunges zum 'Oeuvre Litteraire' von Eugène Delacroix*, Bern, Francke Verlag, 1963, and George P. Mras, *Eugène Delacroix's Theory of Art*, Princeton, Princeton University Press, 1966.

the blessings that await you, not of the emptiness that drives you to seek constant distraction. Think of having peace of mind and a reliable memory, of the self-control that a well-ordered life will bring, of health not undermined by endless concessions to the passing excesses which other people's society entails, of uninterrupted work, and plenty of it.

MONDAY, 26 APRIL [1824]

All my days lead to the same conclusion; an infinite longing for something which I can never have, a void which I cannot fill, an intense desire to create by every means and to struggle as far as possible against the flight of time and the distractions that deaden my soul; then, almost always, there comes a kind of philosophical calm that resigns me to suffering and raises me above petty trifles. But here, perhaps, imagination is again leading me astray, for at the slightest mishap it is goodbye to philosophy. I wish I could identify my soul with that of another person.

TUESDAY, 27 APRIL [1824]

An interesting discussion at Leblond's about geniuses and outstanding men. Dimier thinks that great passions are the source of all genius! I think that it is imagination alone or, what amounts to the same thing, a delicacy of the senses that makes some men see where others are blind, or rather, makes them see in a different way. I said that even great passions joined to imagination usually lead to a disordered mind. Dufresne made a very true remark. He said that fundamentally, what made a man outstanding was his absolutely personal way of seeing things. He extended this to include great captains, etc., and, in fact, great minds of every kind. Hence, no rules whatsoever for the greatest minds; rules are only for people who merely have talent, which can be acquired. The proof is that genius cannot be transmitted.

FRIDAY, 7 MAY [1824]

. . . I confess that I have worked logically, I, who have no love for logical painting. I see now that my turbulent mind needs activity, that it must break out and try a hundred different ways before reaching the goal towards which I am always straining. There is an old leaven working in me, some black depth must be appeased. Unless I am writhing like a serpent in the coils of a pythoness I am cold.

YESTERDAY, 14 MAY [1824]

This morning, as I was reading the note on Lord Byron at the beginning of the book, I again felt the insatiable longing to create. Can I

be sure that this would bring me happiness? I believe, at any rate, that it would.

Loneliness is the torment of my soul. The more it expands among friends and in the habits and pleasures of my daily life, the more it seems to elude me and to retire into its inner fortress. A poet who lives in solitude and produces a great deal can enjoy to the full the treasures which we carry in our hearts, but which forsake us when we give ourselves to others. For when we surrender ourselves entirely to the soul it unfolds itself completely to us, and it is then that this capricious spirit grants us the greatest happiness of all, of which this note on Lord Byron speaks— I mean the joy of expressing the soul in a hundred different ways, of revealing it to others, of learning to know ourselves, and of continually displaying it in our works. This is something of which Lord Byron and Rousseau may perhaps have been unconscious. I am not speaking of mediocre people. But what is this urge not only to write, but to publish one's work? Besides the pleasure of being praised, there is the thought of communicating with other souls capable of understanding one's own, and thus of one's work becoming a meeting place for the souls of all men. For what is the use of the approval of one's friends? It is only natural that they should understand one, and therefore their praise is of no real consequence. Living in the minds of others is what is so intoxicating. I ask myself, why be so discouraged? You can add one more to the number of those who have seen nature in their own way. What they portrayed was made new through their vision and you will renew these things once more. When they painted they expressed their souls, and now yours is demanding its turn.

. . . The very people who believe that everything has already been discovered and everything said, will greet your work as something new, and will close the door behind you, repeating once more that nothing remains to be said. For just as a man in the weakness of his old age believes that nature, and not himself, is degenerating, so men with commonplace minds, who have nothing to add to what has been said already, believe that nature has given only to a few—and these at the beginning of time— the power to say new and striking things. . . . Newness is in the mind of the artist who creates, and not in the object he portrays.

. . . You who know that there is always something new, show it to others in the things they have hitherto failed to appreciate. Make them feel that they have never before heard the song of the nightingale, or been aware of the vastness of the sea—everything that their gross senses can perceive only when someone else takes the trouble to feel it for them. And do not let language trouble you. If you cultivate your soul it will find the means to express itself. It will invent a language of its own far better than the metre or the prose of this or that great writer. What! you

say you have an original mind, and yet your flame is only kindled by reading Byron or Dante! You mistake this fever for creative power when it is really only a desire to imitate. . . .

TUESDAY, 12 OCTOBER [1852]

. . . Why is it that nowadays I never know a moment's boredom when I have a brush in my hand, and feel that if only I had enough strength I should never stop painting, except to eat and sleep? I remember that in the past, at the age when an artist's enthusiasm and imaginative powers are supposed to be at their height, I lacked the experience to profit by these fine qualities and was halted at every step and often discouraged. Nature plays a bad joke on us when she places us in this situation as we begin to grow old. We become completely mature, our imagination is as fresh and active as ever, especially now that age has stilled the mad, impetuous passions of our youth, but we no longer have the same strength; our senses begin to wear out and are more in need of rest than activity. Yet, with all these drawbacks, what consolation we derive from work. I feel so thankful not to have to seek for happiness, as I used to understand the word. What tyranny this weakness of my body has delivered me from! Painting used to be the least of my preoccupations. Therefore we must do the best we can, and if nature refuses to allow us to work for more than a certain length of time we must not ill-treat her, but be thankful for what she still leaves us. We must be less eager in the pursuit of praises that are as empty as the wind, and enjoy work for its own sake, and for those delightful hours when we have the deep satisfaction of realizing that our rest has been earned by a healthy tiredness that keeps our souls in good repair. This in its turn affects the body and prevents the rust of the years from tarnishing the nobler sentiments.

SUNDAY, 20 DECEMBER [1857]

The studio is completely empty, who would ever believe it? Even now that it's all bare and deserted, I still love this place where I used to be surrounded by all kinds of pictures, many of which I enjoyed for their variety and all of them evoking some special memory or feeling. The studio seems twice as big. I still have about ten small pictures to finish and am enjoying the work very much. As soon as I get up, I hurry upstairs to the studio, hardly waiting to comb my hair, and I stay here until dark without one empty moment or desire for the distractions of paying visits, or other so-called entertainments. All my ambition is bounded by these walls. In these last moments I am enjoying the feeling of still being in this room which has known me for so many years, and where I spent so much of the last part of my late youth. I say this, because although I am

now an old man, my imagination and some other faculty (I don't quite know what to call it) still give me the thrills and longings and enthusiasms of the best years of my life. My faculties have never been slaves to uncontrollable ambition, and therefore I am not forced to sacrifice my enjoyment of them and of myself in a vain desire to be envied in some public position. What a futile bauble for a man to play with in his old age! A stupid thing to give his heart and mind to at a time when he should be withdrawing into his memories, or finding some healthy intellectual occupation to console him for all he is losing! He should try to fill his last hours in some other way than with those tedious public affairs over which the ambitious waste so much time merely for the sake of appearing for a few moments in the limelight. I cannot leave this humble place, these rooms, where for so many years I have been alternately melancholy and happy, without feeling deeply moved.

On Form and Composition

SATURDAY, 7 APRIL [1849]

Went with Chopin for his drive at about half-past three.

We talked of music and it seemed to cheer him. I asked him to explain what it is that gives the impression of logic in music. He made me understand the meaning of harmony and counterpoint; how in music, the fugue corresponds to pure logic, and that to be well versed in the fugue is to understand the elements of all reason and development in music. I thought how happy I should have been to study these things, the despair of commonplace musicians. It gave me some idea of the pleasure which true philosophers find in science. The fact of the matter is, that true science is not what we usually mean by that word—not, that is to say, a part of knowledge quite separate from art. No, science, as regarded and demonstrated by a man like Chopin, is art itself, but on the other hand, art is not what the vulgar believe it to be, a vague inspiration coming from nowhere, moving at random, and portraying merely the picturesque, external side of things. It is pure reason, embellished by genius, but following a set course and bound by higher laws.

THURSDAY, 19 MAY [1853]

While I was lunching I read Peisse's article, in which he reviews the Salon as a whole and inquires into the trend of modern art. He is quite right in seeing a tendency towards the *picturesque* which he considers to be a sign of inferiority. Yes, if it were only a question of arranging lines and colours to create a visual effect an arabesque would do as well, but when you add to a composition already interesting on account of its sub-

ject, an arrangement of lines that heightens the impression, a chiaroscuro that grips the imagination, and a colour scheme suited to the characters, you have solved a more difficult problem and, moreover, you are moving on a higher plane. Like a musician, you are adapting to a simple melody the wealth of harmony and its mutations. Peisse calls this tendency *musical,* and he uses the word in a derogatory sense; personally, I think it as praiseworthy as any other.

He has taken his theories about the arts from his friend Chenavard, who considers music an inferior art. Chenavard has the typically French mind which needs ideas that can be expressed in words; when it comes to ideas which language is incapable of describing, he banishes them from the realm of art. But even admitting that drawing is everything, it is clearly not merely a question of form, pure and simple. There may be either grace or vulgarity in this contour, which is all that he demands, and a line drawn by Raphael will have a different charm from one drawn by Chenavard. . . . What is intended for the eyes must be seen; what is intended for the ears must be heard. What has been written as a speech will have far more effect when it comes from the lips of an orator than when it is simply read. A great actor will transform a passage by his delivery. . . .

THURSDAY, 20 OCTOBER [1853]

The type of emotion peculiar to painting is, so to speak, tangible; poetry and music cannot give rise to it. In painting you enjoy the actual representation of objects as though you were really seeing them and at the same time you are warmed and carried away by the meaning which these images contain for the mind. The figures and objects in the picture, which to one part of your intelligence seem to be the actual things themselves, are like a solid bridge to support your imagination as it probes the deep, mysterious emotions, of which these forms are, so to speak, the hieroglyph, but a hieroglyph far more eloquent than any cold representation, the mere equivalent of a printed symbol. In this sense the art of painting is sublime if you compare it with the art of writing wherein the thought reaches the mind only by means of printed letters arranged in a given order. It is a far more complicated art, if you like, since the symbol is nothing and the thought appears to be everything, but it is a thousand times more expressive when you consider that independently of idea, the visible sign, the eloquent hieroglyph itself which has no value for the mind in the work of an author, becomes in the painter's hands a source of the most intense pleasure—that pleasure which we gain from seeing beauty, proportion, contrast, and harmony of colour in the things around us, in everything which our eyes love to contemplate in the outside world,

and which is the satisfaction of one of the profoundest needs of our nature.

Many people will think the art of writing superior to painting precisely because of this simpler means of expression. Such people have never taken pleasure in considering a hand, an arm, or a torso from the antique or by Puget; they appreciate sculpture even less than they do painting, and are strangely mistaken if they imagine that when they have written down the words *foot* or *hand* they have inspired me with an emotion comparable to what I feel when I see a beautiful foot or a beautiful hand. The arts are not algebra, where abbreviation of the figures contributes to the success of the problem. To be successful in the arts is not a matter of summarizing but of amplifying where it is possible, and of prolonging the sensation by every means.

What I have been saying about the *power of painting* now becomes clear. If it has to record but a single moment it is capable of concentrating the *effect* of that moment. The painter is far more master of what he wants to express than the poet or musician who are in the hands of interpreters; even though his memory may have a smaller range to work on, he produces an effect that is a perfect unity and one which is capable of giving complete satisfaction. . . .

On Color

SUNDAY, 15 JULY [1849]

This famous quality, the beautiful, which some see in a curved line and others in a straight, all are determined to see in line alone. But here am I, sitting at my window, looking at the most beautiful countryside imaginable and the idea of a line does not enter into my head. The larks are singing, the river is sparkling with a thousand diamonds, I can hear the rustle of the leaves, but where are any lines to produce such exquisite sensations? People refuse to see proportion and harmony unless they are enclosed by lines. For them, all the rest is chaos, and a pair of compasses the only arbiter.

WEDNESDAY, 5 MAY [1852]

A picture should be laid-in as if one were looking at the subject on a grey day, with no sunlight or clear-cut shadows. Fundamentally, lights and shadows do not exist. Every object presents a colour mass, having different reflections on all sides. Suppose a ray of sunshine should suddenly light up the objects in this open-air scene under grey light, you will then have what are called lights and shadows but they will be pure accidents. This, strange as it may appear, is a profound truth and contains

the whole meaning of colour in painting. How extraordinary that it should have been understood by so few of the great painters, even among those who are generally regarded as colourists!

SUNDAY, 4 FEBRUARY [1847]

Coming home in the omnibus, I watched the effects of half-tones on the horses' backs; that is to say on the shiny coats of the bays and blacks. They must be treated like the rest, as a mass, with a local colour lying half way between the sheen and the warm colouring. Over this preparation, a warm transparent glaze should be enough to show the change of plane for the parts in shadow, with reflected lights. Then, on the parts that project into this half-tone colour, the high lights can be marked with bright, cold tones. This was very remarkable in the bay horse.

SUNDAY, 3 NOVEMBER [1850]

During this same walk, Villot and I noticed some extraordinary effects. It was sunset; the *chrome* and *lake* tones were most brilliant on the side where it was light and the shadows were extraordinarily blue and cold. And in the same way, the shadows thrown by the trees, which were all yellow (*terre d'Italie, brownish red*) and directly lit by the sun's rays, stood out against part of the grey clouds which were verging on blue. It would seem that the warmer the lighter tones, the more nature exaggerates the contrasting grey, for example, the half-tints in Arabs and people with bronzed complexions. What made this effect appear so vivid in the landscape was precisely this law of contrast.

I noticed the same phenomenon at sunset, yesterday evening (13 November), it is more brilliant and striking than at midday, only because the contrasts are sharper. The grey of the clouds in the evening verges on *blue;* the clear parts of the sky are bright *yellow* or orange. The general rule is, *the greater the contrast, the more brilliant the effect.*

25 AUGUST [1854]

During my walk this morning I spent a long time studying the sea. The sun was behind me and thus the face of the waves as they lifted towards me was yellow; the side turned towards the horizon reflected the colour of the sky. Cloud shadows passing over all this made delightful effects; in the distance where the sea was blue and green, the shadows appeared purple, and a golden and purple tone extended over the nearer part as well, where the shadow covered it. The waves were like agate. In the places in shadow you get the same relationship of yellow waves, looking towards the sun, and of blue and metallic patches reflecting the sky.

Of Color Shadow and Reflections

(From scattered notes, probably written in Dieppe in 1854)

The law which governs the greenness of reflections, of shadow edges, or cast shadows, which I discovered previously as applying to linen, applies to everything, since the three [primary] colors in combination are found everywhere. I used to think that they were only in certain objects.

. . . As a plane is composed of little planes, a wave of little waves, so the daylight is modified or decomposed on objects. The law of [color] decomposition which is most apparent, and which first struck me as being the most general, is evident in the sparkle of objects. It was in such things as a breast plate or a diamond that I most clearly noticed the presence of the three united colors. Then there are objects such as cloth, linen, certain aspects of landscape, particularly the sea, in which this effect is very marked. And it did not take me long to observe that it is strikingly present in flesh. I finally became convinced that nothing exists without these three colors. When I find that linen has a violet shadow and green reflections, does that mean, in fact, that it presents only these two colors? Does it not also contain orange by necessity, since there is yellow in the green and red in the violet? . . .

I observe a wall of very red brick in the little corner street. The part lit by the sun is orange red, the shadow very violet, reddish brown, Cassel brown and white.

In rendering flesh, one must paint the simple shadows somewhat violet, and the reflections with somewhat greenish colors. . . .

The true, or least decomposed, flesh color is that which lies next to the high lights, just as in silks, the coats of horses, etc. . . .

I discovered one day that linen always has green reflections and violet shadows.

I perceive that it is the same with the sea, with only this difference that the reflection is very much modified by the great influence of the sky; as for the cast shadows, they are quite evidently violet.

It is probable that I shall find that this law applies to everything. Shadows cast on the ground by anything whatever are violet. . . .

I see from my window the shadows of people walking in the sunlight on the sand of the harbor. The sand of that terrain is in itself violet, but it appears gilded over by the sun. The shadows of these people are so violet that they make the ground appear yellow.

Would it be too bold to say that in the open air, especially under conditions such as I am now observing, reflections ought to be produced by the soil, gilded by the sun, and hence yellow, and by the sky which is blue, and that these two colors between them should necessarily produce a green tone? In the sunlight, these various effects can be observed in their most obvious, almost crude, manifestation; but when they vanish, the color relationships ought to remain the same. If the terrain appears less golden, because the sun is gone, the reflections will appear less green, less lively in short.

I have all my life painted linen with rather true color. I discovered one day, aided by a very clear instance, that shadows are violet and reflections green.

These are observations of which a scientist might well be proud; I am all the more proud of having painted pictures of a good color before I became aware of these laws.

African Impressions

(Letter to J. B. Pierret, from Tangier, 8 February 1832)

. . . My health is good, I only fear a little for my eyes. Although the sun still is not very strong, the bright reflection of the houses, all painted white, tires me excessively. I gradually assume the manners of the country, so as to be able to draw some of these Moors at my ease. They have strong prejudices against the fine art of painting, but a bit of money here and there overcomes their scruples. I take rides around the countryside which give me great pleasure and have enjoyed delicious moments of loafing in a garden at the city gate, beneath a profusion of orange trees in full bloom and covered with fruit. In the midst of this vigorous nature I have sensations which remind me of my childhood. It may be that the dim memory of the southern sun, experienced in earliest youth, is reawakening in me. The work which I am able to do here is nothing compared to what could be done. Sometimes my arms drop with fatigue, and I feel sure that I'll bring home no more than a shadow of all this.

I don't remember whether I told you in my last letter about my reception by the Pasha, three days after our reception at the harbor; perhaps it would only bore you. I also don't think that I wrote to you about a ride we took in the environs of the city, together with the English consul who has a passion for mounting the most difficult horses of this region— which is saying a lot, for even the tamest of these horses are devils. Two of them started a fight, and I witnessed the most ferocious battle you can imagine: the inventions of Gros and Rubens pale beside such

fury. After biting one another in all kinds of ways, climbing on each other, and walking on their hind legs like men, having first thrown their riders, they dashed into a small river in which they continued their combat with incredible fury. It took a devilish effort to pull them out.

(Letter to Fr. Villot, from Tangier, 29 February 1832)

. . . This is a place for painters. Economists and Saint-Simonists would find much to criticize here, from the point of view of the rights of man and equality before the law, but beauty abounds. Not, to be sure, the overpraised beauty of fashionable painting. The heroes of David and his ilk would cut a sad figure, with their rose-tinted limbs, next to these children of the sun. And I am convinced, besides, that the antique costume is better worn here. If some day you can spare a few months, come to the Barbary Coast. Here you will see a nature which in our country is always disguised, here you will feel the rare and precious influence of the sun which gives an intense life to everything. I shall, no doubt, bring home many drawings, but they cannot convey the full impression which this gives.

(Letter to J. B. Pierret, from Tangier, 29 February 1832)

. . . I use a part of my time for work, and another, large part simply for living. The idea of my reputation and of that Salon which I shall miss, as they tell me, never occurs to me. I even feel sure that the many interesting observations which I shall bring away from here will be only of limited use to me. Far from the country where I found them, they will be like trees uprooted from their native soil. I fear that I shall forget these impressions, yet I don't want to make a cold and imperfect record of the living, stirring sublimity which is to be encountered here in every street, and which assaults me with its reality. Imagine, my friend, what it means to see, lying in the sun, walking the streets, adjusting their sandals, Catos and Brutuses, men of Consular bearing, who even have that disdainful air which the masters of the world must have worn. . . . These people own nothing but a coverlet in which they walk, sleep, and are buried, and yet they seem to be as satisfied with this as Cicero must have been with his magistrate's chair. I assure you that you will never be able to judge these impressions by what I shall bring back, because my work will fall far short of the truth and nobility of this nature. Antiquity had nothing more beautiful. Yesterday, a peasant went by, done up like this [drawing]. Here is the getup of a Moor, day before yesterday, to whom we gave twenty *sous*. All of them in white, like Roman senators or the Athenian people in the Panathenaic procession. . . .

On Nature

19 JANUARY [1847]

The Natural History Museum is open to the public on Tuesdays and Fridays. Elephant, rhinoceros, hippopotamus; extraordinary animals! Rubens rendered them marvellously. I had a feeling of happiness as soon as I entered the place and the further I went the stronger it grew. I felt my whole being rise above commonplaces and trivialities and the petty worries of my daily life. What an immense variety of animals and species of different shapes and functions! And at every turn I saw what we call deformity side by side with what seems to us to be beauty and grace of form. Here were the flocks of Neptune, the seals and walruses and the huge fish with their cold eyes and foolish, open mouths; the crustacea and sea-spiders, and the turtles. Next, the loathsome family of serpents, the boa-constrictor with its tiny head and its enormous body coiled elegantly round a tree; the hideous dragon, the lizards, crocodiles and alligators, and the monstrous gavial whose jaws taper sharply and end in a curious protuberance at the nose. Then the animals nearer to our own natural scene, the countless stags, gazelle, elks, buck, goats, sheep, with cloven hoofs, antlered heads, straight horns, and horns that are twisted or coiled; the different kinds of cattle, wild oxen and bison; the camels and dromedaries, the llamas, and the vicuñas which so closely resemble them. And finally the giraffe; Levaillant's specimens are here, all patched up and pieced together; and the famous animal of 1827 himself, who was the admiration of all beholders during his lifetime and gave pleasure to thousands of idlers. He has now paid his debt to nature with a death as obscure as his entrance into the world was glorious. Here he is, at all events, as stiff and clumsy as nature made him. . . .

Tigers, panthers, jaguars, lions, etc.

Why is it that these things have stirred me so much? Can it be because I have gone outside the everyday thoughts that are my world; away from the street that is my entire universe? How necessary it is to give oneself a shake from time to time; to stick one's head out of doors and try to read from the book of life that has nothing in common with cities and the works of man.

5 AUGUST [1854]

Nature is amazingly logical. When I was in Trouville I made a drawing of some fragments of rock the irregularities of which were so

proportioned as to give the impression of a huge cliff when I had set them down on paper; it only needed some suitable object to establish the scale of size. At this very moment, I am writing beside a large ant-hill formed at the foot of a tree, partly with the help of irregularities in the ground, and partly by the patient labour of the ants. Here are gentle slopes and projections overhanging miniature gorges, through which the inhabitants hurry to and fro, as intent upon their business as the minute population of some tiny country which one's imagination can enlarge in an instant. If it is only a mole-hill that I am looking at, I can see if I choose, thanks to the miniature scale of the inhabitants, a vast stretch of country broken up with precipitous crags and steep inclines. A lump of coal or a piece of flint may show in rednced proportions the forms of enormous masses of rock. . . .

When I have been drawing trees, I have often noticed that each separate branch is a miniature tree in itself; in order to see it as such one would only need the leaves to be in proportion.

17 OCTOBER [1853]

Jean-Jacques [Rousseau] was right when he said that the joys of liberty are best described from a prison cell, and that the way to paint a fine landscape is to live in a stuffy town where one's only glimpse of the sky is through an attic window above the chimney-pots. When a landscape is in front of my eyes and I am surrounded by trees and pleasant places my own landscape becomes heavy—too much worked; possibly truer in details, but out of harmony with the subject. When Courbet painted the background of the woman bathing, he copied it faithfully from a study which I saw hanging near his easel. Nothing could be colder; it is like a piece of mosaic. I began to make something tolerable of my African journey only when I had forgotten the trivial details and remembered nothing but the striking and poetic side of the subject. Up to that time, I had been haunted by this passion for accuracy that most people mistake for truth.

On Reality and the Imagination

FRIDAY, 15 APRIL [1853]

To the exhibition of paintings by Courbet. I was amazed at the strength and relief of his principal picture—but what a picture! what a subject to choose! The vulgarity of the forms would not signify, the vulgarity and futility of the idea is what is so abominable, and even that might pass if only the idea (such as it is) had been made clear! But what are the two figures supposed to mean? A fat woman, backview, and

completely naked except for a carelessly painted rag over the lower part
of the buttocks, is stepping out of a little puddle scarcely deep enough
for a foot-bath. She is making some meaningless gesture, and another
woman, presumably her maid, is sitting on the ground taking off her
shoes and stockings. You see the stockings; one of them, I think, is only
half-removed. There seems to be some exchange of thought between the
two figures, but it is quite unintelligible. The landscape is extraordinarily
vigorous, but Courbet has merely enlarged a study that can be seen near
his picture; it seems evident that the figures were put in afterwards, with-
out any connexion with their surroundings. . . .

O Rossini! O Mozart! O inspired genius in every art, you who draw
from things only so much as you need to reveal them to our minds! What
would you say before such pictures? O Semiramis! O entry of the priests
to crown Ninias!

SATURDAY, 21 MAY [1853]

After dinner they looked at the photographs which Durieu has
been kind enough to send me. I persuaded them to try an experiment
that I made quite by chance a couple of days ago. After examining the
photographs of nude models, some of whom were poor physical speci-
mens, with parts of the body over-developed—not very beautiful to look
at—I showed them some engravings by Marcantonio. We felt repelled,
indeed almost disgusted, by the inaccuracy, mannerism, and lack of
naturalness, in spite of the excellence of the style. It is his only admirable
quality, but we were incapable of admiring it at that particular moment.
As a matter of fact, if some genius were to use daguerreotype as it should
be used he could reach untold heights. Above all, when you look at these
engravings, the admitted masterpieces of the Italian School that have
exhausted the admiration of every painter, you realize the truth of
Poussin's remark that "compared with the Antique, Raphael was an ass."
Up to the present, this machine-made art has done us nothing but harm:
it spoils the masterpieces for us, without being able to satisfy us com-
pletely.

WEDNESDAY, 12 OCTOBER [1853]

When Jenny and I were walking in the forest yesterday and I was
praising the forest painting of Diaz, she remarked with her great good
sense: "Exact imitation is always colder than the original." It is per-
fectly true! Conscientiousness over showing only what is seen in nature
always makes a painter colder than the nature he believes he is imitating,
and for that matter nature is by no means invariably interesting from
the point of view of the effect of the whole ensemble. . . . Even though
each detail taken separately has a perfection which I call inimitable,

collectively, they rarely produce an effect equal to what a great artist obtains from his feeling for the whole scene and its composition. This is what I meant when I said, a short while ago, that although the use of a model can add something striking to a picture, it can happen only with extremely intelligent artists; in other words, the only painters who really benefit by consulting a model are those who can produce their effect without one. . . .

It is therefore far more important for an artist to come near to the ideal which he carries in his mind, and which is characteristic of him, than to be content with recording, however strongly, any transitory ideal that nature may offer—and she does offer such aspects; but once again, it is only certain men who see them and not the average man, which is a proof that the beautiful is created by the artist's imagination precisely because he follows the bent of his own genius.

This process of idealization happens almost without my realizing it whenever I make a tracing of a composition that comes out of my head. The second version is always corrected and brought closer to the ideal. This is an apparent contradiction but it explains how an over-detailed execution, like that of Rubens for instance, need not detract from the effect on the imagination. The execution is applied to a theme that has been realized in imagination; therefore the superabundance of details that slip in as a result of imperfect memory cannot destroy the far more interesting simplicity that was present in the first exposition of the idea. And as we have already seen in the case of Rubens, the frankness of the execution more than compensates for the disadvantage caused by the superabundance of details. If therefore you can introduce into a composition of this kind a passage that has been carefully painted from the model, and can do this without creating utter discord, you will have accomplished the greatest feat of all, that of harmonizing what seems irreconcilable. You will have introduced reality into a dream, and united two different arts. . . .

On the imitation of nature. This important matter is the starting point of every school and one on which they differ widely as soon as they begin to explain it. The whole question seems to come to this: is the purpose of imitation to please the imagination, or is it merely intended to obey the demands of a strange kind of conscience which allows an artist to be satisfied with himself when he has copied the model before his eyes as faithfully as possible?

3 AUGUST [1855]

Afterwards I went to the Courbet exhibition. He has reduced the price of admission to ten sous. I stayed there alone for nearly an hour

and discovered a masterpiece in the picture which they rejected; I could scarcely bear to tear myself away. He has made enormous strides, and yet this picture has taught me to appreciate his "Enterrement." In this picture the figures are all on top of one another and the composition is not well arranged, but some of the details are superb, for instance, the priests, the choir-boys, the weeping women, the vessel for Holy Water, etc. In the later picture ("The Studio") the planes are well understood, there is atmosphere, and in some passages the execution is really remarkable, especially the thighs and hips of the nude model and the breasts—also the woman in the foreground with the shawl. The only fault is that the picture, as he has painted it, seems to contain an ambiguity. It looks as though there were a *real sky* in the middle of a painting. They have rejected one of the most remarkable works of our time, but Courbet is not the man to be discouraged by a little thing like that.

3 JULY [1858]

Mercey says a very good thing in his book on the Exhibition: *the beautiful in the arts is truth idealized.* He has cut clean through the argument between the pedants and the genuine artists. He has put an end to the ambiguity which allowed partisans of *the beautiful* to conceal their incapacity for finding *the true.*

On accessories. They have an immense influence on the effect, yet they must always be sacrificed. In a well-ordered picture, there is an infinite number of what I call accessories, for not only are furniture, small details and backgrounds, accessories, but also draperies and figures and even parts of the principal figures themselves. In a portrait where the hands are shown, the hands are accessories; in the first place, they have to be subordinated to the head and often a hand must attract less attention than part of the clothing or background, etc. Why bad painters can never attain to the *beautiful*—that *truth idealized,* of which Mercey speaks—is because, apart from their lack of a general conception of their work with regard to *the truth,* they almost invariably strive to bring out details which should be subordinated, with the result that their accessories distract attention from the general effect instead of enhancing it. . . .

STRASBOURG, 1 SEPTEMBER [1859]

The most confirmed realist, when he attempts to render nature in a painting, is compelled to use certain conventions of composition or of execution. If it is a question of composition he cannot take an isolated fragment, or even a series of fragments, and make a picture out of them. He is bound to set some limit to the idea if the beholder's mind is not to

hover uncertainly over an area, which has unavoidably been cut out from a larger whole; if it were not so, there would be no art. In a photograph of a view you see no more than a portion cut from a panorama; the edges are as interesting as the centre of the picture and you have to guess at the scene of which you are shown merely a fragment, apparently chosen at random. In such a fragment, the details have as much importance as the principal object and, more often than not, obstruct the view because they occur in the foreground. You need to make more concessions to faults of reproduction in photographs than in works of the imagination. The most striking photographs are those in which certain gaps are left, owing to the failure of the process itself to give a complete rendering. Such gaps bring relief to the eyes which are thereby concentrated on only a limited number of objects. Photography would be unbearable if our eyes were as accurate as a magnifying glass; we should see every leaf on a tree, every tile on a roof, and on each tile, the moss, the insects, etc. . . .

22 FEBRUARY [1860]

Realism. Realism should be described as the antipodes of art. It is perhaps even more detestable in painting and sculpture than in history and literature. I say nothing of poetry, if only because the poet's instrument is a pure convention, an ordered language which immediately sets the reader above the earthly plane of everyday life. To speak of "realistic poetry" would be a contradiction in terms even if such a monstrosity were conceivable. But what would the term "realistic art" mean in sculpture, for example?

A mere cast taken from nature will always be more real than the best copy a man can produce, for can anyone conceive that an artist's hand is not guided by his mind, or think that however exactly he attempts to imitate, his strange task will not be tinged with the colour of his spirit? Unless, of course, we believe that eye and hand alone will suffice to produce, I will not say exact imitations only, but any work whatsoever?

For the word *realism* to have any meaning all men would need to be of the same mind and to conceive things in the same way.

For what is the supreme purpose of every form of art if it be not the effect? Does the artist's mission consist only in arranging his material, and allowing the beholders to extract from it whatever enjoyment they may, each in his own way? Apart from the interest which the mind discovers in the clear and simple development of a composition and the charm of a skillfully handled subject, is there not a moral attached even to a fable? Who should reveal this better than the artist, who plans every

part of the composition beforehand in order that the reader or beholder may unconsciously be led to understand and enjoy it.

The first of all principles is the need to make sacrifices.

Isolated portraits, however perfect, cannot form a picture. Personal feeling alone can give unity, and the one way of achieving this is to show only what deserves to be seen.

Art and poetry live on fiction. Ask a professional realist to paint supernatural beings, those gods, nymphs, monsters and furies, all those entrancing creatures of the imagination! . . .

David's work is an extraordinary mixture of realism and the ideal. The followers of Vanloo had ceased to copy the model, and although their forms were trivial to the last degree, they drew upon their memory and experience for everything. It was an art sufficient for its day. Meretricious charms and emasculated forms devoid of any touch of nature sufficed for pictures that were cast in the same mould, without original invention, and without any of the simple graces by which the works of the primitive schools endure. David began by painting a large number of pictures in this manner; it was the manner of the school in which he was trained. I do not think that he possessed very much originality, but he was blessed with plenty of good sense; above all, he was born at the time when this school was declining and a rather thoughtless admiration for antique art was taking its place. Thanks to this fact, and to such moderate geniuses as Mengs and Winckelmann, he fortunately became aware of the dullness and weakness of the shameful productions of the period. No doubt the philosophical ideas in the air at that time, the new ideas of greatness and liberty for the people, were mingled with his feeling of disgust for the school from which he had emerged. This revulsion, which does great honour to his genius and is his chief claim to fame, led him to the study of the Antique. He had the courage completely to reform his ideas. He shut himself up, so to speak, with the Laocoon, the Antinous, the Gladiator, and the other great male conceptions of the spirit of antique art, and was courageous enough to fashion a new talent for himself—like the immortal Gluck, who in his old age abandoned his Italian manner and renewed himself at fresher, purer springs. He was the father of the whole modern school of painting and sculpture. His reforms extended even to architecture and to the very furniture in everyday use. It was through his influence that the style of Herculaneum and Pompeii replaced the bastard Pompadour style, and his principles gained such a hold over men's minds that his school was not inferior to him, and produced some pupils who became his equals. In some respects he is still supreme, and in spite of certain changes that have appeared in the taste of what forms his school at the present day, it is plain that everything still derives from him and from his principles.

On Rubens

6 MARCH [1847]

After a good night's rest I went back to the studio where I recovered my good humour. I am looking at the "Hunts," by Rubens. The one I prefer is the hippopotamus hunt; it is the fiercest. I like its heroic emphasis, I love its unfettered exaggerated forms, I adore them as much as I despise those gushing empty-headed women who swoon over fashionable pictures and M. Verdi's music.

WEDNESDAY, 12 OCTOBER [1853]

Rubens is a remarkable illustration of the abuse of details. His painting, which is dominated by the imagination, is everywhere super-abundant, the accessories are too much worked out. His pictures are like public meetings where everybody talks at once. And yet, if you compare this exuberant manner, not with the dryness and poverty of modern painting, but with really fine pictures where nature has been imitated with restraint and great accuracy, you feel at once that the true painter is one whose imagination speaks before everything else.

THURSDAY, 20 OCTOBER [1853]

Glory to that Homer of painting, the father of warmth and enthusiasm in the art where he puts all others in the shade, not, perhaps, because of his perfection in any one direction, but because of that hidden force—that life and spirit—which he put into everything he did. How strange it is: the picture that perhaps made the strongest impression on me, the "Raising of the Cross" in Antwerp, is not the one where his own peculiar and incomparable qualities shine out most strongly. . . . It is neither by the colour, nor by the delicacy nor the boldness of the execution that this painting surpasses the others, but, strangely enough, it is because of those Italian qualities that do not delight me so much in the work of Italian painters. Here I think it only right to say that I have had exactly the same feeling before Gros's battle pictures and the "Raft of the Medusa," especially when I saw the latter half-finished. There is something sublime in all these works which is partly due to the great size of the figures. The same pictures on a smaller scale would, I am sure, have had an entirely different effect. In both Rubens's picture and in Géricault's, there is an indescribable flavour of the style of Michaelangelo

which adds still further to the impression produced by the size of the figures, and gives them an awe-inspiring quality. Proportion counts for a great deal in the absolute power of a picture. . . .

I must admit, however, that proportion is not everything, for many of Rubens's pictures in which the figures are very large do not give this kind of feeling—to me, the most elevated of all—nor is it solely due to a more Italian quality of style, for pictures by Gros which show no trace of it, and are entirely his own, have this power of projecting me into that spiritual state which I consider to be the strongest emotion that the art of painting can inspire. The impressions that the arts produce on sensitive natures are a curious mystery; when you try to describe them they seem confused but each time you experience them, if only in recollection, they are strong and clear. I firmly believe that we always mingle something of ourselves in the emotions that seem to arise out of objects that impress us. And I think it probable that these things delight me so much only because they echo feelings that are also my own. If, although so different, they give me the same degree of pleasure, it must be because I recognize in myself the source of the kind of effect they produce.

21 OCTOBER [1860]

Admirable Rubens! What a magician! I grow angry with him at times; I quarrel with his heavy forms and his lack of refinement and elegance. But how superior he is to the collection of small qualities that make up the whole stock of other painters! He, at least, had the courage to be himself; he compels you to accept his so-called defects, that come from the impetus with which he is swept along, and wins you over, in spite of precepts that hold good for everyone but himself. Rubens did not correct himself, and he was right. By permitting himself every liberty he carries you to heights which the greatest painters barely attain. He dominates, he overwhelms you with so much liberty and audacity.

I also note that his greatest quality (if you can imagine having to choose one quality in particular) is the astounding relief of his figures, that is to say their astonishing vitality. Without this gift there is no great artist. Moreover, only the greatest succeed in solving this problem of relief and solidity.

On Expression

TUESDAY, 8 OCTOBER [1822]

When I have painted a fine picture I have not given expression to a thought! That is what they say. What fools people are! They would strip painting of all its advantages. A writer has to say almost everything

in order to make himself understood, but in painting it is as if some mysterious bridge were set up between the spirit of the persons in the picture and the beholder. The beholder sees figures, the external appearance of nature, but inwardly he meditates; the true thinking that is common to all men. Some give substance to it in writing, but in so doing they lose the subtle essence. Hence, grosser minds are more easily moved by writers than by painters or musicians. The art of the painter is all the nearer to man's heart because it seems to be more material. In painting, as in external nature, proper justice is done to what is finite and to what is infinite, in other words, to what the soul finds inwardly moving in objects that are known through the senses alone.

THURSDAY, 18 JULY [1850]

"In painting, and especially in portraiture," says Mme Cavé in her treatise, "mind speaks to mind, and not knowledge to knowledge." This observation, which may be more profound than she knows herself, is an indictment of pedantry in execution. I have said to myself over and over again that painting, i.e., the material process which we call painting, is no more than the pretext, the bridge between the mind of the artist and that of the beholder. . . .

WEDNESDAY, 16 OCTOBER [1850]

On pictorial license. The most sublime effects of every master are often the result of *pictorial license;* for example, the lack of finish in Rembrandt's work, the exaggeration in Rubens. Mediocre painters never have sufficient daring, they never get beyond themselves. Method cannot supply a rule for everything, it can only lead everyone to a certain point. Why have no great artists ever attempted to break down this mass of prejudice? They were probably frightened by the magnitude of the task and therefore abandoned the mob to their foolish ideas.

26 MARCH [1854]

Fine works of art would never become dated if they contained nothing but genuine feeling. The language of the emotions and the impulses of the human heart never change; what invariably causes a work to date, and sometimes ends by obliterating its really fine qualities, is the use of technical devices that were within the scope of every artist at the time the work was executed. On the other hand, what usually makes for the material success of most works of art is, I am sure, the use of certain fashionable embellishments of secondary importance compared with the main idea. Those, who by a miracle were able to dispense

with such accessories, have either been appreciated very late and with great difficulty, or else by later generations, who are indifferent to the charm of these particular conventions.

26 JUNE. IN PARIS. [1857]

On the sublime, and on perfection. These two words may appear almost synonymous. *Sublime* means everything that is most elevated; *perfect,* that which is most complete, most finished. *Perficere,* to realize completely, to crown the work. *Sublimis,* that which is highest, which reaches to the skies.

Some men of talent can only breathe in the highest altitudes and on the peaks. Michaelangelo appears like one who would have been stifled in the lower regions of art. We must attribute to this consistent and unbroken strength the authority which he has exercised over the imagination of all artists. Titian stands in exact contrast with him.

Our own writers, who take improvisation for their muse, will find it hard to reach perfection. They hope to be saved by such lucky accidents as improvisation occasionally brings and to meet the *sublime* by chance, and I say good luck to them.

15 JANUARY [1860]

Audacity. It needs great audacity to dare to be oneself, and this quality is particularly rare in a period of decadence like the present. The primitives were bold by nature, almost without being conscious of it, but it really needs the greatest possible audacity to break away from habits and conventions. The men who came first had no conventions to fear, the field was open to them, no tradition fettered their inspiration. In the modern schools, depraved and intimidated as they are by precedents well contrived to curb presumptuous impulses, nothing is so rare as the confidence which alone can beget great masterpieces.

15 JANUARY [1861]

To finish requires a heart of steel. You have to make decisions all the time, and I am finding difficulties where I thought there would be none. The only way I can keep up this life is to go to bed early and do nothing whatsoever outside my work, and I am sustained in my resolution to give up every pleasure, and most of all that of seeing the people I love, only by the hope of carrying the work through to completion. I think it will kill me. It is at times like these that one realizes one's weakness and how many incomplete or uncompletable passages there are, in what a man calls a *finished* or *complete* work.

22 June [1863]

[*Written in pencil in a small notebook.*] The first quality in a picture is to be a delight for the eyes. This does not mean that there need be no sense in it; it is like poetry which, if it offend the ear, all the sense in the world will not save from being bad. They speak of *having an ear* for music: not every eye is fit to taste the subtle joys of painting. The eyes of many people are dull or false; they see objects literally, of the exquisite they see nothing.

Charles Baudelaire (1821–1867) on Delacroix

Nothing illustrates more strikingly the prestige of the arts in the middle decades of the 19th century than the deferential attitude of literary men toward artists. Baudelaire and Ruskin, who otherwise bore little resemblance to one another, shared the belief that painting was a quintessential expression of poetic genius. For each, a great painter stood forth as the exemplar of creative activity, a model for poets, philosophers, and scientists. The central position which Turner occupied in the thought of Ruskin (see page 69) and which Delacroix held in Baudelaire's thought was without parallel in earlier times. Diderot's admiration for Greuze or Chardin (see Vol. I, p. 57) had never led him to regard them as his mentors. Quite on the contrary, he had always felt entitled to instruct and advise artists, in matters of arrangement, expression, and sentiment, and in his highest praise there had lingered an undertone of the literary man's condescension to the pictorial technician.

Baudelaire began his literary career with Salon reviews (see page 153). Throughout his life, his work as an art critic continued to be one of his central concerns, not a journalistic side occupation. He chose to state, or to imply, his thoughts on poetry in his writings on art and music, rather than in literary criticism. It was his passionate interest in the work of Delacroix, with whom his personal acquaintance seems never to have been close, which most deeply influenced his opinions on art. For him, Delacroix was not simply an artist, but the artist. When Delacroix died, on 13 August 1863, Baudelaire wrote an obituary tribute which is one of the rare portraits of a great artist by a great poet.[57]

Delacroix was passionately in love with passion, and coldly determined to seek the means of expressing it in the most visible way.

[57] Translated by Jonathan Mayne, *The Mirror of Art*, London, Phaidon Press, Ltd., 1955, pp. 308 ff., reprinted by permission of the publisher. Baudelaire's article originally appeared in the periodical *Opinion Nationale*, on September 2, November 14 and 22, 1863. It was later included in the posthumous collection *L'Art romantique* (1869).

In this duality of nature—let us observe in passing—we find the two signs which mark the most substantial geniuses—extreme geniuses who are scarce made to please those timorous, easily satisfied souls who find sufficient nourishment in flabby, soft and imperfect works. An immense passion, reinforced with a formidable will—such was the man.

Now he used continually to say:

"Since I consider the impression transmitted to the artist by nature as the most important thing of all to translate, is it not essential that he should be armed in advance with all the most rapid means of translation?"

It is evident that in his eyes the imagination was the most precious gift, the most important faculty, but that this faculty remained impotent and sterile if it was not served by a resourceful skill which could follow it in its restless and tyrannical whims. He certainly had no need to stir the fire of his always-incandescent imagination; but the day was never long enough for his study of the material means of expression.

It is this never-ceasing preoccupation that seems to explain his endless investigations into colour and the quality of colours, his lively interest in matters of chemistry, and his conversations with manufacturers of colours. In that respect he comes close to Leonardo da Vinci, who was no less a victim of the same obsessions.

In spite of his admiration for the fiery phenomena of life, never will Eugène Delacroix be confounded among that herd of vulgar artists and scribblers whose myopic intelligence takes shelter behind the vague and obscure word "realism." The first time that I saw M. Delacroix— it was in 1845, I think (how the years slip by, swift and greedy!)—we chatted much about commonplaces—that is to say, about the vastest and yet the simplest questions; about Nature, for example. . . .

Eugène Delacroix was a curious mixture of scepticism, politeness, dandyism, burning determination, craftiness, despotism, and finally of a sort of personal kindness and tempered warmth which always accompanies genius. His father belonged to that race of strong men of whom we knew the last in our childhood—half of them fervent apostles of Jean-Jacques, and the other half resolute disciples of Voltaire, though they all collaborated with an equal zeal in the French Revolution, and their survivors, whether Jacobins or Cordeliers, all rallied with a perfect integrity (it is important to note) to the aims of Bonaparte.

Eugène Delacroix never lost the traces of his revolutionary origin. It may be said of him, as of Stendhal, that he had a great dread of being made a fool of. Sceptical and aristocratic, he only knew passion and the supernatural through his forced intimacy with the world of dreams.

There was much of the *savage* in Eugène Delacroix—this was in fact

the most precious part of his soul, the part which was entirely dedicated to the painting of his dreams and to the worship of his art. There was also much of the man of the world; that part was destined to disguise and excuse the other. It was, I think, one of the great concerns of his life to conceal the rages of his heart and not to have the seeming of a man of genius. His spirit of dominance, which was quite legitimate and even a part of his destiny, had almost entirely disappeared beneath a thousand kindnesses. You might have called him a volcanic crater artistically concealed behind bouquets of flowers.

He owed also to himself, far more than to his long familiarity with the world of society—to himself, that is to say to his genius and the consciousness of his genius—a sureness, a marvellous ease of manner, combined with a politeness which, like a prism, admitted every nuance, from the most cordial good nature to the most irreproachable rudeness. He possessed quite twenty different ways of uttering the words *"mon cher Monsieur,"* which, for a practised ear, represented an interesting range of sentiments. For finally it must be said—since to me this seems but one more reason for praise—that Eugène Delacroix, for all that he was a man of genius, or *because* he was a man of *complete* genius, had much of the dandy about him. He himself used to admit that in his youth he had thrown himself with delight into the most material vanities of dandyism, and he used to tell with a smile, but not without a certain touch of conceit, how, with the collaboration of his friend Bonington, he had laboured energetically to introduce a taste for English cut in clothes and shoes among the youth of fashion. I take it that this will not seem to you an idle detail, for there is no such things as a superfluous memory when one has the nature of certain men to paint.

I have told you that what most struck the attentive observer was the *natural* part of Delacroix's soul, in spite of the softening veil of a civilized refinement. He was all energy, but energy which sprang from the nerves and from the will—for physically he was frail and delicate. The tiger intent upon his prey has eyes less bright and muscles less impatiently a-quiver than could be observed when the whole spiritual being of our great painter was hurled upon an idea or was struggling to possess itself of a dream. Even the physical character of his countenance, his Peruvian or Malay-like colouring, his great black eyes (which, however, the blinkings of concentration made to appear smaller, so that they seemed to do no more than *sip* at the light), his abundant and glossy hair, his stubborn brow, his tight lips, to which an unceasing tension of will gave an expression of cruelty—his whole being, in short, suggested the idea of an exotic origin. More than once, when looking at him, I have found myself thinking of those ancient rulers of Mexico, of Montezuma,

whose hand, with sacrificial skill, could immolate three thousand human creatures in a single day upon the pyramidal altar of the Sun, or perhaps of some oriental potentate who, amid the splendours of the most brilliant of feasts, betrays in the depths of his eyes a kind of unsatisfied craving and an inscrutable nostalgia—something like the memory and the regret of things not known. . . . The *morality* of his works—if it is at all permissible to speak of ethics in painting—is also visibly marked with Molochism. His works contain nothing but devastation, massacres, conflagrations; everything bears witness against the eternal and incorrigible barbarity of man. Burnt and smoking cities, slaughtered victims, ravished women, the very children cast beneath the hooves of horses or menaced by the dagger of a distracted mother—the whole body of this painter's works, I say, is like a terrible hymn composed in honour of destiny and irremediable anguish. Occasionally he found it possible to devote his brush to the expression of tender and voluptuous feelings—for certainly he was not lacking in tenderness; but even into these works an incurable bitterness was infused in strong measure, and carelessness and joy—the usual companions of simple pleasure—were absent from them.

I know several people who have a right to say *"Odi profanum vulgus"*; but which among them can triumphantly add *"et arceo"*? Too much hand-shaking tends to cheapen the character. But if ever a man had an *ivory tower,* well protected by locks and bolts, that man was Eugène Delacroix. And who has ever had a greater love for his *ivory tower*—that is, for his privacy? He would even, I believe, have armed it with artillery and transported it bodily into a forest or to the top of an inaccessible rock! Who has had a greater love for the *home*—both sanctuary and den? As others seek privacy for their debauches, he sought privacy for inspiration, and once he had gained it, he would give himself up to veritable drunken orgies of work.

. . . Thanks to the sincerity of our admiration, we were able, though still very young, to penetrate the fortifications of that studio where, in spite of the rigours of our climate, an equatorial temperature prevailed, and where the eye was immediately struck by a sober solemnity and by the classic austerity of the old school. We had seen such studios in our childhood, belonging to the late rivals of David—those touching heroes long since departed. One felt instinctively that this retreat could not be the habitation of a frivolous mind, titillated by a thousand incoherent fancies.

There were no rusty panoplies to be seen there, not a single Malayan *kris,* no ancient Gothic scrap-iron, no jewellery, no old clothes, no bric-à-brac, nothing of what indicts its owner of a taste for toys and the desultory wanderings of childish day-dreaming. A marvellous portrait by Jordaens, which he had unearthed somewhere or other, and several stud-

ies and copies, made by the master himself, sufficed to decorate that vast studio, in which a softened and subdued light illumined self-communion.

After a luncheon lighter than an Arab's, and with his palette arranged with the meticulous care of a florist or a cloth-merchant, Delacroix would set himself to grapple with the interrupted idea; but before launching out into his stormy task, he often experienced those feelings of languor, fear and prostration which make one think of the Pythoness fleeing the god, or which remind one of Jean-Jacques Rousseau dillydallying, rummaging among his papers and turning over his books for an hour before attacking paper with pen. But as soon as the artist's special magic had started to work, he never stopped until overcome by physical fatigue.

One day, when we happened to be talking about that question which always has such an interest for artists and writers—I mean, about the *hygienics* of work and the conduct of life—he said to me:

"Formerly, in my youth, I was unable to get down to work unless I had the promise of some pleasure for the evening—some music, dancing, or any other conceivable diversion. But today I have ceased to be like a schoolboy, and I can work without stopping and without any hope of reward. And then [he added], if only you knew how unremitting work makes one indulgent and easy to satisfy where pleasures are concerned! The man who has well filled his day will be prepared to find a sufficiency of wit even in the local postman, and will be quite content to spend his evening playing cards with him!"

The truth is that during his latter years everything that one normally calls pleasure had vanished from his life, having all been replaced by a single harsh, exacting, terrible pleasure, namely *work,* which by that time was not merely a passion but might properly have been called a rage.

After having dedicated the hours of the day to painting, either in his studio or upon the scaffolding whither he was summoned by his great decorative tasks, Delacroix found strength yet remaining in his love of art, and he would have judged that day ill-filled if the evening hours had not been employed at the fire-side, by lamp-light, in drawing, in covering paper with dreams, ideas, or figures half-glimpsed amid the random accidents of life, and sometimes in copying drawings by other artists whose temperament was as far as possible removed from his own; for he had a passion for notes, for sketches, and he gave himself up to it wherever he happened to be.

He once said to a young man of my acquaintance: "If you have not sufficient skill to make a sketch of a man throwing himself out of a window, in the time that it takes him to fall from the fourth floor to the

ground, you will never be capable of producing great *machines.*" This enormous hyperbole seems to me to contain the major concern of his whole life, which was, as is well known, to achieve an execution quick and sure enough to prevent the smallest particle of the intensity of action or idea from evaporating.

Jean Auguste Dominique Ingres (1780–1867)

A hostile critic,[58] *writing in 1855, described Ingres as "the absolute representative of that academic spirit which casts all feelings, all faculties into a mould called style. Henceforth there are to be neither good artists nor bad, neither feeble nor strong temperaments, neither spirit nor imagination; the excellence of the mould is to make up for everything."*

But the label of "academic" fits Ingres no better than David, his teacher. He was in his work and personality one of the most vehement individualists of his time, entirely untouched by the characterless routine, compromise and boredom of ordinary academicism. Like his fellow students in David's atelier, the dissident Primitifs *(see Vol. I, p. 136), Ingres had striven in his youth to energize and purify classicism. He remained to the end of his life a radical stylist, given to extremes of distortion, abstraction, and archaism, and was for this reason the subject of perennial controversy. His peculiar kind of conservatism stemmed not so much from his worship of Raphael and other masters of the past—in this respect, he resembled Delacroix—but from his obsessive fear that art was about to be destroyed by the vulgarity and mediocrity of the modern world. With naïve egoism, he saw himself as its chosen defender, and felt obligated to accept official positions in the academic establishment for which he, privately, had little real respect. He would have preferred to wield the power of a dictator, like David in 1794, or the moral authority of a high priest, but he had to content himself with teaching. As a professor of the École des Beaux Arts in Paris and as director during 1834–1841 of the French Academy in Rome, he left the mark of his influence on several generations of students. He never attempted a coherent, written statement of his doctrine, but he had the gift of terse and impressive speech. His pronouncements, usually in the form of declarations or laments, and often of convulsive brevity, fell like hammer blows on disciples and enemies alike. They must have seemed memorable, for they were often recorded. Theophile Sylvestre garnished his acid pen portrait of Ingres with authentic quotations (1855), and in later years, former pupils of Ingres, such as Amaury-Duval (1874), recorded the characteristic sayings of their master. The quotations which follow are taken from the choice which Henri Delaborde published in*

[58] Theophile Silvestre, *Histoire des artistes vivants,* Paris, Blanchard, 1856, p. 32.

1870 of passages from Ingres' correspondence and studio talk, as reported by his pupils Edouard Odier and Auguste Flandrin.[59]

In matters of art, I have not changed. Age and reflection have, I hope, strengthened my taste, without diminishing its ardor. I still worship Raphael, his century, the Ancients, and above all the divine Greeks; in music, Gluck, Mozart, Haydn. My library consists of some twenty volumes, immortal masterpieces; with all this, life has its charms. [1818]

* * *

I count on my old age: it will avenge me.

* * *

I agree with LaFontaine: there can be no peace with the wicked! In Paris just now they criticize my influence, they criticize "the tendency which has been noticeable for some time in the work of the pensioners [of the French Academy] in Rome." . . . Certainly, yes, there is some influence. I do not see how a director [of the French Academy in Rome] can help influencing the artistic attitudes of his pensioners. Is my influence good? Yes, excellent! Yes, the best ever! Would these miserable enemies of mine, these crooks and hypocrites, prefer to have bad doctrines prevail? They are still smarting from the deep wounds which the truth and beauty of mine has inflicted on them. Very well, although I have not exactly been spoiled by the public, even by that segment which is enlightened, but not quite enough to share my ideas, I shall make this public the judge between them and me. It is impossible, it is impossible despite everything that the public will not, at long last, prefer me to them. . . .

* * *

There are not two kinds of art, there is only one: it is the one which is based on timeless, natural Beauty. Those who seek elsewhere deceive themselves, and in the most fatal manner. What do these so-called artists mean when they preach the discovery of the "new?" Is there anything new? Everything has been done, everything has been found. Our task is not to invent, but to continue. There is enough for us to do if, following the example of the great masters, we make use of those innumerable types which nature constantly offers us, if we interpret

[59] Henri Delaborde, *Ingres, sa vie, ses travaux, ses doctrines*, Paris, 1870; for a more recent edition, cf. *Ingres, raconté par lui-même et par ses amis*, edited by P. Courthion, Geneva, Pierre Cailler, 1957. See also Amaury-Duval, *L'atelier d'Ingres, Souvenirs*, Paris, 1878, and R. Cogniet, *Ingres, écrits sur l'art*, Paris, La Jeune Parque, 1947.

them with all the sincerity of our hearts and ennoble them through that pure and firm style without which no work has beauty. How absurd to believe that our natural dispositions and faculties can be compromised by the study, or even the imitation of classical works? Man, the original type, remains forever: we need only consult it to see whether the classical artists were right or wrong, and whether we lie or tell the truth when we use the same means as they did.

* * *

It is no longer necessary to discover the conditions and principles of beauty. The important thing is to apply them, and not to let the desire for invention mislead us into losing sight of them. Pure and natural beauty need not surprise us through novelty: it is enough to be beautiful. But men are in love with change, and in art change is often the cause of decadence.

* * *

Phidias achieved sublimity by correcting nature with nature. In fashioning his Olympian Zeus, he used all natural beauties in unison to attain what is badly called Ideal Beauty. This term should be understood as expressing the combination of the most beautiful elements in nature, something which is rarely found in a perfect state. But nothing is above nature when nature is beautiful. The best human effort cannot surpass, nor even equal it.

* * *

Study beauty only on your knees!

* * *

Art lives on elevated thoughts and noble passions. It must have character and warmth. We do not die of heat, but cold kills.

* * *

Draw, paint, above all imitate, even if only still-lives. All imitation from nature is substantial work, and imitation can lead to art.

* * *

Masterworks are not made to astonish. They are made to persuade, to convince, to enter into us through our pores.

* * *

Look at that [pointing to the living model]: it is like the Ancients, and the Ancients are like it. It is an antique bronze. The Ancients did not correct their models. I mean to say: they did not de-nature them. If you sincerely render what is before you, then you will proceed as they did and achieve beauty as they did. If you take a different tack, if you pretend to correct what you see, you will merely contrive something false, equivocal, and ridiculous.

* * *

When you lack the respect which you owe to nature, when you dare to offend against it in your work, you kick your mother in the stomach.

* * *

Art is never at a higher level than when it resembles nature so much as to be mistaken for nature itself. Art never succeeds better than when it is hidden.

* * *

Love truth, for in it is beauty, if you can sense and discern it. Let us train our eyes to see well, to see wisely, that is all I ask. If you want to see this leg as ugly, I know you will find material enough, but I say to you: take my eyes, and you will find it beautiful.

* * *

Your work will have beauty if it has truth. All your faults come not from a lack of taste or imagination, but from a want of nature. Raphael and this [pointing to the model] are synonymous. And which road did Raphael choose? Raphael was modest, the great Raphael himself was obedient. Let us be humble before nature.

* * *

The masses are rarely pleased by any other than the lower styles of art, whether it be in painting, poetry, or music. Art's sublimest efforts have no effect on uncultivated minds. A fine and subtle taste is the fruit of education and experience. All we receive at birth is the faculty for creating such a taste in ourselves and for cultivating it, just as we are born with a disposition for receiving the laws of society and conforming to their usages. It is only to this point, and no further, that one may say that taste is natural to us.

* * *

The ignorant will show as little taste in judging the effect or character of a painting as they would in judging living reality. In life, they wax enthusiastic over violence and emphasis; in art, they always prefer forced or strained attitudes and brilliant color over the noble simplicity and quiet grandeur which we find in the painting of the Ancients.

* * *

There are few persons, informed or ignorant, whose freely expressed thoughts about works of art would not be useful to artists. The only opinions which are totally sterile are those of the half-connoisseurs.

* * *

Drawing is the probity of Art.

* * *

To draw does not simply mean to reproduce contours; drawing does not simply consist of line: drawing is also expression, the inner form, the surface, modeling. What else is there? Drawing includes three quarters and a half of what constitutes painting. If I had to put a sign over my door, I should inscribe it *School for Drawing,* and I am sure that I should produce painters.

* * *

One must always draw, draw with your eyes if you cannot draw with a pencil. So long as you do not balance observation with execution, you will do nothing that is really good.

* * *

If I could make you musicians, you would become better painters. In nature, all is harmony: a little more or a little less disturbs the key and produces a false note. We must learn to sing true with our brush or pencil, as much as with our voice. Truth of form is comparable to truth of sound.

* * *

In consulting the model, observe the relationships of sizes, this is what constitutes its character. Obtain a vivid impression of these size relationships, and render them vividly. If, instead, you hesitate and start pushing them around on the paper, you will achieve nothing worth-

while. You must have the whole figure you want to draw in your eye and mind. The execution should merely be the realization of the preconceived image held in your mind.

* * *

The simpler your lines and forms, the more beauty and strength they will possess. Whenever you divide your forms, you enfeeble them. It is the same as with all fractions.

* * *

Beautiful forms are made of straight surfaces with curvatures. Beautiful forms have firmness and fullness; their details. do not diminish the effect of the larger masses.

* * *

Expression in painting calls for great knowledge of drawing, for expression cannot be good if it has not been formulated with absolute exactness. To seize it only approximately is to miss it altogether and to represent people who fake sentiments which they do not feel. We can attain this extreme precision only through the surest talent for drawing. That is why the painters of expression among the moderns happen to have been the greatest draftsmen—witness Raphael!

* * *

Color is an ornament of painting, but it is no more than a hand-maiden to it, since it does no more than render more pleasing those things which are the true perfections of art.

* * *

There exists no example of a great draftsman whose colors did not exactly suit the character of his design. In the opinion of many, Raphael did not use color. He did not use color like Rubens and Van Dyke, by God! he was very careful not to.

* * *

Do not use colors which are too intense—that is anti-historical. Tend, rather, toward greyness than brilliance, if you cannot be precise, if you cannot hit the perfectly true tone.

* * *

To claim that we can do without the study of ancient art and the classics is either folly or laziness. Yes, anti-classical art, if it can be called art, is nothing but an art of the lazy. It is the doctrine of those who want to produce without having worked, who want to know without having learned. It is an art without faith or discipline, wandering blindly in the darkness and expecting chance to lead it to those places which one may reach only through courage, experience, and reflection.

* * *

To remedy the overflow of mediocrity which has caused the disintegration of the French School, to counteract the banality which has become a public misfortune, which sickens taste and overwhelms the state administration of the arts, fruitlessly wasting its resources, it is necessary to renounce exhibitions. There should be a courageous declaration that only monumental painting will henceforth be encouraged. It should be decreed that we decorate our public buildings and churches whose walls cry out for paintings. These decorations should be entrusted to artists of superior ability who would employ mediocre artists as their assistants. The latter would thus cease to oppress art and become useful. Young artists would be proud to help their masters. Everyone who can hold a brush could be used.

Why do the Italians hold sophisticated ideas about painting? Because they see it everywhere. Who would be against having France become the new Italy? . . .

It is true that exhibitions have become a part of our lives. It is therefore impossible to suppress them. But they must not be encouraged. They destroy art, by making it a trade which artists no longer respect. The exhibitions are no more than bazaars in which mediocrity is impudently flaunted. They are useless and dangerous. . . .[60]

* * *

I wish they would take that painting of the *Medusa* out of the Museum and those two great *dragoons,* its acolytes. Let them put the one into some corner of the Ministry of the Navy, and the two others into the Ministry of War, so that they may no longer corrupt the taste of the public which ought to be accustomed exclusively to things of beauty. We should also be delivered once for all of such subjects as executions and *autos-da-fé;* are these the kinds of things which a sound and moral art ought to represent? Should we admire them? Should such horrors

[60] From a report by Ingres to the Commission Permanente des Beaux Arts, meeting in 1849 to consider methods for jurying the Salon; cf. H. Lapauze, *Ingres, sa vie et son oeuvre,* Paris, G. Petit, 1911, pp. 401 ff.

please us? I do not want to rule out effects of pity or terror, but I should want them to be rendered in the manner of Aeschylus, Sophocles, and Euripides. I don't want that *Medusa* and those other paintings of the dissecting room which show us man only in the form of cadavers and which represent only the ugly and hideous. No, I don't want them. Art should always be beautiful and only teach beauty.

<p style="text-align:center">* * *</p>

Théophile Gautier and Charles Baudelaire on Ingres, 1855

The Exposition Universelle, *a world's fair held in Paris in 1855, included an international exhibition of art, the French section of which was devoted largely to the celebration of the work of the two heads of the French school, Delacroix and Ingres. The occasion was less a confrontation than a joint apotheosis of the two aging artists, designed to reconcile the tired remnants of the romantic and classicist factions. The exhibition prompted several notable reviews. The poet Théophile Gautier (1811– 1872) used the opportunity to display a tolerant eclecticism which managed to embrace English anecdotal painting, Chinese bric-a-brac, and Delacroix in one common admiration. His article on Ingres' exhibition, of which the following is an excerpt, amounted to a solemn, official canonization, rather than a critical review, and illustrated Gautier's conversion from the fervid romanticism of the 1830's to the pompous historicism of the era of Napoleon III.*[61]

The first name which comes to mind as we turn to the French school is that of Monsieur Ingres. All Salon reviews, whatever the critic's opinion, invariably begin with him. It is impossible, in fact, not to place him on art's summit, on that throne of gold with ivory steps on which are seated, crowned with laurel, the artists who have accomplished their glory and are ready for immortality. The epithet of "sovereign" which Dante gives to Homer fits Ingres equally well. It has been bestowed on him by the young generation whose life span overlaps his radiant old age. Repudiated at first, long obscured, yet persisting in his direction with admirable constancy, Ingres has now reached the place where posterity will put him: beside the great masters of the 16th century whose soul he, three hundred years later, seems to have received. His has been a noble, an exemplary life, entirely fufilled by art, without a distraction, without faltering or doubt. By his own will, the painter of the *Apotheosis of Homer,* of *Saint Symphorien* and the *Vow of Louis XIII* has walled himself into the

61 Theophile Gautier, *Les Beaux-Arts en Europe, 1855,* Paris, 1855, pp. 142 ff.

Sanctuary and remained in the ecstatic contemplation of beauty, on his knees before Phidias and Raphael who are his gods. Pure, austere, and fervent, he has spent his time in meditation and in the creation of works which bear witness to his faith. He alone represents in our time the high traditions of history painting, of the ideal, and of style. He has, for this reason, been accused of lacking modern inspiration and of ignoring the world around him, in short, of not belonging to his time. The accusation is perfectly just: Ingres is not, in fact, of his time—he is eternal. He belongs to the realm where the personifications of supreme beauty dwell, in that blue, transparent ether which is breathed by the Sybils of the Sistine Chapel, the Muses of the Vatican, and the Victories of the Parthenon.

Far be it from me to reproach artists who are stirred by contemporary passions and excited by the ideas of their time. There is something in modern life which involves us all, a throbbing emotion which art has a right to formulate, and from which it may derive magnificent works. But I prefer the kind of beauty which is absolute and pure, which belongs to all periods, all countries, all religions, and which unites past, present, and future in common admiration. This kind of art which owes nothing to chance, which is heedless of changing fashions and fleeting interests, seems cold, I know, to unquiet spirits and has no appeal for the masses who do not understand synthesis and generalization. It is great art, nevertheless, immortal art, the noblest effort of the human soul; so, at any rate, the Greeks believed, those divine teachers whose traces we ought to worship on our knees. It is to Monsieur Ingres' honor that he has carried the torch which Antiquity passed to the Renaissance, and that he did not allow it to be extinguished by the many mouths that blew on it. . . .

In contrast to Gautier's eulogy, the chapter which Charles Baudelaire devoted to Ingres in his review of the Exposition Universelle *of 1855 expressed an uncompromisingly anticlassicist aesthetic:* [62]

When David, that icy star, rose above the horizon of art, with Guérin and Girodet (his historical satellites, who might be called the *dialecticians* of the party), a great revolution took place. Without analysing here the goal which they pursued; without endorsing its legitimacy or considering whether they did not overshoot it, let us state quite simply that they had a goal, a great goal which consisted in reaction against an excess of gay and charming frivolities, and which I want neither to appraise nor to

[62] Translated by Jonathan Mayne, *The Mirror of Art*, London, Phaidon Press, Ltd., 1955, pp. 200 ff., reprinted by permission of the publisher. Baudelaire's article on the exhibition appeared, in three parts, in the periodical *Le Pays*, on May 26 and June 3, 1855, and in *Le Portefeuille*, on August 12, 1855. The section devoted to Ingres was suppressed. It was first published in the collection *Curiosités esthétiques*, published posthumously in 1868.

define; further, that they fixed this goal steadfastly before their eyes, and that they marched by the light of their artificial sun with a frankness, a resolution and an *esprit de corps* worthy of true party-men. When the harsh idea softened and became tender beneath the brush of Gros, the cause was already lost.

I remember most distinctly the prodigious reverence which in the days of our childhood surrounded all those unintentionally fantastic figures, all those academic spectres—those elongated human freaks, those grave and lanky Adonises, those prudishly chaste and classically voluptuous women (the former shielding their modesty beneath antique swords, the latter behind pedantically transparent draperies)—believe me, I could not look at them without a kind of religious awe. And the whole of that truly extra-natural world was forever moving about, or rather *posing*, beneath a greenish light, a fantastic parody of the real sun. But these masters, who were once overpraised and today are over-scorned, had the great merit—if you will not concern yourself too much with their eccentric methods and systems—of bringing back the taste for heroism into the French character. That endless contemplation of Greek and Roman history could not, after all, but have a salutary, Stoic influence; but they were not always quite so Greek and Roman as they wished to appear. David, it is true, never ceased to be heroic—David the inflexible, the despotic evangelist. But as for Guérin and Girodet, it would not be hard to find in them a few slight specks of corruption, one or two amusing and sinister symptoms of future Romanticism—so dedicated were they, like their prophet, to the spirit of melodrama.

But today we are faced with a man of an immense and incontestable renown, whose work is very much more difficult to understand and to explain. A moment ago, in connection with those illustrious unfortunates, I was irreverently bold enough to utter the word "freakish." No one, then, could object if, in order to explain the sensation of certain sorts of artistic temperament when placed in contact with the works of M. Ingres, I say that they feel themselves face to face with a *freakishness* far more complex and mysterious than that of the masters of the Republican and Imperial school—whence, nevertheless, it took its point of departure.

Before broaching the subject more seriously, I am anxious to record a first impression which has been felt by many people and which they will inevitably remember the moment that they enter the sanctuary consecrated to the works of M. Ingres. This impression, which is hard to define —and which partakes, in unknown quantities, of uneasiness, boredom and fear—reminds one vaguely and involuntarily of the feelings of faintness induced by the rarefied air, the physical atmosphere of a chemistry laboratory, or by the awareness that one is in the presence of an unearthly order of being; let me say, rather, of an order of being which

imitates the unearthly—of an *automatic* population, whose too palpable and visible extraneity would make our senses swim. It is no longer that childlike reverence of which I spoke a moment ago—that reverence which possessed us in front of the *Sabines,* and of *The Dead Marat*—in front of the *Déluge* or the melodramatic *Brutus.* It is a powerful sensation, it is true—why deny M. Ingres's power?—but of an inferior, an almost morbid variety. We might almost call it a negative sensation, if the phrase were admissible. In fact, as must be owned right away, this famous, and in his own way revolutionary, painter has merits—charms, even—which are so indisputable (and whose origin I shall shortly analyse) that it would be absurd not to record at this point a gap, a deficiency, a shrinkage in his stock of spiritual faculties. The Imagination, which sustained his great predecessors, lost though they were amid their academic gymnastics—the Imagination, that Queen of the Faculties, has vanished.

No more imagination: therefore no more movement. I do not propose to push irreverence and ill-will to the lengths of saying that this is an act of resignation on the part of M. Ingres; I have sufficient insight into his character to hold that with him it is an heroic immolation, a sacrifice upon the altar of those faculties which he sincerely considers as nobler and more important.

However enormous a paradox it may seem, it is in this particular that he comes near to a young painter whose remarkable début took place recently with all the violence of an armed revolt. I refer of course to M. Courbet, who also is a mighty workman, a man of fierce and indomitable will. . . . But the difference is that the heroic sacrifice offered by M. Ingres in honour of the idea and the tradition of Raphaelesque Beauty is performed by M. Courbet on behalf of external, positive and immediate Nature. In their war against the imagination they are obedient to different motives; but their two opposing varieties of fanaticism lead them to the same immolation.

And now, to resume the regular course of our analysis, let us ask what is M. Ingres's goal. It is certainly not the translation of sentiments, emotions, or variations of those emotions and sentiments; no more is it the representation of great historical scenes. . . . What then is M. Ingres seeking? What are his dreams? What has he come into this world to say? What new appendix is he bringing to the gospel of Painting?

I would be inclined to believe that his ideal is a sort of ideal composed half of good health and half of a calm which amounts almost to indifference—something analogous to the antique ideal, to which he has added the frills and furbelows of modern art. It is just this coupling which often gives his works their singular charm. Thus smitten with an ideal which is an enticingly adulterous union between Raphael's calm solidity

and the gewgaws of a *petite-maîtresse,* M. Ingres might be expected to succeed above all in portraiture; and in fact it is precisely in this genre that he has achieved his greatest and his most legitimate successes. . . . Beautiful women, rich and generous natures, embodiments of calm and flourishing health—here lies his triumph and his joy!

But at this point a question arises which has been a thousand times debated, and which is still worth returning to. What is the quality of M. Ingres's drawing? Is it of a superior order? is it absolutely *intelligent?* Anyone who has made a comparison of the graphic styles of the leading masters will understand me when I say that M. Ingres's drawing is the drawing of a man with a system. He holds that nature ought to be corrected, improved; he believes that a happily-contrived and agreeable artifice, which ministers to the eye's pleasure, is not only a right but a duty. Formerly it was said that nature must be interpreted and translated as a whole and in her total logic; but in the works of the present master, sleight-of-hand, trickery and violence are common occurrences, and sometimes downright deception and sharp-practice. Here we find an army of too-uniformly tapered fingers whose narrow extremities cramp the nails, such as a Lavater, on inspection of that ample bosom, that muscular forearm, that somewhat virile frame, would have expected to be square-tipped—indicative of a mind given to masculine pursuits, to the symmetry and disciplines of art. Here again we find a sensitive face and shoulders of a simple elegance associated with arms too robust, too full of a Raphaelesque opulence. But Raphael loved stout arms, and the first thing required was to obey and to please the master. Elsewhere we shall find a navel which has strayed in the direction of the ribs, or a breast which points too much towards the armpit. . . .

Let us note further that, carried away as he is by this almost morbid preoccupation with *style,* our painter often does away with his modelling, or reduces it to the point of invisibility, hoping thus to give more importance to the contour, so that his figures look like the most correct of paper-patterns, inflated in a soft, lifeless manner, and one quite alien to the human organism. Sometimes it happens that the eye falls upon charming details, irreproachably alive; but at once the wicked notion flashes across the mind, that it is not M. Ingres who has been seeking nature, but Nature that has *ravished* M. Ingres—that that high and mighty dame has overpowered him by her irresistible ascendency.

From all that goes before, the reader will easily understand that M. Ingres may be considered as a man endowed with lofty qualities, an eloquent amateur of beauty, but quite devoid of that energy of temperament which constitutes the fatality of genius. His dominant preoccupations are his taste for the antique and his respect for the School. . . .

but it often seems to me that M. Ingres is to antiquity what the transitory caprices of good taste are to the natural good manners which spring from the dignity and charity of the individual. . . .

To sum up, and setting aside his erudition and his intolerant and almost wanton taste for beauty, I believe that the faculty which has made M. Ingres what he is—the mighty, the indisputable, the absolute despot— is the power of his will, or rather an immense abuse of that power. . . .

A thousand lucky circumstances have combined in the establishment of this formidable renown. He has commanded the respect of polite society by his ostentatious love of antiquity and the great tradition. The eccentric, the *blasé* and the thousand fastidious spirits who are always looking for something new, even if it has a bitter taste—all these he has pleased by his *oddness*. But his good, or at all events his *engaging*, qualities have produced a lamentable effect in the crowd of his imitators; and this is a fact that I shall have more than one opportunity of demonstrating.

The Suicide of Benjamin Robert Haydon (1846)

Haydon (see page 83) was a painter whose intellect and idealism far outstripped his rather modest talent as an artist. His Diary *and* Autobiography *are not merely of interest as documents of their time, but contain superb passages which prove that Haydon's real gift was for descriptive writing. But he had set his heart on conquering England for monumental history painting, and in this he utterly failed. In the summer of 1846, crushed by debts and exhausted from forty years of futile struggling, having spent all his energy and hope, he cut his throat.*[63]

June 12. O God carry me through the evils of this day. Amen.

June 13. Picture much advanced, but my necessities are dreadful, owing to my failure at the Hall. In God alone I trust, to bring me through next week safe & capable of paying my way. O God, it is hard, this struggle of 42 years, but thy will & not mine be done, if it save the Art in the end. O God bless me through all my Pictures, the 4 remaining, & grant nothing on Earth may stop the completion of the Six.

June 14. Sunday. Bless me today & through the week. Amen. O God, let it not be presumption in calling for thy blessing on my six works. Let no difficulty on Earth stop or impede their progression, for one moment. Out of nothing thou couldst create Worlds; O God bless me this week with Thy Divine aid. From sources invisible to us raise up Friends, save

[63] W. B. Pope (ed.), *The Diary of Benjamin Robert Haydon*, Cambridge, Harvard University Press, 1960, V, 546 ff.

me from the embarrassments want of money must bring on. O God grant this day week I may be able to thank thee from my soul for extrication, & preserve my health & head & spirit & piety to bear up & vanquish all obstructions. Amen. Amen.

June 16. I sat from 2 till 5 staring at my Picture like an Idiot, my brain pressed down by anxiety and anxious looks of my dear Mary & children, whom I was compelled to inform. I dined, after having raised money on all our Silver, to keep [us] from want in case of accidents, & Rochfort, the respectable old man in Brewer St., having expressed great sympathy for my position, I saw white locks under his cap, I said, "Rochfort, take off your cap." He took it off, & shewed a fine head of silvery hair. "This is the very thing I want; come & sit." He smiled & looked through me. "When?" "Saturday, at 9." "I will, Sir"; and would any man believe I went home with a lighter heart *at having found a model for the hair of the kneeling figure of Alfred?* This is as good [as] anything I remember of Wilkie in my early days.

I came home, & sat as I describe. I had written Sir R. Peel, Duke of Beaufort, Lord Brougham, saying I had a heavy sum to pay. I offered the Duke's Study to the Duke of Beaufort for £50. Who answered first? Tormented by D'Israeli, harrassed by public business, up came the following letter:

Whitehall, June 16, 1846.

Sir,

I am sorry to hear of your Continued Embarrassments.

From a limited fund which is at my disposal I send as a Contribution towards your Relief from those embarrassments the sum of fifty pounds.

I am, Sir
Your obedient Servt.
Robert Peel

B. R. Haydon, Esq.
Be so good as to sign & return the accompanying Receipt.

That's Peel. Will Brougham or Beaufort or Hope or Barry answer?

Dearest Mary, with a Woman's passion, wishes me at once to stop payment & close the whole thing. I will not. I will finish my Six, under the blessing of God, reduce my expences, and hope his mercy will not desert me, but bring me through in health & vigor, gratitude & grandeur of soul, to the end. In him I trust—alone. Let my imagination keep Columbus before my mind for Ever. Amen.

O God bless my Efforts with success, through every variety of Fortune! & support my dear Mary & family. Amen.

In the morning, fearing I should be involved, I took down Books I had not paid for of a young Bookseller with a family, to return them. As I drove along, I thought I might get money on them! I felt disgusted at such a thought, & stopped and told him I feared I was in danger, & as he might lose, I begged him to keep them for a few days. He was grateful, & in the evening came this £50. I know what I believe.

June 18. O God bless me through the Evils of this day. Amen. Great anxiety. My Landlord Newton called. I said, "I see a Quarter's rent in thy face, but none from me." I appointed tomorrow to see & lay before him every iota of my position. Good hearted Newton! I said, "Don't put in an execution." "Nothing of the sort," he replied, half hurt.

No reply from Brougham, Beaufort, Barry, or Hope!—& this Peel is the man who has *no heart.*

I sent the Duke, Wordsworth, dear Fred, & Mary's heads to Miss Barrett to protect. I have the Duke's boots [and] hat, & Lord Grey's coat, & some more heads—tonight I got her letter.

I offered my new Friend Commissioner Evans to paint him Byron musing at Harrow for 50 gs.

June 20. O God bless us all through the evils of this day. Amen.

June 21. Sunday. Slept horribly. Prayed in sorrow and got up in agitation.

June 22. God forgive—me—Amen.

<div align="center">

Finis

of

B. R. Haydon

"Stretch me no longer on this tough World"—Lear.

End—

XXVI Volume.

</div>

At noon on the 22nd his daughter found him in his painting-room "stretched out dead, before the easel on which stood his unfinished picture of Alfred and the first British Jury"—(as though he appealed to British justice still), "his white hairs dabbled in blood, a half-open razor smeared with blood, at his side, near it, a small pistol recently discharged, in his throat a frightful gash, and a bullet-wound in his skull. A portrait of his wife stood on a smaller easel facing his large picture."

THE ARTIST AND HIS CRITICS

The early decades of the 19th century produced a vast amount of art criticism, a large part of it ephemeral and of little value, except for the insight which it gives into contemporary tastes and prejudices. The occasions for nearly all the published criticism were the periodic exhibitions which had become an established institution in many of the capitals and which were usually held under academic auspices. The Paris Salons continued to be the most important exhibitions in terms of frequency, size, and influence. Biennial at the beginning of the century, they became annual events in the 1830's. Their size increased enormously from 1800, when 412 paintings were listed in the official catalogue in addition to some 120 sculptures, prints, and architectural designs, to 1847, by which year the catalogue had swelled to 2,010 paintings and some 300 works in other media. Every Paris Salon, and, to a lesser extent, the other large exhibitions, produced a crop of newspaper articles and longer critical essays which, often published as separate pamphlets or books, tended to grow bulkier from year to year as the exhibitions increased in size; the reviews by Jal of the Salons of 1824 and 1827 number 468 and 544 pages, respectively. The level of criticism varied greatly. Some pamphlets were written for popular appeal, in the form of dialogue or doggerel, and illustrated with farcical vignettes, while others were detailed, scholarly, and carefully illustrated. The tone of most reviews was sharply and systematically partisan.

Géricault on the Critics of the Medusa

At the Salon of 1819, Géricault's Raft of the Medusa *(see page 102) caused a sensation, for reasons which were in part political. The shipwreck which had furnished the idea for the picture had been exploited by the Liberal parliamentary opposition for the purpose of embarrassing the Conservative government. Géricault's choice of the controversial subject for a painting of unusually large dimensions was misinterpreted by many as a deliberate, political manifestation. This fact strongly colored the critical notices of the work, both in the Liberal and the Conservative press. Deeply irritated, Géricault wrote to a friend:* [64]

[64] Charles Clément, *Géricault, étude biographique et critique*, Paris, 1868, pp. 170 ff.

I am more flattered by your four lines and very kind prediction of my future success than by all those newspaper articles which so sagely distribute both insult and praise. Artists must imitate the actors in cultivating a total indifference for everything emanating from journals and journalists. The lover of true glory must seek it sincerely, in the beautiful and sublime, and turn a deaf ear to these merchants of empty smoke.

This year, our newspaper scribblers have reached the height of ridicule. They judge every picture by the political spirit in which it was composed. A Liberal review will praise a certain work for its truly patriotic execution, its national touch. The same work, judged by an Ultra-Conservative, will be merely a revolutionary composition dominated by a general tint of sedition; the faces of its figures will be described as wearing expressions of hatred for the paternal government. I have been accused by a certain *Drapeau blanc* of having slandered the entire Ministry of the Navy by the expression of one of the heads in my picture. The wretches who write such rubbish have certainly never had to go without food for two weeks on end. If they had, they would perhaps realize that neither poetry nor painting could ever fully render the horror and anguish endured by the men on the raft.

Adolphe Thiers' Review of Delacroix' Bark of Dante

At the Salon of 1822, Delacroix' Bark of Dante, the first exhibited work of this very young artist who was then quite unknown to the public, received the following enthusiastic notice from Adolphe Thiers (1797–1877) of the influential Constitutionnel. *The journalist and historian Thiers, who later became one of the leading statesmen of France, entertained political relations with Talleyrand whom some believe to have been the father of Delacroix.*[65]

It is a pleasure . . . to be able to announce the coming of a great talent among this rising, young generation.

In my opinion, no picture at the Salon more clearly foretells the future of a great painter than M. Delacroix' *Dante and Virgil in Hell.* It is particularly in this work that we can see that thrust of talent, that

[65] A. Thiers, *Salon de Mil-Huit-Cent Vingt-Deux,* Paris, 1822, pp. 56 ff. Thiers' Salon review was published originally in serial form in *Le Constitutionnel.* It is from this version that Baudelaire took the quotation which he included in his review of the *Salon of 1846* (cf. J. Mayne, *The Mirror of Art,* p. 53). As originally published, Thiers' article apears to have had an additional paragraph which the later publication in book form lacks: "I do not believe that I am mistaken when I say that M. Delacroix has been given genius. Let him forward this assurance, let him devote himself to immense tasks, an indispensable condition of talent; and let him take still further confidence when I say that the opinion which I am expressing here is shared by one of the great masters of the school." (Trans. J. Mayne.)

surge of unfolding mastery which revive hopes somewhat dampened by the mediocrity of all the rest.

The bark of Dante and Virgil, ferried by Charon across the river of Hell, moves with difficulty through the crowd of bodies which press around it and try to climb into it. Dante, shown in life, wears the horrid colors of the place; Virgil, crowned with the somber laurel, has the colors of death. The damned souls, condemned to strive forever toward the opposite shore, fasten themselves to the bark. One of them vainly reaches for it and is thrown back into the water by its motion. Another holds on to it and kicks with his foot the others who want to climb in. Two others bite the timbers of the bark as it eludes them. The picture sums up the egoism and despair of Hell. Though it verges on exaggeration, we find in its treatment of the subject a severity of taste and a kind of propriety which elevate a design that severe judges (ill-advisedly, I think) might otherwise have accused of lacking in nobility. The brushwork is large and firm, the color plain and full of vigor, though perhaps a little crude.

The artist possesses, besides that poetic imagination which painter and writer share, that other kind of imagination which might be called the pictorial and which is of a quite different nature. He dashes off his figures, groups them, and twists them about with a boldness that recalls Michelangelo and a fertility of invention that reminds us of Rubens. At the sight of this painting, I am seized by the memory of I know not what great artist. I find in it a wild power, an ardent, spontaneous intensity which is carried along by its own momentum.

Stendhal at the Salon of 1824

Having been exiled from Milan by the Austrians, in 1821, the novelist Stendhal (Henri-Marie Beyle, 1783–1842) spent the following nine years in Paris, where he supported himself by literary hack work. His review of the Salon of 1824, published in the Journal de Paris, *shows him to have been an indifferent critic of individual paintings, but a keen observer of general tendencies in modern art. His practical, cutting common sense and his insistence that art be relevant to contemporary life influenced Baudelaire's art criticism (see page 153).*[66]

Try as I might, I cannot admire M. Delacroix and his *Massacre of Scio*. It always seems to me as if this picture had been started as a scene of the plague and then converted by the artist, with the help of newspaper accounts, into a *Massacre of Scio*. I cannot see in that big living

[66] Stendhal (Henri-Marie Beyle), *Mélanges d'art et de literature*, Paris, 1867, p. 154; p. 179 (on Delacroix); p. 191 (on Constable).

corpse in the middle of the composition anything other than a plague-stricken wretch who has tried to lance his sores, as is shown by the blood which appears on the left side of this figure. Another episode such as art students never fail to include in plague pictures is the child seeking the breast of his dead mother—he can be found in the right corner of M. Delacroix' picture. A massacre needs a butcher and a victim. There should have been a fanatical Turk, as handsome as M. Girodet's Turks, slaying Greek women of angelic beauty and threatening their aged father who will be the next to fall under his blows.

M. Delacroix, like M. Schnetz, has feeling for color; that is something in this time of draftsmen. He looks to me like a pupil of Tintoretto; his figures have movement.

The *Journal des Debats* of day before yesterday found Shakespearian poetry in the *Massacre of Scio*. What causes the picture to be mediocre, in my opinion, is its eccentricity, rather than the insignificance which is to be found in many classical paintings which I could name, but which I shall refrain from attributing to the school of Homer, whose spirit must be amazed by what is said and done in his name. M. Delacroix at any rate has this great superiority over the artists whose big pictures are plastered over the walls of the Salon: the public has at least taken a great interest in his work. That is better than being praised in three or four newspapers which hang on to old ideas and distort new ones because they cannot disprove them.

The English have sent us some magnificent landscapes by Mr. Constable this year. I do not think that we have anything to compare with them. It is their truthfulness which strikes you and draws you to these charming works. Mr. Constable's brushwork is excessively negligent, the planes of his composition are not well studied, and he has refrained from idealization. But his delicious landscape with a dog at the left is the very mirror of nature. It completely outshines a large landscape by M. Watelet which hangs next to it in the large Salon. . . .

A week ago, I went to the rue Godot-de-Mauroi to look for an apartment. I was struck by the smallness of the rooms. Since this was precisely the day on which I had been asked to write on painting for the *Journal de Paris,* my mind was filled with the thought of the honor I should have of addressing myself to the most discriminating public of Europe. I took from my wallet a page on which I had noted the dimensions of the most famous paintings. And, comparing these with the size of the small rooms through which the landlord was showing me, I said to myself with a sigh: "The days of painting are over, only print-making will prosper from now on. Our new style of life has led to the levelling of the great town houses and the demolition of castles; it has made the

taste for pictures obsolete. Only engraving will from now on be useful to the public, and as a result get public support." The landlord looked at me with surprise; I realized that I had been speaking aloud and that he must have taken me for a madman. I hurried away. Scarcely recovered, I was struck by another thought. Guido Reni, one of the lights of the Bolognese school, was a gambler. Toward the end of his career, he painted as many as three pictures a day. A hundred *sequins,* sometimes a hundred and fifty *sequins* was the price he got for them. The more he worked, the more money he made.

In Paris, the more a painter works, the poorer he gets. A personable young artist can easily manage, between exhibitions, to establish relations with the editor of a journal. When next he exhibits his work, never mind how poor its quality or how awkward his heros, he will always find some good paper to praise and to deceive him, because he has such a pleasant manner and would be hurt by the truth. He will find his pictures emphatically noticed, and praised as little masterpieces. But nobody will buy them. And yet in order to paint a picture, he must hire models, and that is more expensive than you think, he must buy paint and canvas, and he must live. A young artist of the modern school can afford to be an artist only by going into debt. . . . Forced to take his works back after the exhibition, he can live only on illusions, on disappointed hopes and on privations, until one day he discovers a sure way to prosper—by stopping to work.

This, surely, is an extraordinary state of affairs in the history of art, and one which, judging by the emphatically positive tone of the exhibition reviews, we should not expect to find. Here as elsewhere, hypocrisy in the realm of ideas leads to unhappiness in real life. The young artist who regains prosperity by throwing his brushes out the window is thirty years old—he has lost the better part of his life, or spent it in developing a useless talent. What should he do . . . ?

These are the dire results of the excessive encouragement given to painting by the budget of the Ministry of the Interior. This is the unexpected result of academic competitions and Rome prizes.

In the prize competitions, aged artists gravely examine the work of young artists, to see whether they have well imitated their style of painting. . . . Think of how ridiculous these competitions are in which a bunch of fifty-year-old artists is called to judge the work of young men. Public opinion scarcely affects these judgments, yet it ought to be possible, if a sincere attempt were made, to find a way of consulting the public. The prize-winning pictures might then actually find purchasers. As things stand now, the public likes only those kinds of painting which it can freely judge.

Who is, in effect, the only painter, in this year of 1824, who thrives

on his own talent and puts no burden whatever on the state budget? It
is M. Horace Vernet. . . .

Heinrich Heine on Delacroix' Liberty on the Barricades

*Delacroix' Liberty, inspired by the Revolution of 1830, was the
popular success of the Salon of 1831, where it figured under Number 311,
with the title:* Le 28 Juillet. La liberté guidant le peuple. *The poet
Heine (1797–1856) had moved to Paris in May of 1831, largely for
political reasons. The following passage is taken from his review of the
Salon of 1831, written in September and October of that year for the
German press, and published shortly thereafter in French translation.
Heine later wrote two further Salon reviews, in 1833 and 1843. His style
may have had some influence on Baudelaire's beginnings as a critic.*[67]

I pass over the other not less important works of Horace Vernet,
the versatile artist who paints everything, pictures of saints, battles, still-
lives, landscapes, portraits, all rapidly, as it were like pamphlets. I now
come to *Delacroix,* who has contributed a picture before which there
was always a crowd, and which I therefore class among those which
attracted the most attention. The sacredness of the subject forbids a
severe criticism of the colouring, with which fault might otherwise be
found. But despite a few artistic defects, there prevails in the picture
a great thought, which strangely attracts us. It represents a group of the
people during the Revolution of July, from the centre of which—almost
like an allegorical figure—there rises boldly a young woman with a red
Phrygian cap on her head, a gun in one hand, and in the other a tri-
colour flag. She strides over corpses calling men to fight—naked to the
hips, a beautiful impetuous body, the face a bold profile, an air of
insolent suffering in the features—altogether a strange blending of
Phryne, fishwife, and goddess of liberty. It is not distinctly shown that
the artist meant to set forth the latter; it rather represents the savage
power of the people which casts off an intolerable burden. I must admit
that this figure reminds me of those peripatetic female philosophers,
those quickly running couriers of love or quickly loving ones, who swarm
of evenings on the Boulevards. And also that the little chimney-sweep
Cupid, who stands with a pistol in either hand by this alley-Venus, is
perhaps soiled by something else as well as soot; that the candidate for
the Pantheon, who lies dead on the ground, yesterday may have been
selling tickets at the door of a theatre, and that the hero who storms
onward with his gun, the galleys in his features, has certainly the smell
of the criminal court in his abominable garments. And there we have

[67] Trans. C. G. Leland (pseud. Hans Breitman), *The Works of Heinrich Heine,
The Salon,* London, 1893, pp. 24 ff.

it! a great thought has enobled and sainted these poor common people, this rabble, and again awakened the slumbering dignity in their souls.

There is no picture in the Salon in which colour is so sunk in as in the July Revolution of Delacroix. But just this absence of varnish and sheen, with the powder-smoke and dust which covers the figures as with a grey cobweb, and the sun-dried hue which seems to be thirsting for a drop of water, all gives to the picture a truth, a reality, an originality in which we find the real physiognomy of the days of July.

Among the spectators were many who had been actors or lookers-on in the Revolution, and these could not sufficiently praise the picture. "Matin!" exclaimed a grocer, "these gamins fought like giants.". . .

"Papa," asked a little Carlist girl, "who is the dirty woman with the red cap?" "Well, truly," replied the noble parent with a sweetly subdued smile, "I do not find her so ugly—she looks like the most beautiful of the seven deadly sins." "And she is so dirty!" observed the little one. "Well, it is true, my dear," he answered, "that she has nothing in common with the purity of the lilies. She is the goddess of liberty." "But, Papa, she has not on her even a chemise." "A true goddess of freedom, my dear, seldom has a chemise, and is therefore very angry at all people who wear clean linen."

Saying this, he drew his linen sleeve-cuffs still farther over his long idle hands, and said to his neighbour, "Your Eminency, should the Republicans succeed to-day in having some old woman shot by the National Guard at the Porte Saint-Denis, then they would bear the sacred corpse round the Boulevards; the mob would go mad, and we should have a new Revolution."

Charles Baudelaire (1821–1867)

At the end of his life, Baudelaire jotted into a notebook, among other remembrances and intentions: [68] *"To glorify the cult of pictures (my great, my unique, my primitive passion)." The worship of art in effect had dominated his life and work from the time when, at the age of twenty-four, he wrote the* Salon of 1845, *his earliest signed publication. This first essay in art criticism was soon followed by the review of the* Musée Classique *of the Bazar Bonne Nouvelle (1846) and the masterly* Salon of 1846. *After a long interruption, Baudelaire resumed art criticism with the review of the exhibition at the* Exposition Universelle *of 1855 (see page 140), the* Salon of 1859, *and, finally, the long articles on Delacroix (see page 127), and on Constantin Guys, the "Painter of Modern Life," both published in 1863.*

[68] From *Mon coeur mis à nu,* cf. Baudelaire, *Oeuvres completes,* Paris (Bibliothèque de la Pléiade, Galimard), 1961, XXXVIII, 1295.

In his writings on art, he never assumed the position of a detached observer, but wrote as a poet who felt directly concerned with artistic matters and whose opinions carried the weight of experience. The function of his criticism within the economy of his own creative life shaped the form and character of his reviews: "You will often find me appraising a picture exclusively for the sum of ideas or of dreams that it suggests to my mind." Of all his critical writings, only the Salon of 1845, *an immature attempt, conformed to an established pattern of salon reviews. Its staccato sequences of brief descriptions or abrupt dismissals, and its frequent, jovial impertinences betray a youthful imitation of the manner of Diderot and Stendhal. From 1846 onward, by contrast, Baudelaire's reviews assumed the character of reasoned philosophical arguments, in which descriptions or analyses of particular works gave way more and more to a theoretical discussion of general questions of art. By the time he wrote his* Salon of 1859, *his most carefully composed review, a single cursory visit to the exhibition gave him material enough for a series of largely theoretical essays. The example of Delacroix constantly dominated Baudelaire's view of art and set the standard by which he measured other artists (see page 127). His conception of art and his exaltation of the individual artist resembled the old notion of creative genius. For him, the source of art was neither external nature, nor any principle of beauty, but solely the individual artist's image-making faculty, his imagination. From this source derived the special beauty and spirit of vital art, its stirring modernity which, in the case of Delacroix, he found to consist of the "unique and persistent melancholy with which all his works are imbued, and which is revealed in his choice of subject, in the expression of his faces, in gesture and in the style of colors." [69]*

On the Heroism of Modern Life (Salon of 1845)

We do not think that we have been guilty of any serious omissions. This Salon, on the whole, is like all previous Salons. . . . For the rest, let us record that everyone is painting better and better—which seems to

[69] All excerpts are from the translation by J. Mayne, *The Mirror of Art*, London, Phaidon Press, Ltd., 1955, reprinted by permission of the publisher. The *Salon of 1845* first apeared in the form of a booklet; for the sections quoted above, cf. J. Mayne, p. 37. The *Salon of 1846* was also originally published as a booklet; for the sections quoted cf. J. Mayne, p. 43 ("What is the Good . . ."); p. 45 ("What is Romanticism?" p. 83 ("On the Ideal . . . "). The *Salon of 1859* first appeared serially in the *Revue Francaise*, during June and July of 1859; for the sections quoted cf. J. Mayne, p. 225 ("Modern Public and Photography"); and p. 236 ("Reign of the Imagination"). Catherine Crowe, whom Baudelaire quotes in this last essay, was a writer on psychical phenomena, whose *The Night Side of Nature, or Ghosts and Ghost Seers,* London 1848, enjoyed some success at the time. For a study of the art criticism of Baudelaire, see Margaret Gilman, *Baudelaire the Critic,* New York, Columbia University Press, 1943.

us a lamentable thing; but of invention, ideas or temperament there is no more than before. No one is cocking his ear to tomorrow's wind; and yet the heroism of modern life surrounds and presses upon us. Our true feelings choke us; we know them well enough. We do not lack for subjects or colors with which to make epics. The painter, the true painter for whom we are searching, will be the one who can seize the epic quality of contemporary life and make us see and understand, with brush or with pencil, how great and poetic we are in our cravats and patent-leather boots.—Let us hope that next year the true seekers may grant us the extraordinary joy of celebrating the advent of the *new!*

What is the Good of Criticism? (Salon of 1846)

What is the good?—A vast and terrible question-mark which seizes the critic by the throat from his very first step in the first chapter that he sits down to write.

At once the artist reproaches the critic with being unable to teach anything to the bourgeois, who wants neither to paint nor to write verses —nor even to art itself, since it is from the womb of art that criticism was born.

And yet how many artists today owe to the critics alone their sad little fame! It is there perhaps that the real reproach lies.

I sincerely believe that the best criticism is that which is both amusing and poetic: not a cold, mathematical criticism which, on the pretext of explaining everything, has neither love nor hate, and voluntarily strips itself of every shred of temperament. But, seeing that a fine picture is nature reflected by an artist, the criticism which I approve will be that picture reflected by an intelligent and sensitive mind. Thus the best account of a picture may well be a sonnet or an elegy.

But this kind of criticism is destined for anthologies and readers of poetry. As for criticism properly so-called, I hope that the philosophers will understand what I am going to say. To be just, that is to say, to justify its existence, criticism should be partial, passionate and political, that is to say, written from an exclusive point of view, but a point of view that opens up the widest horizons.

To extol line to the detriment of colour, or colour at the expense of line, is doubtless a point of view, but it is neither very broad nor very just, and it indicts its holder of a great ignorance of individual destinies.

You cannot know in what measure Nature has mingled the taste for line and the taste for colour in each mind, nor by what mysterious processes she manipulates that fusion whose result is a picture.

Thus a broader point of view will be an orderly individualism—

that is, to require of the artist the quality of *naïveté* and the sincere expression of his temperament, aided by every means which his technique provides. An artist without temperament is not worthy of painting pictures, and—as we are wearied of imitators and, above all, of eclectics—he would do better to enter the service of a painter of temperament, as a humble workman. 1 shall demonstrate this in one of my later chapters.

The critic should arm himself from the start with a sure criterion, a criterion drawn from nature, and should then carry out his duty with passion; for a critic does not cease to be a man, and passion draws similar temperaments together and exalts the reason to fresh heights.

Stendhal has said somewhere: "Painting is nothing but a construction in ethics!" If you will understand the word "ethics" in a more or less liberal sense, you can say as much of all the arts. And as the essence of the arts is always the expression of the beautiful through the feeling, the passion and the dreams of each man—that is to say a variety within a unity, or the various aspects of the absolute—so there is never a moment when criticism is not in contact with metaphysics.

As every age and every people has enjoyed the expression of its own beauty and ethos—and if, by *romanticism,* you are prepared to understand the most recent, the most modern expression of beauty—then, for the reasonable and passionate critic, the great artist will be he who will combine with the condition required above—that is, the quality of *naïveté*—the greatest possible amount of romanticism.

What is Romanticism? (Salon of 1846)

Few people today will want to give a real and positive meaning to this word; and yet will they dare assert that a whole generation would agree to join a battle lasting several years for the sake of a flag which was not also a symbol?

If you think back to the disturbances of those recent times, you will see that if but few romantics have survived, it is because few of them discovered romanticism, though all of them sought it sincerely and honestly.

Some applied themselves only to the choice of subjects; but they had not the temperament for their subjects. Others, still believing in a Catholic society, sought to reflect Catholicism in their works. But to call oneself a romantic and to look systematically at the past is to contradict onself. Some blasphemed the Greeks and the Romans in the name of romanticism: but you can only make Romans and Greeks into romantics if you are one yourself. Many others have been misled by the idea of

truth in art, and local colour. Realism had already existed for a long time when that great battle took place.

Romanticism is precisely situated neither in choice of subjects nor in exact truth, but in a mode of feeling.

They looked for it outside themselves, but it was only to be found within.

For me, Romanticism is the most recent, the latest expression of the beautiful.

There are as many kinds of beauty as there are habitual ways of seeking happiness.

This is clearly explained by the philosophy of progress; thus, as there have been as many ideals as there have been ways in which the peoples of the earth have understood ethics, love, religion, etc., so romanticism will not consist in a perfect execution, but in a conception analogous to the ethical disposition of the age.

It is because some have located it in a perfection of technique that we have had the *rococo* of romanticism, without question the most intolerable of all forms.

Thus it is necessary, first and foremost, to get to know those aspects of nature and those human situations which the artists of the past have disdained or have not known.

To say the word Romanticism is to say modern art—that is, intimacy, spirituality, colour, aspiration towards the infinite, expressed by every means available to the arts.

Thence it follows that there is an obvious contradiction between romanticism and the works of its principal adherents.

Does it surprise you that colour should play such a very important part in modern art? Romanticism is a child of the North, and the North is all for colour; dreams and fairytales are born of the mist. England— that home of fanatical colourists, Flanders and half of France are all plunged in fog; Venice herself lies steeped in her lagoons. As for the painters of Spain, they are painters of contrast rather than colourists.

The South, in return, is all for nature; for there nature is so beautiful and bright that nothing is left for man to desire, and he can find nothing more beautiful to invent than what he sees. There art belongs to the open air: but several hundred leagues to the north you will find the deep dreams of the studio and the gaze of the fancy lost in horizons of grey.

The South is as brutal and positive as a sculptor even in his most delicate compositions; the North, suffering and restless, seeks comfort with the imagination, and if it turns to sculpture, it will more often be picturesque than classical.

Raphael, for all his purity, is but an earthly spirit ceaselessly investigating the solid; but that scoundrel Rembrandt is a sturdy idealist who makes us dream and guess at what lies beyond. The first composes creatures in a pristine and virginal state—Adam and Eve; but the second shakes his rags before our eyes and tells us of human sufferings.

And yet Rembrandt is not a pure colourist, but a harmonizer. How novel then would be the effect, and how matchless his romanticism, if a powerful colourist could realize our dearest dreams and feelings for us in a colour appropriate to their subjects!

On the Ideal and the Model (Salon of 1846)

The title of this chapter is a contradiction, or rather an agreement of contraries; for the drawing of a great draftsman ought to epitomize both things—the ideal and the model.

Colour is composed of coloured masses which are made up of an infinite number of tones, which, through harmony, become a unity; in the same way, Line, which also has its masses and its generalizations, can be subdivided into a profusion of particular lines, of which each one is a feature of the model.

The circumference of a circle—the ideal of the curved line—may be compared with an analogous figure, composed of an infinite number of straight lines which have to fuse with it, the inside angles becoming more and more obtuse.

But since there is no such thing as a perfect circumference, the absolute ideal is a piece of nonsense. By his exclusive taste for simplicity, the idiotic artist is led to a perpetual imitation of the same type. But poets, artists, and the whole human race would be miserable indeed if the ideal—that absurdity, that impossibility—were ever discovered. If that happened, what would everyone do with his poor *ego*—with his crooked line? . . .

Although the universal principle is one, Nature presents us with nothing absolute, nothing even complete; I see only individuals. Every animal of a similar species differs in some respect from its neighbour, and among the thousands of fruits that the same tree can produce, it is impossible to find two that are identical, for if so, they would be one and the same; and duality, which is the contradiction of unity, is also its consequence. But it is in the human race above all that we see the most appalling capacity for variety. Without counting the major types which nature has distributed over the globe, every day I see passing beneath my window a certain number of Kalmouks, Osages, Indians, Chinamen and Ancient Greeks, all more or less Parisianized. Each individual is a unique harmony; for you must often have had the surprising

experience of turning back at the sound of a known voice and finding yourself face to face with a complete stranger—the living reminder of someone else endowed with a similar voice and similar gestures. This is so true that Lavater has established a nomenclature of noses and mouths which agree together, and he has pointed out several errors of this kind in the old masters, who have been known to clothe religious or historical characters in forms which are contrary to their proper natures. It is possible that Lavater was mistaken in detail; but he had the basic idea. Such and such a hand demands such and such a foot; each epidermis produces its own hair. Thus each individual has his ideal.

I am not claiming that there are as many fundamental ideals as there are individuals, for the mould gives several impressions; but in the painter's soul there are just as many ideals as individuals, because a portrait is a *model complicated by an artist.*

Thus that ideal is not that vague thing—that boring and impalpable dream—which we see floating on the ceilings of academies; an ideal is an individual put right by an individual, reconstructed and restored by brush or chisel to the dazzling truth of its native harmony.

The first quality of a draftsman is therefore a slow and sincere study of his model. Not only must the artist have a profound intuition of the character of his model; but further, he must generalize a little, he must deliberately exaggerate some of the details, in order to intensify a physiognomy and make its expression more clear. . . .

Drawing is a struggle between nature and the artist, in which the artist will triumph the more easily as he has a better understanding of the intentions of nature. For him it is not a matter of copying, but of interpreting in a simpler and more luminous language.

The introduction of the portrait—that is to say, of the idealized model—into historical, religious or imaginative subjects necessitates at the outset an exquisite choice of model, and is certainly capable of rejuvenating and revitalizing modern painting, which, like all our arts, is too inclined to be satisfied with the imitation of the old masters.

The Modern Public and Photography (Salon of 1859)

During this lamentable period, a new industry arose which contributed not a little to confirm stupidity in its faith and to ruin whatever might remain of the divine in the French mind. The idolatrous mob demanded an ideal worthy of itself and appropriate to its nature— that is perfectly understood. In matters of painting and sculpture, the present-day *Credo* of the sophisticated, above all in France (and I do not think that anyone at all would dare to state the contrary), is this:

"I believe in Nature, and I believe only in Nature [there are good reasons for that]. I believe that Art is, and cannot be other than, the exact reproduction of Nature [a timid and dissident sect would wish to exclude the more repellent objects of nature, such as skeletons or chamber-pots]. Thus an industry that could give us a result identical to Nature would be the absolute of art." A revengeful God has given ear to the prayers of this multitude. Daguerre was his Messiah. And now the faithful says to himself: "Since Photography gives us every guarantee of exactitude that we could desire [they really believe that, the mad fools!], then Photography and Art are the same thing." From that moment our squalid society rushed, Narcissus to a man, to gaze at its trivial image on a scrap of metal. A madness, an extraordinary fanaticism took possession of all these new sun-worshippers. Strange abominations took form. By bringing together a group of male and female clowns, got up like butchers and laundry-maids at a carnival, and by begging these *heroes* to be so kind as to hold their chance grimaces for the time necessary for the performance, the operator flattered himself that he was reproducing tragic or elegant scenes from ancient history. Some democratic writer ought to have seen here a cheap method of disseminating a loathing for history and for painting among the people, thus committing a double sacrilege and insulting at one and the same time the divine art of painting and the noble art of the actor.

As the photographic industry was the refuge of every would-be painter, every painter too ill-endowed or too lazy to complete his studies, this universal infatuation bore not only the mark of a blindness, an imbecility, but had also the air of a vengeance. . . . I am convinced that the ill-applied developments of photography, like all other purely material developments of progress, have contributed much to the impoverishment of the French artistic genius, which is already so scarce.

. . . If photography is allowed to supplement art in some of its functions, it will soon have supplanted or corrupted it altogether, thanks to the stupidity of the multitude which is its natural ally. It is time, then, for it to return to its true duty, which is to be the servant of the sciences and arts—but the very humble servant, like printing or shorthand, which have neither created nor supplemented literature. Let it hasten to enrich the tourist's album and restore to his eye the precision which his memory may lack; let it adorn the naturalist's library, and enlarge microscopic animals; let it even provide information to corroborate the astronomer's hypotheses; in short, let it be the secretary and clerk of whoever needs an absolute factual exactitude in his profession—up to that point nothing could be better.

But if it be allowed to encroach upon the domain of the im-

palpable and the imaginary, upon anything whose value depends solely upon the addition of something of a man's soul, then it will be so much the worse for us!

It is an incontestable, an irresistible law that the artist should act upon the public, and that the public should react upon the artist; and besides, those terrible witnesses, the facts, are easy to study; the disaster is verifiable. Each day art further diminishes its self-respect by bowing down before external reality; each day the painter becomes more and more given to painting not what he dreams but what he sees. Nevertheless *it is a happiness to dream,* and it used to be a glory to express what one dreamt. But I ask you! does the painter still know this happiness? . . .

The Reign of the Imagination (Salon of 1859)

Yesterday evening I sent you the last pages of my letter, in which I wrote, not without a certain diffidence: *"Since Imagination created the world, it is Imagination that governs it."* Afterwards, as I was turning the pages of *The Night Side of Nature,* I came across this passage, which I quote simply because it is a paraphrase and justification of the line which was worrying me: *"By imagination, I do not simply mean to convey the common notion implied by that much abused word, which is only* fancy, *but the* constructive *imagination, which is a much higher function, and which, in as much as man is made in the likeness of God, bears a distant relation to that sublime power by which the Creator projects, creates, and upholds his universe."* I feel no shame—on the contrary, I am very happy—to have coincided with the excellent Mrs. Crowe on this point. . . .

I said that a long time ago I had heard a man who was a true scholar and deeply learned in his art, expressing the most spacious and yet the simplest of ideas on this subject. When I met him for the first time, I possessed no other experience but that which results from a consuming love, nor any other power of reasoning but instinct. . . . Obviously he wished to show the greatest indulgence and kindness to me; for we talked from the very beginning of *commonplaces*—that is to say, of the vastest and most profound questions. About nature, for example: "Nature is but a dictionary," he kept on repeating. Properly to understand the extent of meaning implied in this sentence, you should consider the numerous ordinary usages of a dictionary. In it you look for the meaning of words, their genealogy and their etymology—in brief, you extract from it all the elements that compose a sentence or a narrative: but no one has ever thought of his dictionary as a *composition,* in the poetic sense of the word. Painters who are obedient to the

imagination seek in their dictionary for the elements which suit with their conception; in adjusting those elements, however, with more or less of art, they confer upon them a totally new physiognomy. But those who have no imagination just copy the dictionary. . . .

For this great painter, however, no element of art, of which one man takes this and another that as the most important, was—I should rather say, is—anything but the humblest servant of a unique and superior faculty.

If a very neat execution is called for, that is so that the language of the dream may be translated as neatly as possible; if it should be very rapid, that is lest anything may be lost of the extraordinary vividness which accompanied its conception; if the artist's attention should even be directed to something so humble as the material cleanliness of his tools, that is easily intelligible, seeing that every precaution must be taken to make his execution both deft and unerring.

With such a method, which is essentially logical, all the figures, their relative disposition, the landscape or interior which provides them with horizon or background, their garments—everything, in fact, must serve to illuminate the idea which gave them birth, must carry its original warmth, its livery, so to speak. Just as a dream inhabits its own proper atmosphere, so a conception which has become a composition needs to move within a coloured setting which is peculiar to itself. Obviously a particular tone is allotted to whichever part of a picture is to become the key and to govern the others. Everyone knows that yellow, orange and red inspire and express the ideas of joy, richness, glory and love: but there are thousands of different yellow or red atmospheres, and all the other colours will be affected logically and to a proportionate degree by the atmosphere which dominates. In certain of its aspects the art of the colourist has an evident affinity with mathematics and music. And yet its most delicate operations are performed by means of a sentiment or perception to which long practice has given an unqualifiable sureness. . . . It is obvious that the larger a picture, the broader must be its *touch;* but it is better that individual strokes should not be materially fused, for they will fuse naturally at a distance determined by the law of sympathy which has brought them together. Colour will thus achieve a greater energy and freshness.

A good picture, which is a faithful equivalent of the dream which has begotten it, should be brought into being like a world. Just as the creation, as we see it, is the result of several creations in which the preceding ones are always completed by the following, so a harmoniously conducted picture consists of a series of pictures superimposed on one another, each new layer conferring greater reality upon the dream, and raising it by one degree towards perfection. On the other hand I re-

member having seen in the studios of Paul Delaroche and Horace Vernet huge pictures, not sketched but actually begun—that is to say, with certain passages completely finished, while others were only indicated with a black or a white outline. You might compare this kind of work to a piece of purely manual labour . . .

I have no fear that anyone may consider it absurd to suppose a single education to be applicable to a crowd of different individuals. For it is obvious that systems of rhetoric or prosody are no arbitrarily invented tyrannies, but rather they are collections of rules demanded by the very constitution of the spiritual being. And systems of prosody and rhetoric have never yet prevented originality from clearly emerging. The contrary—namely that they have assisted the birth of originality—would be infinitely more true.

To be brief, I must pass over a whole crowd of corollaries resulting from my principal formula, in which is contained, so to speak, the entire formulary of the true aesthetic, and which may be expressed thus: The whole visible universe is but a storehouse of images and signs to which the imagination will give a relative place and value; it is a sort of pasture which the imagination must digest and transform. All the faculties of the human soul must be subordinated to the imagination, which puts them in requisition all at once. . . . It is clear that the vast family of artists—that is to say, of men who have devoted themselves to artistic expression—can be divided into two quite distinct camps. There are those who call themselves "realists"—a word with a double meaning, whose sense has not been properly defined, and so, in order the better to characterize their error, I propose to call them "positivists"; and *they* say, "I want to represent things as they are, or rather as they would be, supposing that I did not exist." In other words, the universe without man. The others however—the "imaginatives"—say, "I want to illuminate things with my mind, and to project their reflection upon other minds."

But besides the imaginatives and the self-styled realists, there is a third class of painters who are timid and servile, and who place all their pride at the disposal of a code of false dignity. In this very numerous but very boring class we include the false amateurs of the antique, the false amateurs of style—in short, all those men who by their impotence have elevated clichés to the honours of the grand style.

Ruskin on Art Critics

Ruskin's anger at criticisms of Turner's paintings in various British magazines prompted him to begin writing Modern Painters *(see page 69). He remained throughout his life an enemy of the critical press. The following passage from the preface to the second edition of* Modern

Painters *(1844) expresses and explains his contempt for journalistic critics.*[70]

I do not consider myself as in any way addressing, or having to do with, the ordinary critics of the press. Their writings are not the guide, but the expression, of public opinion. A writer for a newspaper naturally and necessarily endeavours to meet, as nearly as he can, the feelings of the majority of his readers; his bread depends on his doing so. Precluded by the nature of his occupations from gaining any knowledge of art, he is sure that he can gain credit for it by expressing the opinion of his readers. He mocks the picture which the public pass, and bespatters with praise the canvas which a crowd concealed from him.

Writers like the present critic of *Blackwood's Magazine* deserve more respect; the respect due to honest, hopeless, helpless imbecility. There is something exalted in the innocence of their feeble-mindedness: one cannot suspect them of partiality, for it implies feeling; nor of prejudice, for it implies some previous acquaintance with their subject. I do not know that, even in this age of charlatanry, I could point to a more barefaced instance of imposture on the simplicity of the public, than the insertion of those pieces of criticism in a respectable periodical. We are not so insulted with opinions on music from persons ignorant of its notes; nor with treatises on philology by persons unacquainted with the alphabet; but here is page after page of criticism, which one may read from end to end, looking for something which the writer knows, and finding nothing.

[70] From the Preface of the second edition (1844) of *Modern Painters*, E. T. Cook and Alexander Wedderburn, *The Works of John Ruskin*, III, *Modern Painters*, I, London, G. Allen, 1903, p. 16.

Index

A

Abelard and Heloise, tomb of, 6
Academy, 7, 60, 99-101
Academy, Copenhagen, 52
Academy, French, in Rome, 132-33
Academy, Royal, in London, 93
Achilles, 49
Acropolis, 91
Adonis, 36
Aeolian harp, 20
Aeschylus, 139
Albano (Albani), Francesco (1578–1660), Bolognese painter, 10
Alfred and the First British Jury (by Haydon), 144-46
Amaury–Duval, Eugène (1806–1885), 132-33
Amiens, peace of, 9
Andrews, K., 33
Angelico, Fra, 70
Antichrist, 19
Antinous, 122
Apollo, 59
Apollo of Belvedere, Roman copy after Greek sculpture of the 4th century B.C., 8, 11, 13, 83, 87-89, 92
Apotheosis of Homer (by Ingres), 139
Art–Loving Friar, see *Outpourings*
Art romantique, l' (by Baudelaire), 127
Assassination of Dentatus (by Haydon), 84
Autobiography (by Haydon), 84, 144

B

Babylon (by Turner), 79
Bacchus, classical statues of, at the Louvre, 8
Bacchus and Ariadne (by Titian), 73
Backgrounds, Introductions of Architecture and Landscape (lecture by Turner), 94-97
Bamberg, 20
Bark of Dante (by Delacroix), 148-49
Barry, Sir Charles (1795–1860), English architect, 145-46
Battle of Romans and Sabines (by David), 103, 142
Baudelaire, Charles (1821–1867), 70, 127-32, 139-44, 148, 153-62
Bayreuth, 20

Beaufort, Duke of, 145-46
Beaumont, Sir George (1753–1827), English art patron, 62
Beauvais, tapestry manufactures of, 16
Beaux–Arts en Europe (by Gautier), 139
Bellini, Giovanni (c. 1426–1516), Venetian painter, 28
Berghem, Nicolaes Pieterszoon (1620–1683), Dutch landscape painter, 71
Bergholt, 63, 68
Bible, 21
Blackwood's Magazine, 69, 164
Blake, William (1757–1827), 3, 19-20
Blucher (Blücher), Gebhard Leberecht von (1742–1819), Prussian general, 13
Boehme, Jakob (1575–1624), German theologian and mystic, 42
Bonaparte, see Napoleon
Bonington, Richard Parkes (1801–1828), English painter, 104, 129
Both, Andries (c. 1608—c. 1640) and Jan (c. 1618–1652), Flemish painters and etchers, 71
Boucher, Francois (1703–1770), French painter, 67, 99
Boulanger, Louis (1807–1867), French painter and lithographer, 104
British Gallery, 66
British Institution, 66-67
Brotherhood of St. Luke, see Nazarenes
Brougham, Henry Peter, Lord (1778–1868), British statesman, 145-46
Brutus, 115
Brutus after the Execution of his Sons (by David), 142
Buonaparte, see Napoleon
Buonarotti, see Michelangelo
Burning of the House of Parliament (by Turner), 97-98
Byron, George Gordon Noel, Lord (1788–1824), 104, 107-8, 146

C

Cabot, J. E., 43
Callcott, August (1779–1844), English landscape painter, 64, 98
Campo Vaccino in Rome, 95
Canaletto (Antonio Canal, 1697–1768), Venetian painter, 71

R

S